U0058421

探索無限 NATIONAL GEOGRAPHIC AT 125

國家地理125年
經典影像大展
A New Age of Exploration
人文遠雄博物館特展

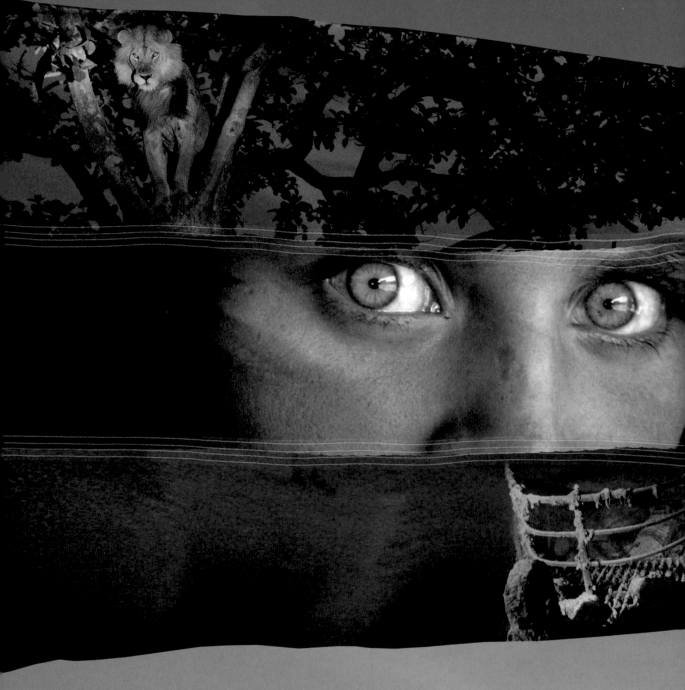

A NEW AGE OF EXPLORATION

探索無限

序言

在 1888 年，一群由科學家、探險家、外交官、律師、軍官等「社會賢達」組成的群體決定創立一個旨在「增進與普及地理知識」的機構時，也理所當然地認為這個機構應該有一份會員刊物。《國家地理》雜誌就這樣在同年 10 月誕生。

對這本披著深棕色封面、裝訂簡陋、報導內容只能稱之為枯燥的雜誌，絲毫不能讓人聯想一百多年後將世界的五彩繽紛帶到全球數千萬讀者面前的《國家地理》雜誌。將這本雜誌從專業冷僻的學術雜誌改造為一本讓廣泛大眾樂於接受、勤於閱讀的刊物，其中最重大的關鍵之一，是這本雜誌自 19 世紀末以來，堅持以視覺的語言來報導世界，用大量的照片將讀者從家中帶到地球的各個角落。

《國家地理》雜誌的攝影語言大約可以用「平易近人」來描述。儘管在雜誌中也不時能見到表現手法新穎的攝影方式，但是整體而言，形式的創新不如內容的傳達來得重要。這是因為國家地理始終沒有忘記自己是一本以一般大眾為對象、以報導「我們的世界，及其中的一切」為目標的一本普及性地理刊物，因此相對於追求表現手法的新穎與創新，《國家地理》雜誌的攝影更加倚賴平舖直敘的紀實手法；換句話說，對《國家地理》雜誌而言，最重要的是故事本身，而攝影的風格與方式，必須在故事能被清楚傳達的前提下進行。

用圖片說故事，說來容易，實際上卻是攝影師能力的最大考驗，攝影師追求的不僅僅是一張好看的照片：飽和的色彩、平衡的構圖、完美的光線，或迷人的氣氛，這些對國家地理的攝影師來說遠遠不夠。他們的照片必須說出故事，講述一張張照片後面所代表的議題，這包括大自然面臨的危機、人類社會的挫折與挑戰、動物的行為與人類對牠們的影響，甚至是宇宙的浩瀚與神祕或新科技對未來帶來的期望。這些故事，有時具體，有時抽象；有時凝聚在一個畫面裡，有時在一系列自成章法、自有結構的圖組之中。它們總能牽動觀者的情感：有時讓人會心一笑，有時讓人潸然淚下，有時讓人怒髮衝冠。通過這些照片，我們周遭的世界不是刻板地被複製下來，而是充滿情緒，引人入勝，就像真實的世界帶給我們的感覺一樣。

這並不意味著國家地理的攝影師們就因此對個人風格與詮釋有絲毫減少。相反地，大衛‧亞倫‧哈維（David Alan Harvey）在全世界各個地方，都能以他一貫強烈的個人風格捕捉到不同文化下街頭巷尾同樣蓬勃的生命力。以拍攝阿富汗少女著名的史提夫‧麥凱瑞（Steve McCurry）不論在什麼國度，都能拍出一張張震撼人心的肖像，幾乎能讓人一望而知作者是誰。卡里‧伍林斯基（Cary Wolinsky）的科學報導，同時具有豐富的想像力，又講述複雜的科技原理，風格一樣鮮明可辨。肯尼斯‧加瑞特（Kenneth Garrett）通過神乎其技的人為光源運用，把本來可能最枯燥無趣的考古現場，變成一處處藝術的展場。

國家地理報導的特色之一，就是這本發行量最盛時期每月超過 1000 萬份的雜誌，能夠動用全球絕無僅有的資源，把攝影師送到世界各個一般人難以想像的地方，來述說那裡的故事。《國家地理》雜誌前總編輯威廉・艾倫（William Allen）曾說：過去有個笑話說，當一個攝影師接到《國家地理》雜誌指派的攝影任務後，第一件事是買張頭等艙機票坐飛機到巴黎，住進當地最好的酒店，找個裁縫做一套西服，然後開始想怎麼拍攝這個任務。「這不是壞事，」艾倫說，「只有能夠提供攝影師這樣的條件，我們才能夠得到最好的作品。」

　　今天在全球的經濟情勢與媒體革命的新環境下，國家地理過去那種沒有預算上限，採訪時間隨意安排的年代已經不存在了，但是國家地理仍舊將大量採訪人員送到更加偏遠、更加危險、更加出人意表的地方去。例如：麥可・山下（Michael Yamashita）以三年時間重走馬可波羅東遊路線，從義大利、穿越中亞、一路追尋到中國北京，訴說了這個偉大遊記，也報導絲綢之路的現狀。保羅・尼克蘭（Paul Nicklen）不只是拍攝南極洲，而是到南冰洋冷冽的海洋下去記錄企鵝在水下優雅的行動。著名導演，也是國家地理駐會探險家的詹姆斯・卡麥隆（James Cameron）在一項國家地理支持的探險計畫中，潛到 11,000 公尺的馬里亞納海溝去探測地球最深處的海底景觀。有時，他們則利用最新的技術來取得前所未見的角度，在圖片氾濫的時代裡依舊月月帶來視覺的震撼與驚喜。布魯斯・戴爾（Bruce Dale）為了拍攝現代大客機，將照相機安裝在波音 747 的尾翼上，拍攝到飛機從舊金山機場起降的驚人畫面。麥可・尼可斯（Michael Nichols）最近在塞倫蓋帝草原用遙控車上裝置的相機以貼身的距離拍攝獅群的生活，我們第一次觀察到獅子們許多細緻的社會行為。

　　這一次又一次史詩般的採訪行動，換回來一幅幅經典的影像，講述一個又一個關於我們的世界的精彩故事。125 年來，這些故事已經積累成許多永垂不朽的傳奇，「國家地理 125 年經典影像大展」集結了其中最精華的一些故事，將它們齊聚一堂展出，可以說是台灣藝文活動的一大盛事。這次展覽不僅標誌著國家地理的一又四分之一個世紀以來的里程碑，也是《國家地理》雜誌中文版在台重新出發的一個新起點。我們能夠協同時藝多媒體一同組織、主辦此次展覽，除了深感幸運之外，也希望這些經典之作能夠感動更多讀者一同加入國家地理「激發大眾關愛地球」的行動行列之中，並一起為我們的世界記錄下更多精采迷人的影像故事。

《國家地理》雜誌中文版總編輯

2013 年 9 月 9 日

Foreword

In 1888, when a group of scientists, explorers, diplomats, lawyers and military officers gathered to establish an organization for the "increase and diffusion of geographic knowledge," it seemed only natural that the organization should have a member's publication. And so the National Geographic magazine was born in October of that same year.

It is difficult to associate the drab cover and crude binding of the early magazine, with contents that can only be described as dull and forbidding, with the publication it would become today, bringing the world in all its colors to tens of millions of readers around the world. The key to transforming the magazine from an arcane academic journal to a well-loved and avidly read publication is the National Geographic's insistence, since the end of the 19th century, on reporting about the world through visual language, transporting readers from their homes to every corner of the earth through the use of plenty of pictures.

The photographic language of the National Geographic magazine can perhaps be described as "approachable." Although inventive use of photography can at times be found within the magazine's pages, generally speaking the innovation in form and style takes second place to the communication of content and context. This is because National Geographic never lost sight of the fact that it is a geographic magazine meant for a general audience, and "the world and all that is in it" is its theme. Instead of pursuing novel or innovative ways of photographic expression, the magazine relied more on a straight-forward, documentary style for its reportage. For the National Geographic, the story came first; the photographic style or method had to ensure that the story could be clearly told.

Telling a story with pictures may sound easy. In fact, it presents the photographer's greatest challenge. A photographer seeks not only a pleasant looking picture, with saturated colors, balanced composition, perfect light, or a charming atmosphere. No, that is not quite enough for the National Geographic picture men. Their pictures must tell stories and iterate the issues behind each image: from the crises facing the natural world, the setbacks and challenges in human society, animal behaviors and how human activity impacts them, to the mysteries of the universe and the hopeful future that new sciences and technologies promise. These stories, sometimes concrete, other times abstract, are condensed in one frame or told through a well-structured series of images. But always, they connect emotionally with the viewer: sometimes bringing a smile to our face, other times moving us to tears, still other times enraging us. Through these pictures, the world around us is not simply duplicated, but captured in such a way that it is fascinating and charged with emotions, just like the real world makes us feel.

This does not mean that National Geographic photographers are limited from applying their personal style and interpretation of the world. Quite the contrary; with typical flair, David Alan Harvey has captured the same kind of vibrant energy in the streets of different cultures around the world. Steve McCurry, best known for the "Afghan girl", brings back stunning portraits from wherever he goes, to the extent that one look is enough to determine who took the picture. Equally recognizable is Cary Wolinsky's science coverage, infused with a rich sense of imagination while elucidating complex scientific and technological theories. Kenneth Garrett, through ingenious use

of artificial light, is capable of rendering potentially dull sites of archaeological excavation into showrooms of art.

At the height of its circulation, the National Geographic printed more than 10 million copies monthly. One of the hallmarks of a National Geographic coverage was that it could muster unparalleled resources to send photographers to places unimaginable for the common person and tell the stories of those places. Former Editor in Chief William Allen once shared a running joke: When a photographer received an assignment from the National Geographic, the first thing he would do was catch a first-class flight to Paris, check into the best hotel there, have a suit tailor made, and then start thinking about how to go about carrying out the assignment. "It wasn't a bad thing," Allen said. "Only by providing photographers with such conditions could we get the best works."

Under today's global economy and media revolution, the National Geographic of unlimited budget and time spent while on assignment belongs to a bygone era. But the magazine continues to dispatch editorial staff to places that are even more remote, dangerous and unexpected. Case in point: Michael Yamashita spent three years retracing the travels of Marco Polo from Italy, through Central Asia to Beijing, China. The result: a story of an epic historical journey and an updated look at the fabled Silk Road. Paul Nicklen went beyond taking pictures of Antarctica and went under— diving in the ice cold waters of the Southern Ocean to document the graceful underwater movement of penguins. Acclaimed director and National Geographic Society Explorer-in-Residence James Cameron dove to the depths of the Mariana Trench, 11,000 meters below the sea surface, to explore the landscape at the deepest place on earth. Sometime, the photographers employ the latest technology to obtain never-before-seen angles, creating images that still stun and surprise, even in this age of visual overdrive. To photograph large passenger aircrafts, Bruce Dale attached his camera to the tail of a Boeing 747, capturing stunning scenes of the plane taking off and landing at the San Francisco airport. Most recently, using a camera affixed to a robot, Michael Nichols was able to take close-up photos of a pride of lions living on the Serengeti Plain. We are able to observe many subtle social behaviors of lions for the first time.

These epic assignments have rewarded us with classic images, telling fascinating stories about our planet. After 125 years, these stories have become legends. Some of the best of these legends have been brought together and presented here at this exhibition: "A New Age of Exploration: National Geographic at 125." The exhibition not only marks the century-and-a-quarter milestone for the National Geographic Society, but also marks a new beginning for the National Geographic magazine in Taiwan. We have been fortunate to partner with Media Sphere Communications to organize and host this exhibition. We hope these timeless works will move viewers to join the Society's effort of "inspiring people to care about the planet," and together document our world with even more colorful and enchanting stories in pictures.

Editor-in-Chief, *National Geographic* Magazine Chinese Edition
9 September 2013

展覽簡介

永垂不朽的探險傳奇與攝影經典

1888 年 1 月 13 日的晚上，國家地理學會在美國華盛頓成立。從那時候起，這個獨樹一幟的科學與教育機構既是傳播資訊的媒體，也是使命的推動者。它聚集了說故事的人、科學家與探險家，贊助了多項偉大的探險考察行動，在 125 年來成為人類科技與知識發展的重要先鋒。

「探索無限 - 國家地理 125 年經典影像大展」展出了代表國家地理學會一又四分之一個世紀以來具有重要歷史意義的 150 幅影像，分為「影像歷史」、「深入險境」、「生命之歌」、「憤怒大地」、「人文探索」、「走進科學」、「攝影精粹」及「台灣記憶」等八大主題。除此之外，展覽還特地從美國華盛頓國家地理學會總部取得許多珍貴的實物展品，包括曾經在野外捕捉到許多生動畫面的動物攝影機、相機陷阱，以及有百年歷史的珍貴雜誌，並且結合了動人的影片與互動式多媒體，共同訴說國家地理學會精采的歷史與經典的時刻。

在一個大多數人只能坐在扶手椅上幻想旅行的年代，《國家地理》雜誌的作者和攝影師突破種種困境，把色彩繽紛的世界帶到讀者跟前。125 年後的今天，國家地理學會的探險家、科學家、文字記者與攝影師，仍不改初衷，持續探索地球上每個角落不為人知的面貌，繼續記錄最動人的地球真相。

Introduction
Legendary Photographs, Adventures and Discoveries that Changed the World

The National Geographic Society was founded in Washington, D.C., on the night of January 13, 1888. Since then, this unique scientific and educational institution has been a media for the dissemination of information, and a supporter of missions. Bringing together storytellers, scientists and explorers, it has supported numerous epic adventures and expeditions, always at the forefront for the advancement of science, technology and knowledge in the 125 years since its birth.

On display at the exhibition, "A New Age of Exploration: National Geographic at 125," are 150 images that represent important moments from the Society's century-and-a-quarter history, organized into eight themes: "A Photographic History," "Into the Unknown," "Wild Lives of Wildlife," "Violent Earth," "Peoples and Cultures," "Science of the Times," "Simply Beautiful," and "Remembering Taiwan." Also on display are priceless items on loan from Society headquarters in Washington, D.C.,: Crittercams and camera traps that have captured electrifying images and hundred-year-old magazines. Together with moving footages and interactive displays, they tell the story of the Society's remarkable history and definitive moments.

At a time when most people could travel only by armchair, National Geographic writers and photographers overcame obstacles and dangers and brought home the world in color. Today, 125 years after its founding, the explorers, scientists, writers and photographers remain committed to the exploration of unknown corners of the world and documenting the truth about our planet.

12 影像歷史
A PHOTOGRAPHIC HISTORY

26 深入險境
INTO THE UNKNOWN

48 生命之歌
WILD LIVES OF WILDLIFE

86 人文探索
PEOPLES &
CULTURES

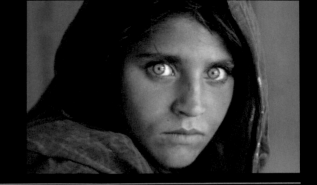

130 走進科學
SCIENCE
OF THE TIMES

146 攝影精粹
SIMPLY BEAUTIFUL

158 台灣影像
REMEMBERING
TAIWAN

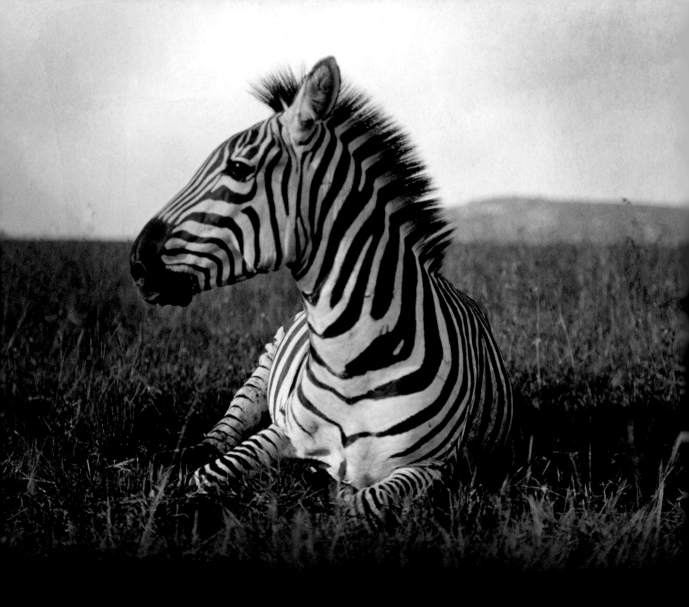

影像歷史
A Photographic History

照片

是《國家地理》雜誌的語言。在進入 20 世紀之前，國家地理學會的第二任理事會主席，也是電話的發明人亞歷山大 · 葛拉漢 · 貝爾（Alexander Graham Bell），以及第一任雜誌全職總編輯吉伯特 · 葛羅夫納 (Gilbert H. Grosvenor)，就為年輕的雜誌定下了這個原則。這也是讓《國家地理》雜誌成為世界上最成功的雜誌的主要因素之一。

《國家地理》雜誌從 1896 年開始就定位為一本「插圖月刊」，但自貝爾與葛羅夫納接手學會與雜誌開始，照片成為雜誌不可或缺的元素。「照片，而且要用很多」是貝爾的明確指示。雜誌在 1890 年刊出了第一張戶外照片；1905 年雜誌刊登了⋯張西藏拉薩的照片，幾個月後，甚至一次刊出了 138 張關於菲律賓原住民的照片；1910 年，雜誌開始刊登手工上色的「彩色」照片⋯⋯。隨著雜誌的讀者（學會會員）人數不斷攀升，國家地理強調攝影的基本風格逐漸根深柢固。這本雜誌從一開始就是紀實攝影在藝術與技術上的推動者，一直到今天仍是如此。

Pictures

are the language of the *National Geographic* magazine. This principle was laid down for the young magazine by National Geographic Society's second President, Alexander Graham Bell, and its first full-time Editor, Gilbert H. Grosvenor, by the end of the 19th century. This would become one of the defining factors that contributed to the phenomenal success of the *National Geographic*.

The magazine was repositioned as an "illustrated monthly" in 1896, but it was not until Bell and Grosvenor took the helm at the Society and magazine that pictures became an integral part of the publication. "Use pictures, and plenty of them" had been Bell's unambiguous instruction. The magazine published its first outdoor photograph in 1890; 11 pictures from Lhasa, Tibet's forbidden city, appeared in the magazine in January 1905; a few months later came 138 photographs of Philippine tribesmen; in 1910, the magazine began publishing hand-tinted "color" photographs... As the Society's membership (and thus the magazine's readership) soared, *National Geographic*'s emphasis on photography gradually became a well-established style. From the very beginning, the magazine was a pioneer of the art and techniques of documentary photography, a description that remains true to this day.

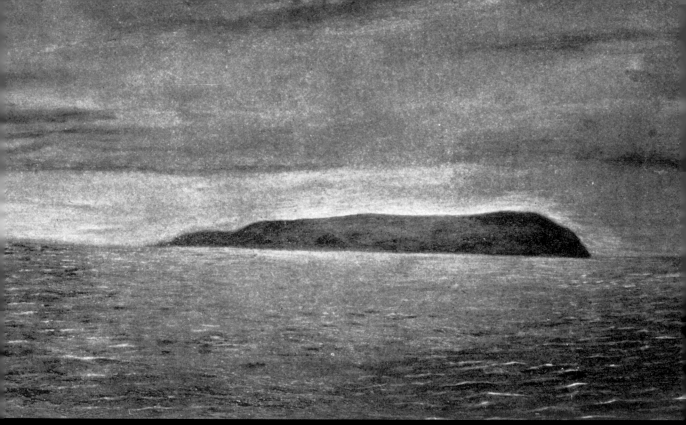

攝影／J.Q. 洛韋爾（美國海軍助理軍需官）
Photography/ Asst. Paymaster J.Q. Lovell, USN

這是《國家地理》雜誌刊登的第一張戶外照片。《國家地理》在 1890 年 7 月刊登了這張俄羅斯赫拉德島的照片，是前一年從一艘船顛簸的甲板上拍攝的。

國家地理學會的創始成員期許這本雜誌能「帶動地理調查」，並成為「發表調查結果的適當媒介」。成立不到兩年後，國家地理學會就贊助探險隊前往阿拉斯加聖伊利亞斯山區，這個神祕的山區常年為白雪覆蓋，山峰與冰河縱橫交錯，連地圖繪製者也還未曾進入。

The first outdoor photograph published in *National Geographic* did not appear until July 1890. It showed Russia's Herald Island and was shot from the heaving deck of a ship.

National Geographic founders hoped the magazine might "stimulate geographic investigation" as well as prove "an acceptable medium for the publication of results." Within two years, the young Society was sponsoring an expedition to the mysterious, snowbound Mount St. Elias region of Alaska, a maze of mountains and glaciers no mapmaker had penetrated. □

▶ 南非，維瓦特斯蘭一帶　│　**19 世紀晚期**
**WITWATERSRAND, REPUBLIC OF SOUTH AFRICA
│ LATE 19TH CENTURY**

這張照片刊登於 1896 年 11 月號，在《國家地理》雜誌出現的諸多裸胸婦女之中，這位祖魯族新娘是第一人。

不久之後，學會新總部「哈伯德廳」的大門，走了一代代外交官、軍人、科學家和浪跡天涯的旅行家，他們成為之後數十年間雜誌內容的主要提供者。與此同時，一列列身上刺青、包著頭巾的部落男子，身穿長靴斗篷的人物，纏著腰部手持長矛的戰士，以及戴著頸環、超大寬邊帽，穿著傳統服飾或裸露著胸部的女性，也從雜誌頁面走出來，進入美國人的家中。

This Zulu bride, from the November 1896 issue, was first in a long line of bare-breasted women to appear in *National Geographic*.

Through the doors of Hubbard Hall, the Society's new headquarters, soon wandered the first of that long line of diplomats, soldiers, scientists, and gadabout travelers who would be the magazine's primary contributors for the next several decades. Meanwhile a cavalcade of tattooed and turbaned tribesmen, of figures booted and caped, of warriors garbed in loincloths and carrying spears, of women festooned with neck rings or capped with tremendous bonnets or dressed in traditional costumes or notoriously bare-breasted—marched out of the magazine's pages and into American parlors. □

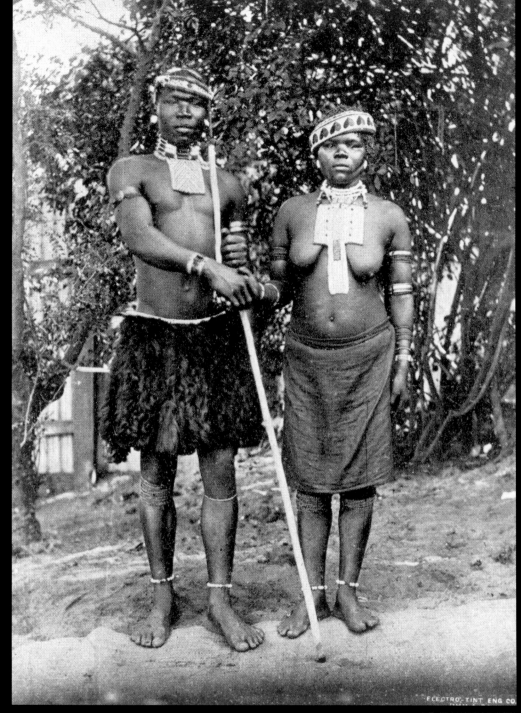

來源／國家地理學會影像收藏
Source/ NGS Image Collection

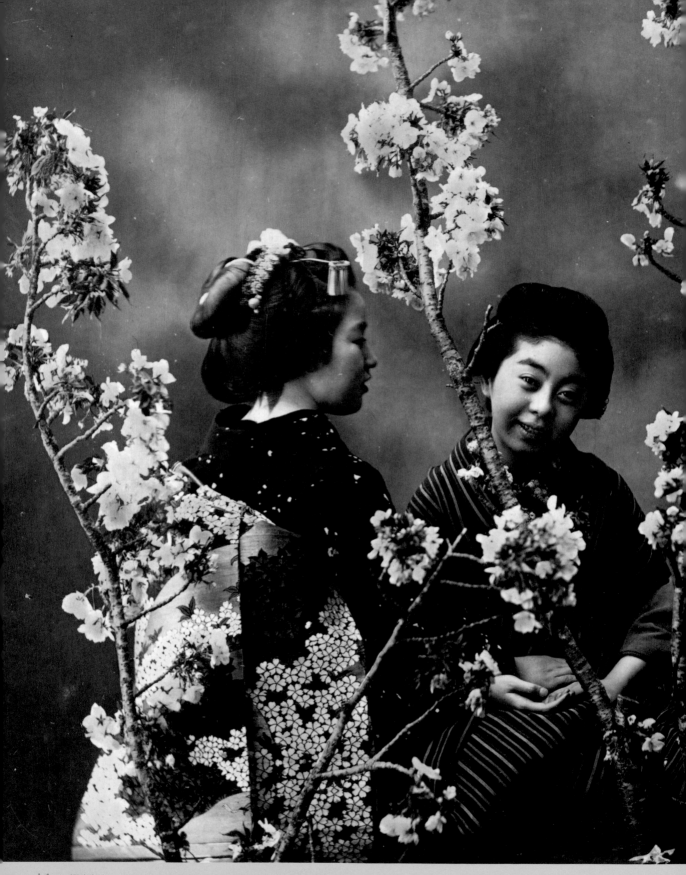

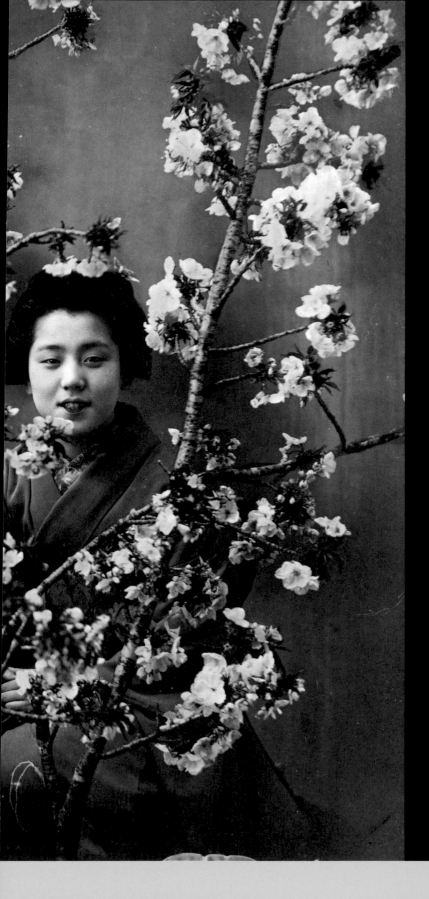

日本 │ 約 1900 年
JAPAN │ CIRCA 1900

日本的櫻花季一到，旅遊作家伊莉莎·
席德摩就會架好相機，因為這搖曳生姿
的花朵總是「讓人滿心歡喜」。早在她
開始提供手工上色的照片給《國家地理》
雜誌使用的兩年前，《國家地理》雜誌
就已經在 1910 年 11 月號首度刊出由一
位日本藝術家手工上色的照片，這也讓
當期的印刷費用比平常多出了四倍。
儘管手工替黑白照片上色的結果可能讓
色彩顯得過分鮮豔，這種技法在 19 世紀
末 20 世紀初卻很常見。日本橫濱就有一
整條街專門做這種生意。

Whenever the cherry trees flowered
in Japan, travel writer Eliza Scidmore
set up her camera, for the trembling
blossoms filled "the people with joy."
Two years earlier, the November 1910
Geographic began to publish hand-
colored photographs by a Japanese
artist—although it cost the Society four
times the normal printing fee.
Although the results could be garish,
hand-tinting black-and-white prints was
common practice at the turn of the 20th
century. An entire street in Yokohama,
Japan, specialized in the trade. □

攝影／伊莉莎·席德摩
Photography/ Eliza Scidmore

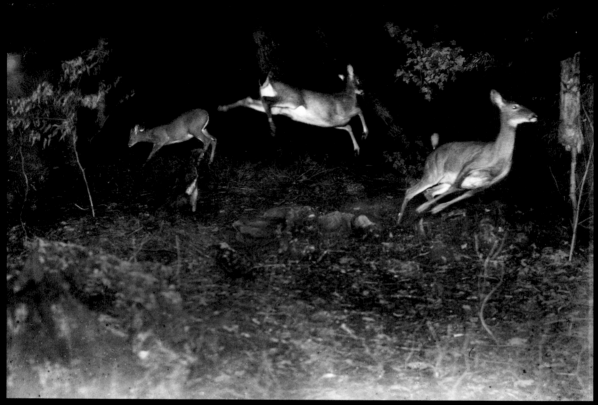

攝影／喬治 · 希拉斯
Photography/ George Shiras

▲ 美國，密西根 ｜ 約於 1900 年
MICHIGAN, US ｜ **CIRCA 1900**

喬治 · 希拉斯首開先河拍攝的野生動物夜間照片，發表在《國家地理》雜誌。因驚嚇躍起的白
尾鹿照片張力十足，拍攝時使用了雙重觸發裝置：第一條拉線觸發空包彈，第二條觸發閃光燈。
這張照片與其他生動的野生動物照片在 1906 年 7 月號刊載後，雜誌開始大量採用野生動物攝影。
之前鮮少有人拍攝野生動物，希拉斯製作出早期的相機陷阱，把線橫過獸徑，只要有東西絆到線，
即點燃閃光粉。他也會將相機架在小舟船頭，靜靜沿著湖畔划行，慢慢接近渾然不覺的動物，然
後觸發閃光燈、釋放快門。

George Shiras's pioneering photos of wildlife at night are published in *National Geographic*
Magazine. A double rig—the tripwire first firing a blank cartridge and secondly the flash—
resulted in this dramatic shot of whitetailed deer in startled mid-leap.
With the July publication of this and other dramatic shots of wild animals, *National Geographic*
embraces wildlife photography. Wildlife photography hardly existed. But Shiras was the
inventive type. He rigged early camera traps, stretching wires across game trails that, when
tripped, fired off trays of flash powder. He mounted cameras on the bow of his canoe, gliding
quietly along the lakeshores, closing in on unsuspecting creatures—then firing his flashgun and
releasing the shutter. □

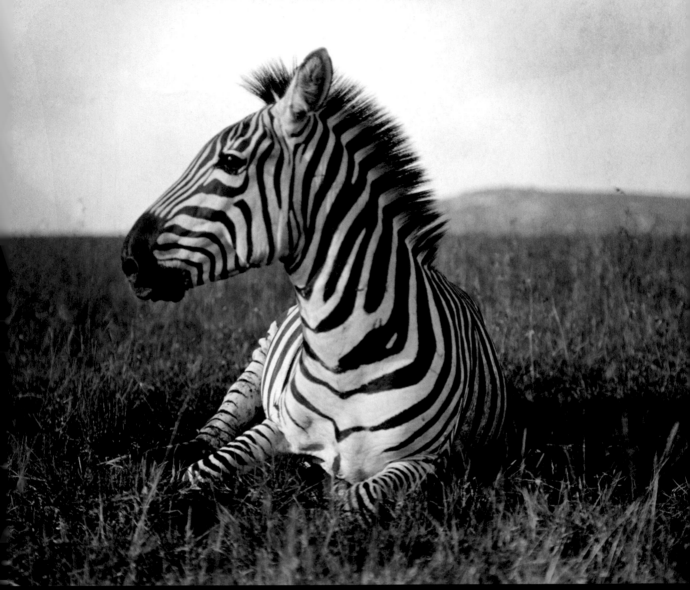

攝影／卡爾 · 艾克利
Photography/ Carl Akeley

▲ **肯亞** │ **約於 1910 年**
KENYA │ **CIRCA 1910**

任職於美國自然史博物館的卡爾 · 艾克利，在亞提河平原拍攝到這隻休息中的布氏斑馬的近距離特寫，展現出驚人的細節。1909 至 1910 年間，《國家地理》雜誌緊緊跟隨西奧多 · 羅斯福橫跨肯亞與烏干達的壯遊。這位前總統此番出門探險，是為了替史密森學會採集標本，以科學為名進行獵殺。問題也就在這裡：當時的自然探險篇章，搭配的往往是已經死掉的動物照片，也就是狩獵的戰利品。把真正的野生動物攝影帶入《國家地理》雜誌的，是喬治 · 希拉斯。

Carl Akeley captured this startlingly detailed close-up of a Burchell's zebra at rest on the Athi Plains. Working for the American Museum of Natural History, he hunted elephants for his life-size dioramas.
For natural-history adventures, Grosvenor followed the tracks of the big-game hunters. The *Geographic* followed every stage of Theodore Roosevelt's epic 1909–1910 safari across Kenya and Uganda. The former President was on a collecting trip for the Smithsonian, slaying for science. The accompanying pictures for such natural-history stories, however, generally featured dead animals, the trophies of the hunt. It was George Shiras 3d (he preferred the Arabic numeral to the Roman) who brought true wildlife photography to the *National Geographic*. □

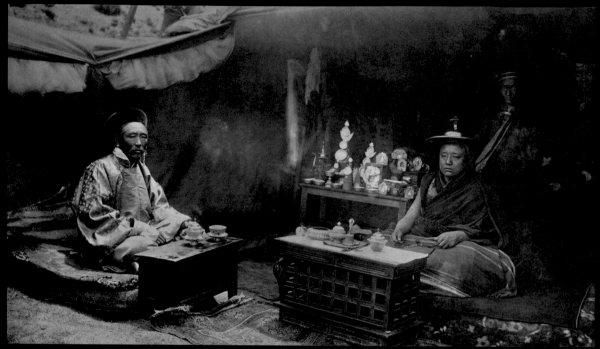

攝影／約翰・克勞德・懷特
Photography/ John Claude White

▲ **中國，西藏**
TIBET | **1916 年**

在西藏仍是封閉王國的當年，雜誌總編輯吉伯特・葛羅夫納只要有機會拿到充滿異國風情的西藏照片，一定會刊登在雜誌中。

由於能夠接觸到日喀則寺院的住持（圖右，正與其祕書一同喝茶），約翰・克勞德・懷特成為早期《國家地理》雜誌通訊記者的理想人選。懷特當時在英國的保護國錫金擔任英國外派官員，因此幾乎認得這遙遠喜馬拉雅王國的每一位喇嘛和部落領袖。由於他特殊的外交身分，讓他能在英國軍隊接近禁城拉薩時，會見在藏傳佛教中地位崇高的札什倫布寺住持。

Exotic pictures of Tibet, at the time a closed kingdom, appeared in the *Geographic* whenever Gilbert Grosvenor could lay his hands on them.

Access to the abbot of Shigatse monastery (at right, sharing tea with his secretary below), made John Claude White the ideal type of correspondent for the early *National Geographic*. As a British political officer for Sikkim, White knew practically every lama and village chief in the faraway Himalayan kingdom. His status as a diplomatic insider allowed him to meet with the abbot—a powerful figure in Tibetan Buddhism—just as a British military force neared the forbidden city of Lhasa. □

攝影／威廉 · 隆利；查爾斯 · 馬汀
Photography/ W.H. Longley; Charles Martin

▲ **美國，佛羅里達群島**
FLORIDA KEYS, US | **1927 年**

《國家地理》雜誌開創了水中攝影的先河。1926 年，海洋生物學家威廉 · 隆利和《國家地理》雜誌攝影師，也是第一任國家地理攝影研究室主任的查爾斯 · 馬汀帶著包黃銅的防水相機，用木筏拖著約 450 公克、相當於 2400 顆燈泡的爆炸性閃光粉，踏入海龜群島周圍淺灘進行拍攝。雖然隆利一度在引爆閃光粉時受到嚴重灼傷，不過，他們還是拍到了第一張海底彩色照片。

National Geographic pioneers underwater photography. In 1926, using a brass-bound waterproof camera and dragging a raft rigged with a pound of explosive flash powder—the equivalent of 2,400 flashbulbs—marine biologist William Longley and *Geographic* photographer Charles Martin (also the first chief of the newly established Photo Lab) stalked the shallows around the Dry Tortugas, having a blast. (Once quite literally so, when Longley got severely burned. But they also got their pictures.) □

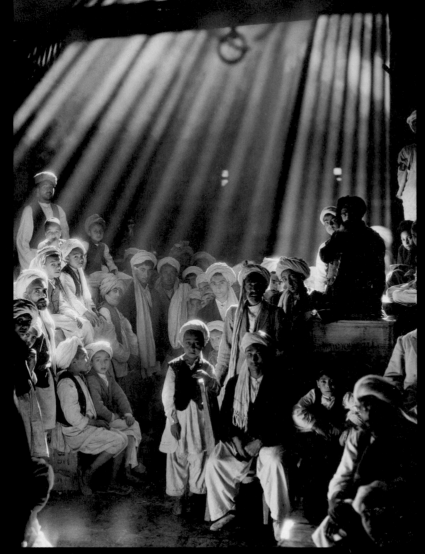

攝影／梅納德 · 歐文 · 威廉斯
Photography/ Maynard Owen Williams

▲ 阿富汗
AFGHANISTAN | 1931 年

這是國家地理特派員梅納德 · 歐文 · 威廉斯最喜歡的一張照片。最令他自己驚奇的是，在曝光所需要的整整三秒鐘時間內，赫拉特這處市集內入鏡的人，沒有一個人眨眼。

為從世界各地帶回符合雜誌風格的故事與圖片，學會將撰稿人與攝影師送到世界各地，也造就許多傳奇人物。建立駐外編輯人員的想法，來自高大、總是面帶微笑的前傳教士梅納德 · 歐文 · 威廉斯。他是學會有史以來第一位全職特派員，自 1919 年起開始任職。他建議學會成立一群專屬的記者與攝影師，不僅遠赴海外採訪雜誌內容，並擔任「駐外人員」，在世界各地代表學會利益並推廣學會的名聲。

In his favorite picture, Maynard Williams marveled how, in this Herat bazaar, not a single subject blinked during the three full seconds required to make the exposure.

To bring back the right stories and illustrations, the Society dispatched its own staff writers and photographers around the globe. Many became legends of the breed. The idea for a Foreign Editorial Staff came from a big, smiling former missionary named Maynard Owen Williams, who had been hired in 1919 as the Society's first full-time correspondent. Williams suggested establishing a corps of staff writer-photographers who would not only gather magazine material abroad but also serve as the Geographic's "foreign service", representing its interests and spreading its good name around the globe. □

畢比和巴頓坐在簡陋的「深海探測球」中,看起來就像是英國小說家威爾斯 1895 年短篇小說《大海深淵》裡的科學家,駕著極類似的潛水器前往海底。

深海探測球是球形的深海潛水器,沒有動力,以鋼索垂降入海中。在 1930 — 1934 年間,用於百慕達沿海的一系列深海探測。深海探測球由歐第斯 · 巴頓設計給自然學家威廉 · 畢比用於研究水下生物,使得海洋生物學家第一次得以在自然環境中觀察深海動物。他們以深海探測球創下一連串人類下潛最深的世界紀錄,最深的一次是在 1934 年 8 月 15 日,深度達 923 公尺。

In their crude bathysphere, Beebe and Barton resembled the scientist in H. G. Wells's 1895 story, "In the Abyss", who rode a remarkably similar craft to the seabed.

The Bathysphere is a spherical deep-sea submersible which was unpowered and lowered into the ocean on a cable, and was used to conduct a series of dives off the coast of Bermuda from 1930 to 1934. Beebe and Barton conducted dives in the Bathysphere together, marking the first time that a marine biologist observed deep-sea animals in their native environment. Their dives set several consecutive world records for the deepest dive ever performed by a human. The record set on August 15 1934, 3,028 feet, remained unbroken for 15 years. ☐

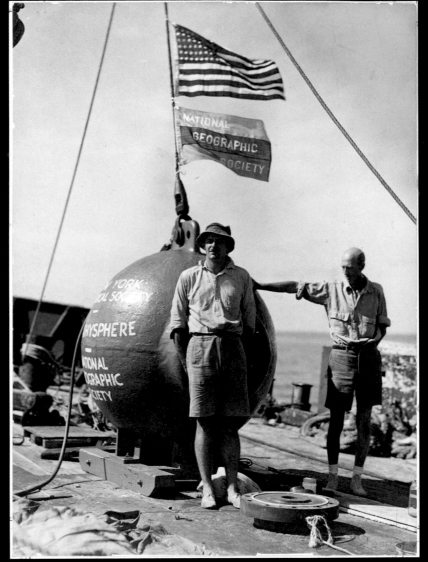

攝影／約翰 · 提馮;野生動物保育協會
Photography/ John Tee-Van; Wildlife Conservation Society

▲ 百慕達外海
OFF THE COAST OF BERMUDA　　1934 年

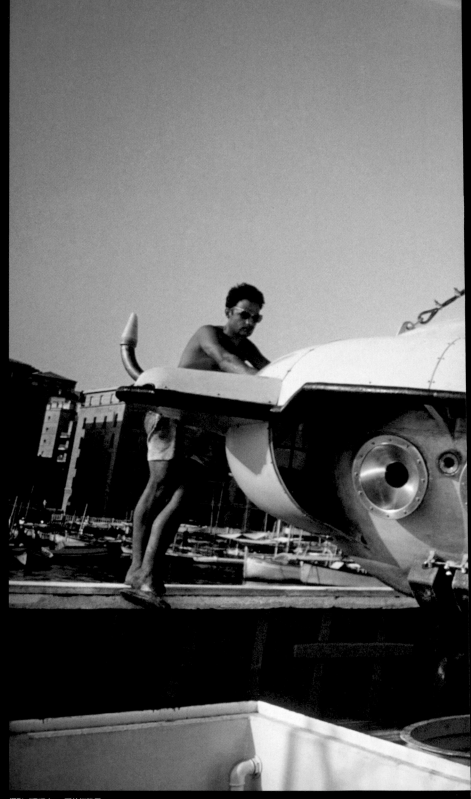

▸ **波多黎各**
PUERTO RICO │ **1960 年**

學會在 1952–1967 年間贊助了賈克 · 伊夫 · 庫斯托的研究，結果不但改良了水中攝影技術，還成功打造出第一艘可以完全操控的研究用潛艇。

1952 年開始，接連出現了好幾位海底英雄新面孔，當時，國家地理學會也開始贊助仍默默無聞的法國海軍上校庫斯托，他與夥伴共同研發了世上第一個實用的水肺裝置。到了 1960 年，庫斯托已是家喻戶曉的人物。這位夢想家代表了一個對海洋探索與太空探險同樣熱中的時代。太空人穿越雲霄進入外太空的同時，庫斯托的潛航員則一躍而入水下的「內太空」。

Society support for Jacques-Yves Cousteau results in improved underwater photography and the first fully maneuverable research submersible.

A parade of new heroes had started as early as 1952, when National Geographic supported an unknown French naval captain who had co-invented the first practical scuba system. By 1960 Cousteau was a household name—a visionary who symbolized an era as excited about exploring the sea as it was the stars. Just as the astronauts were soaring into "outer space", Cousteau's aquanauts plunged into "inner space." ☐

攝影／湯瑪士 · 亞伯柯隆畢
Photography/ Thomas J. Abercrombie

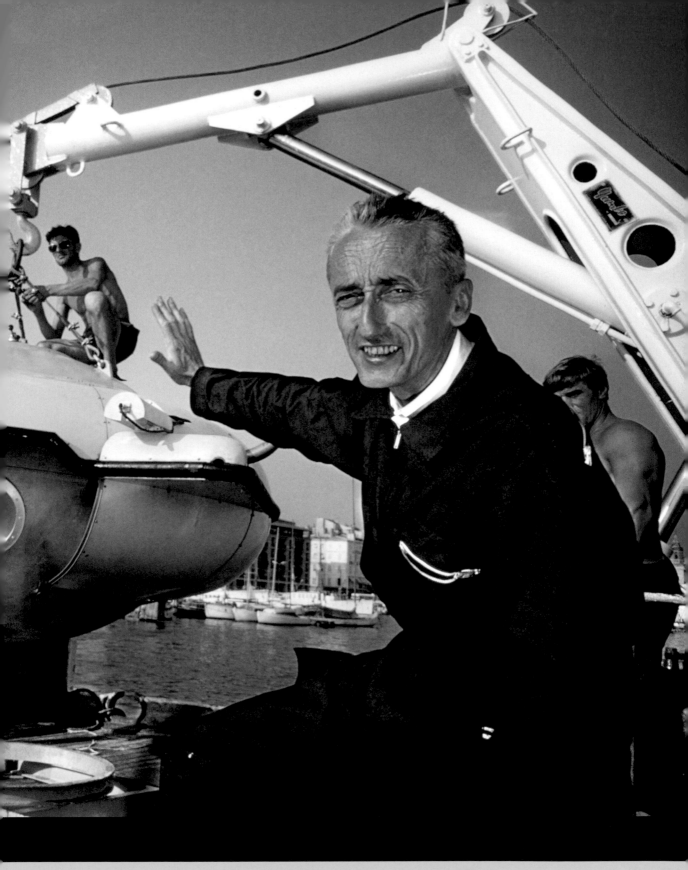

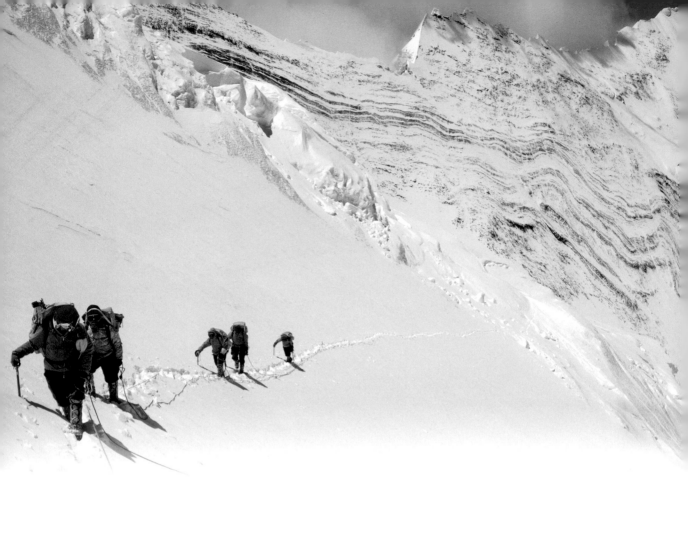

深入險境
Into the Unknown

125 年來，國家地理學會成功拓展了對探險與發現的支持，贊助了許多知名與不知名的探險隊，致力於揭露地球每個角落的面貌。上自最高的平流層，下至世界底部的大海深淵，國家地理學會總是不斷求新求變，讓科學家能安心使用最新科技，在探索未知的同時，也能保障自身安全，並蒐集到最多資訊以供研究。

國家地理攝影師隨著冒險犯難的探險隊前進地球各角落，記錄下世界上許許多多的「第一次」。極地、冰川、高山、峽谷、海底、洞穴、甚至天際，都有《國家地理》攝影師的蹤跡。在美國，《國家地理》雜誌是極地資訊的主要來源。極地探索的時代恰好與攝影技術、照相製版和無線電通訊的快速發展重疊。這些技術讓全世界觀眾得以及時了解探險家的最新進展，最重要的是，還可以欣賞到相關的人、地和物的照片。

不論在世界之巔或是世界之底，還是中間的任何一個地方，都有許多極致偉大之處。國家地理則一直在展現這世界的偉大。

For one-and-a-quarter century, National Geographic Society has successfully broadened support for exploration and discovery, sponsoring famous and obscure expeditions alike, with a commitment to revealing the truth about every corner of the earth. Sending expeditions to the bottom of the world, the depths of the sea, and the heights of the stratosphere, the Society harnessed technology to help scientists stay safe and collect as much data for research as possible as they explored the unknown, increasing our understanding of the world.

National Geographic photographers have followed fearless expeditions to the ends of earth, documenting many of the world's "firsts". From polar regions, glaciers to mountain peaks, from the bottom of the sea to cavernous caves, even high into the skies, National Geographic photographers can be found. In the United States, the National Geographic Society's magazine was the primary source of polar coverage. The era of polar exploration coincided with the rapid development of photography, photomechanical reproduction and telecommunications. These technologies allowed a global mass audience to read in timely fashion about explorers' latest efforts and, more important, to see photographs of the people, places and things involved.

Whether it is the top or bottom of the world or anywhere in between, there are many great places. And to reveal that greatness has always been the mission of *National Geographic*.

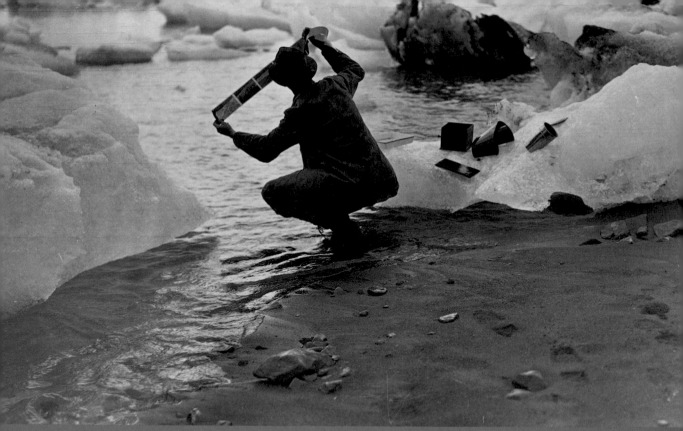

來源／Ｏ・Ｄ・恩格倫
Source/ O.D. Von Engeln

▲ **美國，阿拉斯加**
ALASKA, US | 1909 年

攝影師 Ｏ・Ｄ・恩格倫在夏季隨著國家地理學會贊助的探險隊前往阿拉斯加期間，在冰山遍布的海水中清洗底片是每日例行公事。在捕鯨船上撐篙穿越覺醒灣內的浮冰，同樣也是探險隊隊長勞夫・塔爾和勞倫斯・馬汀幾乎每天要做的事；他們的任務是測量並繪製阿拉斯加壯觀的入海冰川，這裡的入海冰川是極區以外全世界最大的。他們歷時三季的工作成果在 1914 年出版後，至今仍受研究人員引用。

Washing his films in iceberg-choked seawater was an everyday chore for photographer O. D. Von Engeln during the summer months he spent on a Society-sponsored expedition in Alaska. Poling a whaleboat through the floes of Disenchantment Bay was likewise practically a daily task for expedition leaders Ralph Tarr and Lawrence Martin; they had been charged with mapping and measuring Alaska's magnificent tidewater glaciers, largest in the world outside the polar regions. The report of their three seasons' work, published in 1914, is still cited today. □

▶ **加拿大**
CANADA | 1909 年

1909 年，羅伯特・皮里帶領由國家地理學會贊助的探險隊遠征北極。無論皮里和助理是否真的抵達北極點，不可否認的，他們比之前任何人都更接近這個目標。

1907 年初，在葛羅夫納終於穩定了學會財政之後，他說服理事會出資 1000 美金，贊助由皮里領軍的北極攻堅隊。

雖然皮里有多數腳趾因凍傷切除，但當他從美國總統老羅斯福手中接下國家地理學會第一個「哈伯德獎章」時，依然風度翩翩。皮里締造了當時人類北進的紀錄──抵達北緯 87 度 06 分，距離北極點僅 281.6 公里。

Whether Robert E. Peary and his assistant reached the North Pole in 1909 or not, they came closer to that goal than anyone before them.
In early 1907, having stabilized the Society's finances at last, Gilbert Grosvenor persuaded its board to contribute $1,000 to an upcoming assault on the North Pole being led by Cmdr. Robert E. Peary. Despite having lost most of his toes to frostbite, Peary still cut a fine figure when Theodore Roosevelt awarded him the Society's first Hubbard Medal for having attained a new "Farthest North" record—87°06'—only 175 miles short of the Pole. □

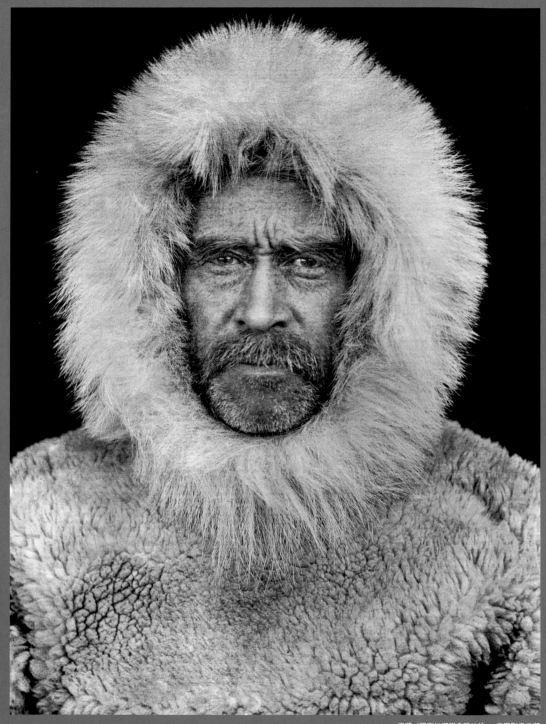

來源／國家地理學會羅伯特 ‧ 皮里影像收藏
Source/ Robert E. Peary Collection; NGS

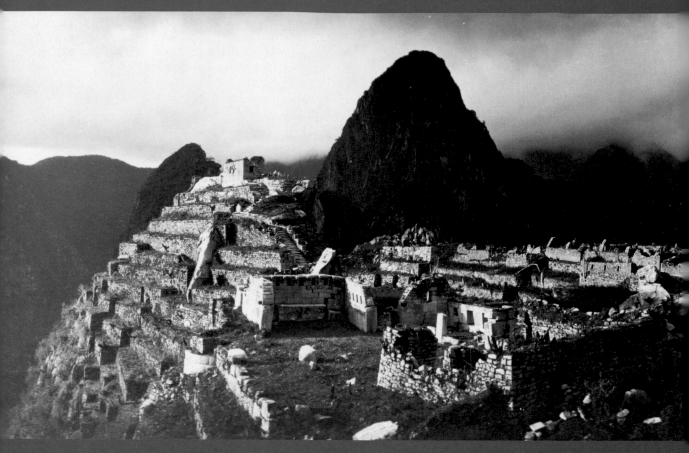

攝影／希拉姆 · 賓漢
Photography/ Hiram Bingham

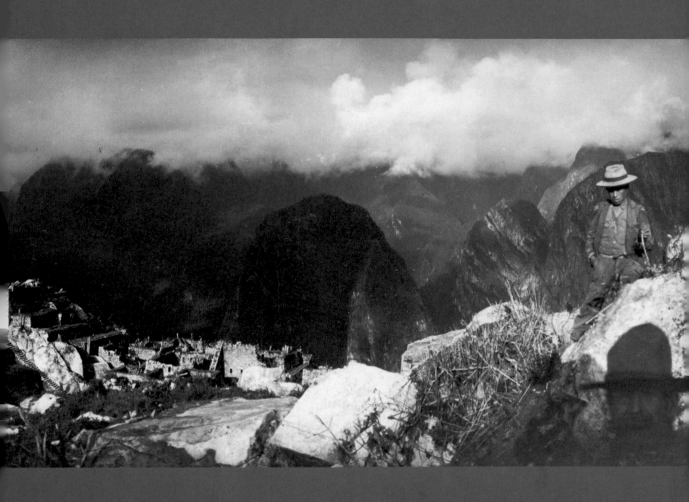

▲ 祕魯　｜ 1912 年
PERU

探險家希拉姆 · 賓漢發現了馬丘比丘。當然，賓漢並不是真的「發現」馬丘比丘，數世紀以來當地人一直都知道這個地方，不過他立意向全世界揭露此地的存在。能與馬丘比丘的壯闊景觀相提並論者並不多，尤其在揮舞大砍刀的印第安人為攝影師清除植被之後，美景更是一覽無遺。

國家地理學會以共同贊助的身分，參加耶魯大學的「1912 年祕魯探險隊」。此次遠征共有 11 位成員，還有克丘亞印第安人提供協助（他們的報酬以古柯葉支付），在七個月的探險期間一同挑戰險惡的馬丘比丘遺址。

Explorer Hiram Bingham discovers Machu Picchu. Bingham did not discover Machu Picchu, of course—the locals had known its whereabouts for centuries—but he intended to reveal it to the world. Few corners of the world were more spectacular than Machu Picchu—especially just after an army of machete-wielding Indians had cleared away the vegetation for the cameraman.

The Society joined Yale University as a co-sponsor of the Peruvian Expedition of 1912. For seven months that expedition's 11 men, aided by a troop of Quichua Indians—each of whom was paid in coca leaves—confronted the forbidding site of Machu Picchu. □

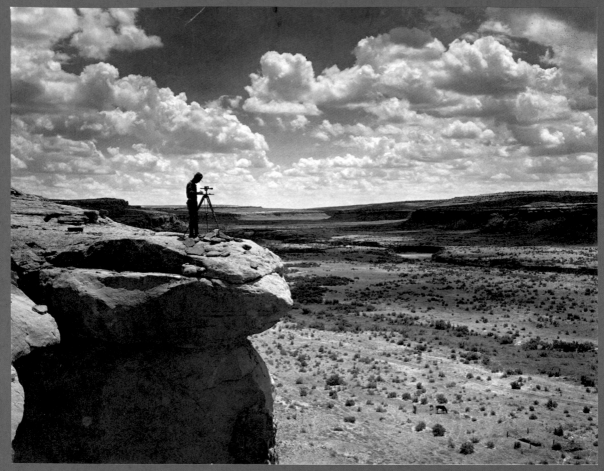

撮影／尼爾 ‧ 賈德
Photography/ Neil M. Judd

▲ **美國，新墨西哥州**　| 1922 年
NEW MEXICO, US

對勘測員 R ‧ P ‧ 安德生上尉和兩名印第安信號旗手來說，測繪查科峽谷是一項艱難的任務。因為「峽谷底酷熱難耐，」記者尼爾 ‧ 賈德寫道。「而且上方破碎的緣岩又有無休止的強風威脅，幾乎要把測量員和經緯儀吹落懸崖。」然而，憑著不懈的堅持與良好的平衡感，勘測團隊協助製作出第一份精確標示出查科峽谷許多主要遺址的地圖，如今，查科峽谷已是聯合國教科文組織認定的世界遺產。

For Capt. R. P. Anderson, surveyor, and his two Indian flagmen, mapping Chaco Canyon was a tough task. "Down on the valley floor the heat was intense," as Neil Judd reported, "and up on the broken rim rock tireless winds threatened to blow both surveyor and transit over the edge." Through sheer persistence, however, and a good sense of balance, the team helped produce the first map to pinpoint many of the principal ruins in what is a UNESCO World Heritage site today. □

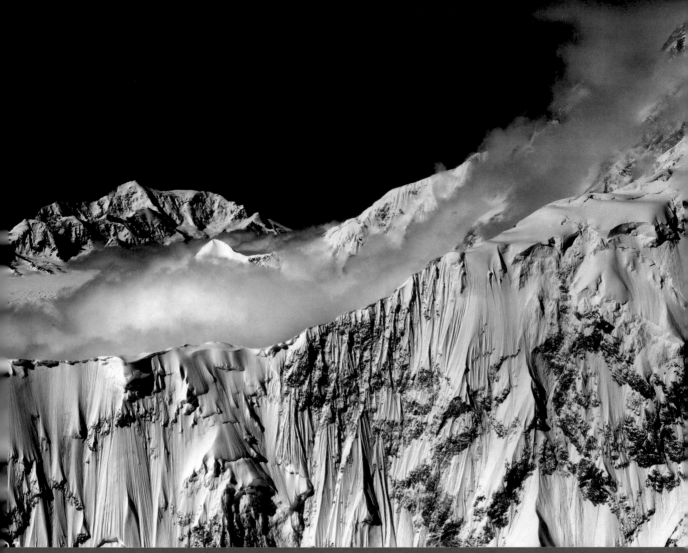

攝影／布拉德 • 沃什波恩
Photography/ Bradford Washburn

▲ 美國，阿拉斯加 │ 1935 年
ALASKA, US

阿拉斯加聖伊利亞斯山脈暴風肆虐、終年覆雪、山壁聳立在太平洋上方，在這道山脈後方，是加拿大地圖上一片將近 1 萬 3000 平方公里的空白。由於布拉德 • 沃什波恩的努力，這個空白終於有了等高線的輪廓。

布拉德 • 沃什波恩在學會贊助下組織了探險隊，為北美洲地圖上最後一塊空白處進行測繪，終於在 1935 年完成人類第一次從育空出發、穿越聖伊利亞斯山脈抵達阿拉斯加的壯舉。此行發現並測繪了四條新的冰川、45 座之前地圖從未標示的山峰，還以當時加拿大的英王喬治五世和瑪莉皇后為其中最高的兩座山峰命名。

Behind Alaska's St. Elias Mountains—storm-swept, snowbound, heaving its ramparts above the Pacific Ocean—something was hidden: a 5,000-square-mile blank on the map of Canada. Thanks to Brad Washburn, that blank reared itself into a map, contour by rock-ribbed contour.

Washburn organised a Society-sponsored expedition to map the last blank spot in North America, completing the first crossing of the St. Elias Mountains from Yukon to Alaska in 1935. All told, the Washburn party discovered and mapped four new glaciers and 45 previously uncharted peaks. They named two of the highest after King George V and Queen Mary, the reigning sovereigns of Canada. □

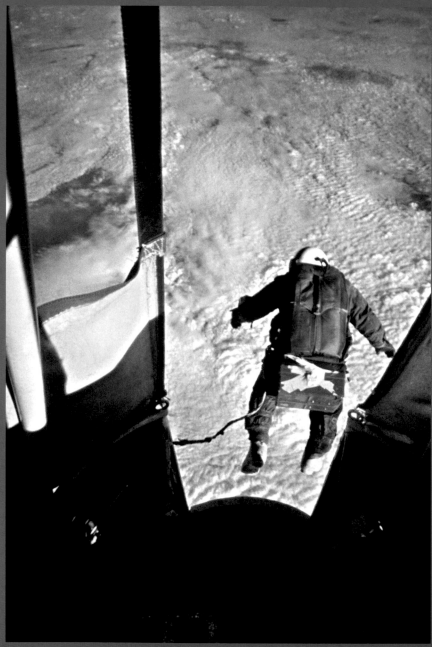

1960 年 8 月 16 日，美國空軍上尉喬 · 基廷格從 3 萬 1333 公尺高的平流層熱氣球吊艙一躍而下時，地球大氣層超過 99% 都在他腳下。這 30 多公里的垂直下降距離花了他 13 分 45 秒，他在打開降落傘後，於美國新墨西哥州的沙漠中平緩著陸。當基廷格從太空邊緣躍下時，《國家地理》雜誌攝影師沃爾克默 · 溫策爾則利用設置在熱氣球吊艙內的遙控相機，捕捉到這難得的一刻，拍出一張總結了太空時代偉大冒險的照片。

On August 16, 1960, when Air Force captain Joe Kittinger leaped out of a stratosphere balloon's gondola from a height of 102,800 feet, more than 99 percent of the Earth's atmosphere lay beneath him. It took 13 minutes and 45 seconds for him to fall 19 miles—and he did open a parachute—to a soft landing in the New Mexico desert. A human being had leaped from the edge of space, and a remotely operated camera, positioned in the balloon's gondola by *National Geographic* photographer Volkmar Wentzel, memorably captured the instant he did so, producing an image that summed up the high adventure of the space age. □

攝影／沃爾克默 · 溫策爾
Photography/ Volkmar Wentzel

▲ 美國，新墨西哥州
NEW MEXICO, US | 1960 年

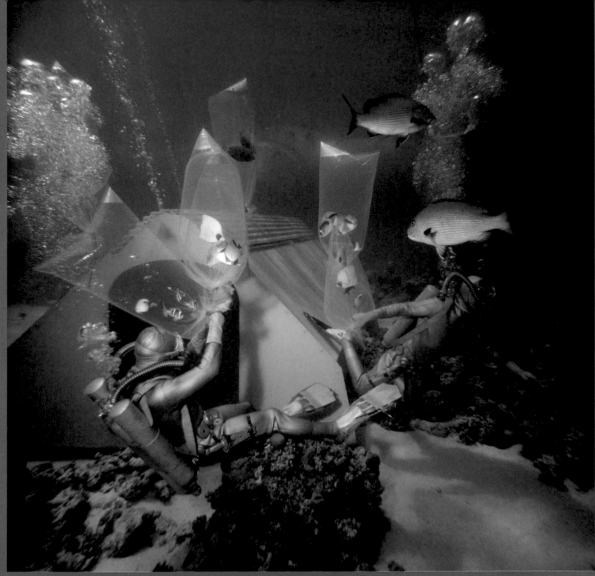

攝影／羅伯特 • B • 古德曼
Photography/ Robert B. Goodman

▲ **紅海**
RED SEA │ **1963 年**

參與賈克 • 庫斯托「大陸棚二號」計畫、在水底紮營的潛水員正在保護裝袋的魚類樣本免受捕食魚類攻擊。庫斯托預言「水下人」時代即將來臨，說服學會贊助一系列名為大陸棚一號、二號與三號的海底棲息地實驗。這些未來住所被設置在地中海與紅海，海底觀察員住在水底下 10 至 100 公尺的地方，在這些海底家園中休憩，每天都能讀到潛水員送來的報紙。

當時的庫斯托認為，世上多數的大陸棚很快就會出現人類棲地和海底城市。多年後，已熱切投身環保的庫斯托，將這一切當成「全然幻想」，拋諸腦後。

Camping beneath the sea, divers from Jacques Cousteau's Conshelf II defend their bagged specimens against hungry predators. Jacques Cousteau, prophet of the coming age of *Homo aquaticus*, persuaded the Society to help sponsor the series of experimental submarine habitats called Conshelf I, II, and III. The futuristic dwellings, deployed in the Mediterranean and Red Seas, saw oceanauts living at depths ranging from 33 to 330 feet. Within those underwater palaces they relaxed by reading newspapers delivered daily by divers.

At the time, Cousteau believed that continental shelves would soon abound with human habitations and underwater cities. Yet years later, the mercurial Cousteau, by then an ardent environmentalist, shrugged it all off as having been a "complete fantasy." □

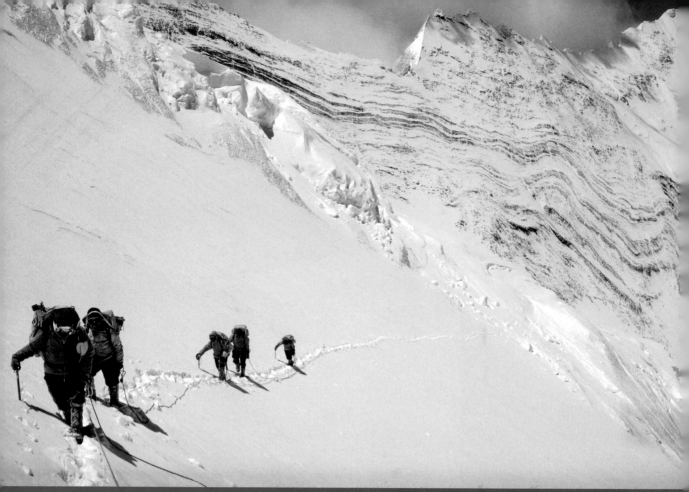

攝影／貝利‧比夏普
Photography/ Barry Bishop

▲ **尼泊爾，洛子峰** | **1963 年**
LHOTSE, NEPAL

學會為紀念成立 75 周年，派出了美國聖母峰探險隊前往世界之顛。遠征隊成員在前往南鞍營地途中，穿越險峻的洛子峰。

1963 年春天，長長的腳夫隊伍蜿蜒穿過尼泊爾的峽谷，前往聖母峰山腳。學會贊助的隊伍中有 19 名登山家和 32 位雪巴嚮導，看來就像是一支準備包圍大山的迷你軍隊。在 27 噸重的補給品中，除了冷凍乾燥口糧、氧氣筒、啤酒、以及一盒盒香煙，還有七部攝影機與 8.5 公里長的底片，因為探險隊隊長諾曼‧狄倫佛斯不僅是登山能手，也是才華洋溢的攝影師。

The Society commemorates its 75th anniversary by dispatching the American Mount Everest Expedition to the top of the world. Members of the American Mount Everest Expedition, on their way to the South Col camp, cross Lhotse's forbidding face.

In the spring of 1963 long lines of porters wound their way through the valleys of Nepal to the foot of Chomolungma. The Society-sponsored Expedition, with its 19 climbers and 32 Sherpa guides, was a miniature army preparing to lay siege to a mountain. Among its 27 tons of supplies—which also included freeze-dried rations, oxygen canisters, bottles of beer, and cartons of cigarettes—were seven movie cameras and 28,000 feet of film, for expedition leader Norman Dyhrenfurth was not only an expert climber but also a talented cinematographer. □

由威爾 · 史帝格領軍的「史帝格國際極地探險隊」成員與他們的49隻雪橇犬,全部擠進一架包機,飛往他們探險行程的起點。

1986 年 4 月 8 日,往北極的路上發生了一件妙事:探險隊在冰上發現了陌生的軌跡。當時正在冰凍的北冰洋表面行進的只有另一個人:試著獨自滑雪抵達北極的法國醫生尚－路易 · 艾蒂安。兩組人馬竟然在那個面積和俄羅斯差不多大、視線不清的冰天雪地巧遇了。在分道揚鑣之前,他們也許比較了手上的國家地理學會會旗──威爾 · 史帝格的是一面大旗子,艾蒂安的只有口袋大小。

Members of the Steger International Polar Expedition and their 49 sled dogs pile into a chartered aircraft to reach their mushing-off point. On April 8, 1986, a funny thing happened on the way to the North Pole. The Steger Expedition glimpsed tracks on the ice. Only one other human was known to be on the frozen surface of the Arctic Ocean at the time: He was Dr. Jean-Louis Etienne, a French physician attempting to ski solo to the Pole. On that blinding, vast expanse of ice roughly the size of Russia the two parties collided. Perhaps they compared their respective National Geographic flags─Will Steger's was large; Etienne's pocket-size─ before going their separate ways. □

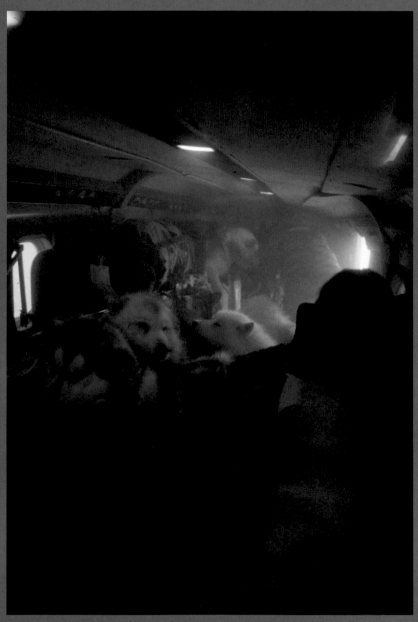

攝影／吉姆 · 布蘭登堡
Photography/ Jim Brandenburg

▲　加拿大
CANADA　│　1986 年

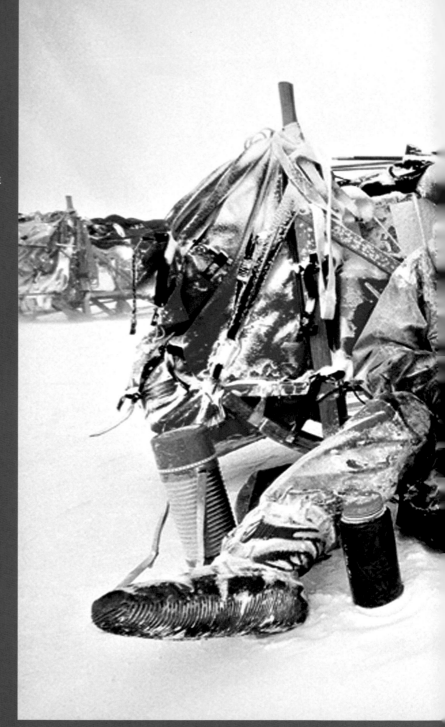

▶ 南極半島，雷克斯山
MOUNT REX, ANTARCTIC PENINSULA | 1989 年

1989 年，挑戰橫跨南極洲的探險隊趁著午餐時間休息聊天。極地探險家史帝格和艾蒂安曾各自在北極挑戰極限。這次，他們從北極轉往南極，不過是在同一個團隊裡，擔任六人團隊的共同領隊。隊員分別來自美國、法國、英國、中國、日本和前蘇聯。「橫跨南極洲國際探險隊」的目標，是要挑戰史上第一次只利用狗拉雪橇橫越這片冰封大陸的壯舉。1989 年 7 月，隊員在南極半島北端替雪橇犬繫上了套帶，此後歷經七個月、5586 公里的長途跋涉後，這支勇敢無畏的隊伍終於抵達威克斯地海岸的俄國基地。

Lunch break allows rest and conversation for the team of explorers who crossed Antarctica in 1989. Steger and Etienne found themselves driven to extremes once again. This time they were at the opposite end of the Earth but on the same team, serving as co-leaders of an international party of six explorers—one each from the United States, France, Britain, China, Japan, and the Soviet Union. The International Trans-Antarctic Expedition was seeking to cross the ice-shrouded continent by dogsled alone—a historic first. After hitching the dogs into their harnesses at the northern tip of the Antarctic Peninsula in July 1989, the intrepid band slid into a Russian base on the shores of Wilkes Land seven months and 3,471 miles later. □

攝影／威爾・史帝格
Photography/ Will Steger

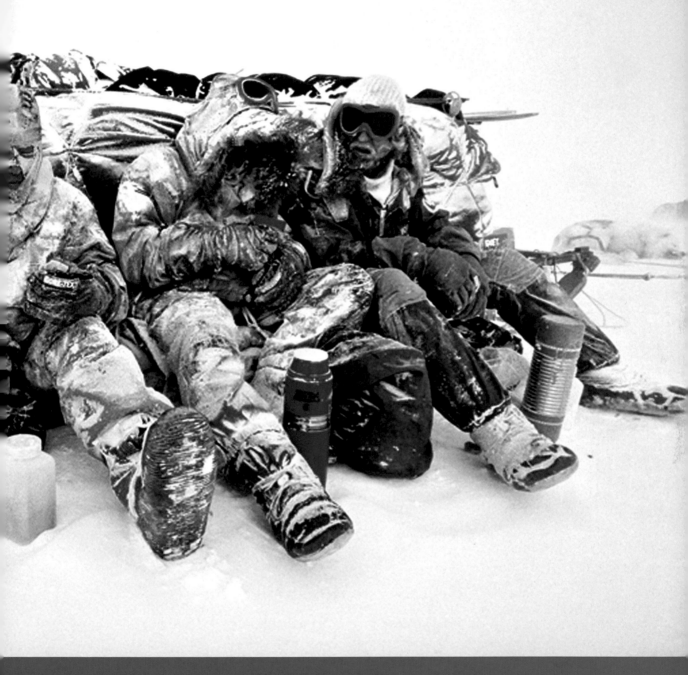

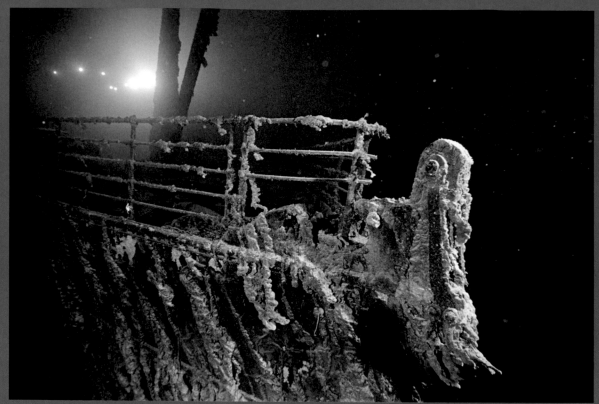

攝影／艾墨利 · 克里斯多夫
Photography/ Emory Kristof

▲ 北大西洋
NORTH ATLANTIC | 1991 年

探險家羅伯特 · 巴拉德在 1985 年發現了鐵達尼號的最後安息處。在俄國和平一號潛水艇的照明下，艾墨利 · 克里斯多夫拍下了鐵達尼號船首自海底深處浮現的影像。

1985 年 9 月，國家地理學會向世界宣布了那個時代最引人注目的沉船遺跡發現。由羅伯特 · 巴拉德博士領軍的法美團隊，終於找到了鐵達尼號的永眠之地，位於北大西洋超過 3 公里深的水底。而且，這項調查完全沒有派人下水，而是藉由可以遙控操作的深海潛水器阿爾戈號，以及學會攝影師艾墨利 · 克里斯多夫參與設計的電子相機系統來進行。

Explorer Robert Ballard discovered the resting place of the Titanic in 1985. The bow of the R.M.S. Titanic looms out of the deep, illuminated by the Russian Mir I submersible and photographed by Emory Kristof.

It was the most dramatic shipwreck discovery of its era, announced to the world during a press conference in September 1985. A French-American team, led by Dr. Robert Ballard, had found the resting place of the Titanic, more than two miles beneath the surface of the North Atlantic. And it had done so without wetting the first toe. Argo, a remotely operated deepwater vehicle, had done the work, using an electronic camera system partially designed by National Geographic photographer Emory Kristof. □

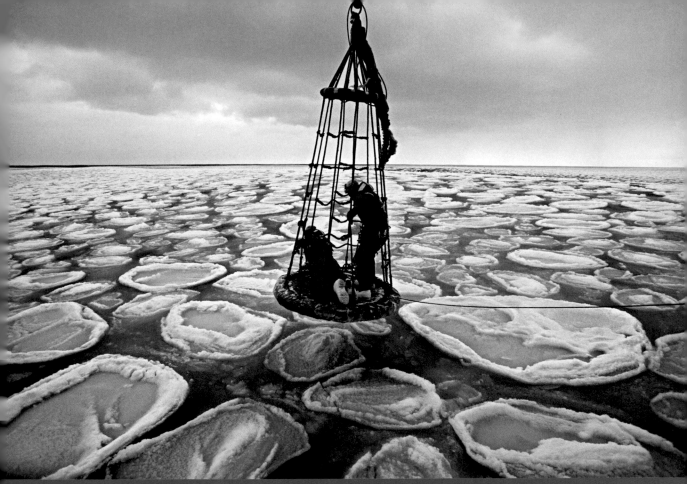

攝影／瑪莉亞 · 史丹佐
Photography/ Maria Stenzel

▲ 南冰洋
SOUTHERN OCEAN | 1996 年

攝影師瑪莉亞 · 史丹佐捕捉到的這個景象中，科學家為了解開深藏在南極冬季海冰底下的祕密而進行打撈。現在，科學家在具有特殊配備的破冰船協助下，已經發現南極海冰的世界比從前想像的更為複雜，也更充滿生命力。

若是旅客有機會登上國家地理學會／林德布勞德遠征船，更可以加入科學家的行列，親臨科學發現的現場。舉例來說，美國國家海洋和大氣總署的羅伯特 · 皮特曼與約翰 · 德班就是與其他乘客一起搭船時，發現了南極洲水域的虎鯨族群有兩個類型，甚至有可能是兩個不同的物種。

Photographer Maria Stenzel captured this image of scientists fishing for secrets locked inside Antarctica's winter sea ice. Today on specially equipped ice-breaking vessels, researchers explore icescapes more complex—and flowing with life—than previously thought possible.

Aboard National Geographic/Lindblad Expeditions ships, travelers join forces with scientists for real-time scientific discovery. Passengers aboard the Explorer with NOAA's Robert Pitman and John Durban, for example, were on hand when the pair realized that a group of killer whales in Antarctic waters included two distinct types, and possibly even two distinct species. □

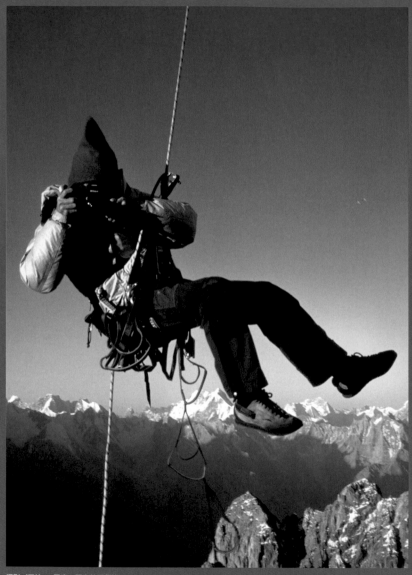

靠著一條繩子懸吊在 5730 公尺的高空中，攝影師比爾‧哈徹用相機拍下同行登山家在喀喇崑崙山脈川口塔峰攻頂的景象。「山邊一直有岩石滑落，」他回憶道，「沒多久你就習慣了石頭打在頭盔上的聲音。」登山家一直是學會歷史的一部分。在學會贊助下完成人類第一次從育空出發、穿越聖伊利亞斯山脈抵達阿拉斯加壯舉的布拉德‧沃什波恩，與他的太太芭芭拉是測繪地圖與登山的最佳拍檔。芭芭拉在 1947 年成為首位登上北美最高峰德納利峰的女性；1963 年為慶祝學會 75 周年，學會也贊助了美國聖母峰探險隊。時至今日，以繩索垂吊於山壁上的登山家，仍是國家地理的出版品或影片中常見的身影。

Dangling by a strand at 18,800 feet, photographer Bill Hatcher shoots a fellow climber's ascent of Trango Tower in the Karakoram Range. "Rock slides poured off that mountain," he recalled. "You got used to the sound of stones pelting your helmet."
Climbers have always been a part of the National Geographic story. Brad Washburn, who had completed the first crossing of the St. Elias Mountains from Yukon to Alaska with Society support, and his wife Barbara were a mapmaking and mountaineering team. In 1947 she became the first woman to summit Denali. To mark its 75th anniversary, the Society sponsored the American Mount Everest Expedition. To this day, climbers dangling from ropes can often be seen somewhere in the Society's publications or films. □

攝影／巴比‧馬度；國家地理圖片
Photography/ Bobby Model; National Geographic Stock

▲ 巴基斯坦
PAKISTAN | 1996 年

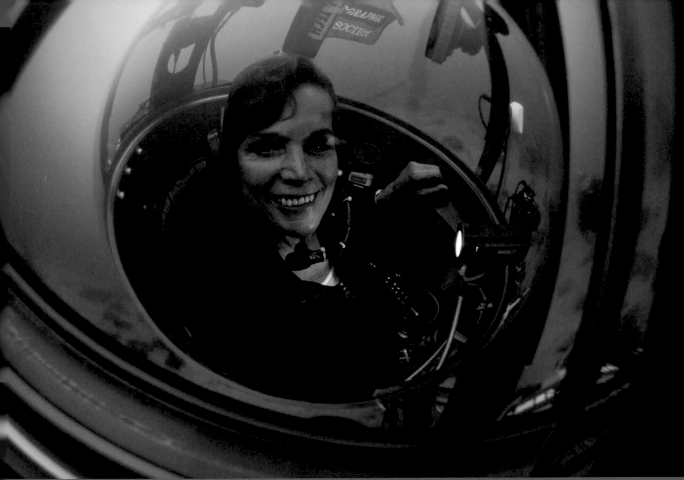

攝影／奇普 · 伊凡斯
Photography/ Kip Evans

▲ **海洋**
THE SEA | **2000 年**

潛水器中笑容滿面的席薇亞 · 厄爾是海洋藻類專家，曾是一項全由女性隊員執行的水下居住艙「玻璃隕石二號」計畫的領隊，更是唯一曾經穿上加壓硬殼潛水衣，以無纜方式在海平面下 366 公尺深處的竹珊瑚間漫步的潛水員。被暱稱為「深海女王」的厄爾，是唯一曾在這麼深的海底異世界漫步的人類。

曾任美國國家海洋暨大氣總署首席科學家的厄爾，如今是國家地理學會駐會探險家，曾領導為期五年的「永續海洋探險計畫」，至今仍致力於提倡保護海洋及其中的生態系，她希望終有一天，人類「能像鳥熟知天空一樣地熟知海洋。」

Earle was an expert in marine algae, the leader of the first all women team to live in the underwater habitat called Tektite II, and the only person to strap on a Jim suit—a pressurized, hard-shell diving outfit—and stroll tetherless among bamboo corals 1,200 feet below the ocean's surface. "Her Deepness," as the Earle of the sea was dubbed, was the only human to have walked that far down in the alien world of the ocean bottom.

Now the former chief scientist for NOAA is a National Geographic explorer-in-residence who for five years led the Sustainable Seas Expedition. Earle remains a tireless advocate of the oceans and their ecosystems: One day, she hopes, humans will come "to know the sea as birds know the sky." □

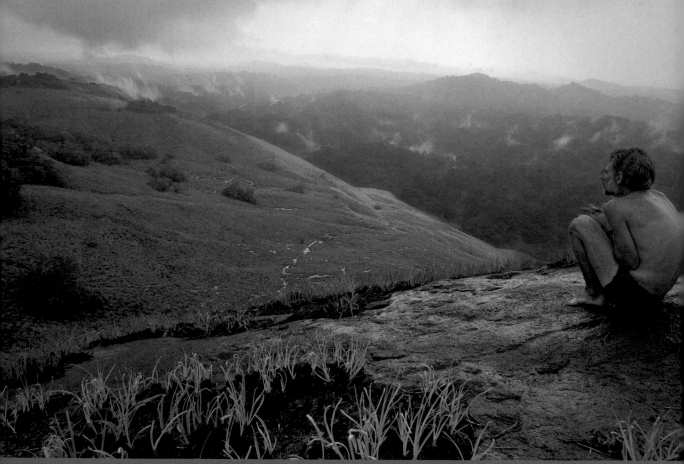

攝影／麥可・尼可斯
Photography/ Michael Nichols

▲ **加彭**
GABON | 2001 年

保育學者暨生態學家麥可・費伊蜷曲著身體坐在明凱貝森林一座山頂的花崗岩上。
1999 年 9 月 20 日，他深入剛果共和國的叢林，除了雨季時短暫休息外，他跋涉 455 天、行經 1930 公里後才終於步出叢林，抵達加彭的大西洋海岸。打著赤膊的費伊單憑意志力驅策筋疲力竭的中非大穿越團隊，靠著羅盤和山刀，穿過棘刺密布的灌叢、大象出沒如伊甸園般的林間空地，渡過鱷魚肆虐的沼澤。但艱辛路途終有回報：加彭總統彭戈在翻閱了攝影師麥可・尼可斯沿途拍攝的照片後，決定在費伊調查過的路線上設立 13 座國家公園。

Conservationist and ecologist Michael Fay huddles on the granite of a mountaintop in Minkébé forest.
On September 20, 1999, wildlife biologist Michael Fay plunged into the bush of the Republic of Congo and—except for breaks during the rainy season—only emerged 455 days and 1,200 miles later on the Atlantic shores of Gabon. Shirtless, Fay had driven the exhausted expedition onward by sheer force of will, pushing by compass and machete through thorny thickets, across Edenic glades frequented by elephants, and through swamps crawling with crocodiles. Yet his trials paid off: after leafing through photographer Michael Nichols's photographs, Omar Bongo, President of Gabon, established 13 national parks along the route Fay had explored. □

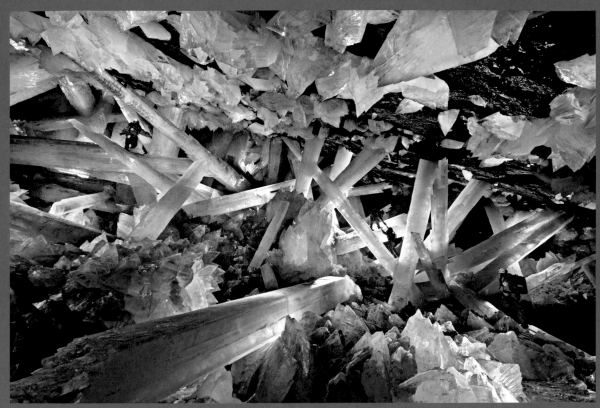

影像／卡斯坦 · 彼得；Speleoresearch & Films；國家地理學會圖片
Credits/ Carsten Peter; Speleoresearch & Films; National Geographic Stock

▲ 墨西哥
MEXICO | **2008 年**

巨大的透石膏柱，讓前往墨西哥契瓦瓦沙漠下方「水晶洞」探險的人類顯得渺
小。這些耗時千萬年才形成的晶體，是目前地球上所發現最龐大的結晶體之一。
拍攝這張照片的德國攝影師卡斯坦 · 彼得經常冒著生命危險拍照。無論世界
上哪個角落有火山爆發，他都會盡快趕去報到。穿著防熱衣，他爬過世界各地
無數的火山口，沿著邊緣朝火山的熾熱中心前去。他說：「自然比人類龐大太
多，讓人不禁感到敬畏。這就是我喜歡追尋的感覺。」

Massive beams of selenite dwarf humans exploring the Cave of Crystals deep
below the Chihuahuan Desert. Formed over millennia, these crystals are
among the largest yet discovered on Earth.
The photo was taken by German photographer Carsten Peter, who risks
death whenever a volcano awakens somewhere in the world. Dressed in
a heatproof suit, he has climbed over the rims of craters and edged down
toward their fiery bubbling centers all over the globe.
"Nature is so much bigger than you that you feel awe before it. That's the
feeling I love to hunt for," he says. □

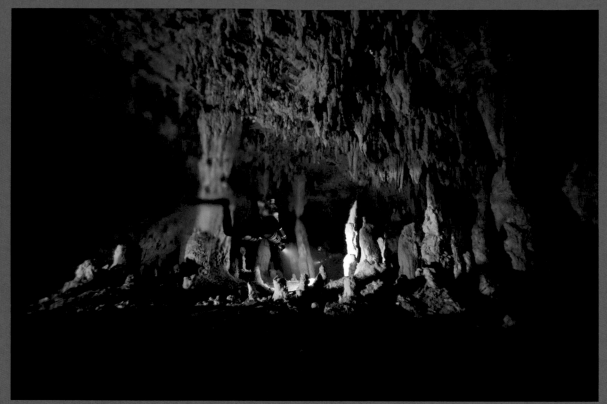

攝影／威斯 · 史凱爾
Photography/ Wes Skiles

▲ 巴哈馬群島 | 2009 年
BAHAMAS

對潛水人來說，深潛進入丹洞這個位於巴哈馬群島的謎樣藍洞，就好比登山客攀爬聖母峰。這些看似無底的水下世界常瀰漫有毒氣體，危機四伏──也充滿祕密。「有時，似乎有黑色觸手從虛空往上伸，試著要把你拉下去。」經驗豐富的洞穴潛水員暨攝影師威斯 · 史凱爾表示。「我們所有人都曾有朋友因為受到想潛入更深處的誘惑而喪生。」儘管這類洞穴可能會讓人喪生，它們也可能帶來生命。研究巴哈馬群島藍洞化學過程的科學家就相信，這樣的環境條件可能和孕育地球第一個生命的環境類似。

A descent into the abyss of Dan's Cave, one of the blue holes that riddle the Bahamas, is the diver's equivalent of climbing Everest. Often hazy with noxious gases, these seemingly bottomless underwater worlds are filled with danger──and their own closely held secrets.
"At times it feels like black tendrils are reaching up from the void and trying to pull you down," explained photographer Wes Skiles, a seasoned cave diver. "All of us have lost friends to the lure of descending too deep into the unknown."
Though caves like this can claim life, they also may have conferred it. Scientists studying the chemical processes under way in Bahamian blue holes believe they may be akin to the conditions that spawned Earth's first living organisms. □

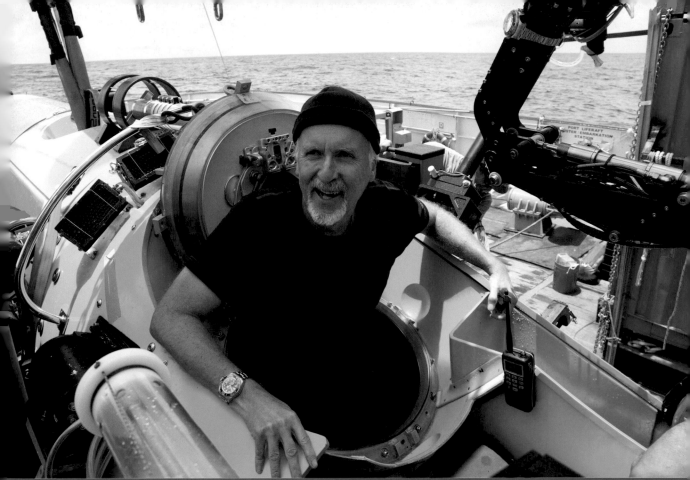

攝影／馬克 ‧ 希森；國家地理學會
Photography/ Mark Thiessen; NGS

▲ 太平洋
PACIFIC OCEAN | 2012 年

電影導演及國家地理學會駐會探險家詹姆斯 ‧ 卡麥隆，從他最先進的潛水艇「深海挑戰者號」現身。他成功抵達海平面以下 11 公里處的馬里亞納海溝深處，締造了世界最深的單人下潛紀錄。

幾個小時以後，這位國家地理學會駐會探險家帶著豐富的 3D 電影素材回到海面，不過深海挑戰者號的機械手臂故障，導致他無法蒐集太多科學樣本。但除去這個小瑕疵，對海洋探險而言，2012 年 3 月 26 日確實是個意義重大的日子：因為自 1960 年以來，就沒有人下潛至挑戰者海淵。

Filmmaker and National Geographic Explorer-in-Residence James Cameron emerges from his state-of-the-art submersible DEEPSEA CHALLENGER. He reached the depths of the Mariana Trench—6.6 miles (11 km) down—setting a world record for the deepest solo dive.

When Cameron surfaced several hours later, he had shot plenty of footage for a 3-D film. But the robotic arm on the DEEPSEA CHALLENGER had malfunctioned, keeping him from collecting many scientific samples. That lapse aside, March 26, 2012, had been a landmark day for ocean exploration: No one had ventured into the Challenger Deep since 1960. □

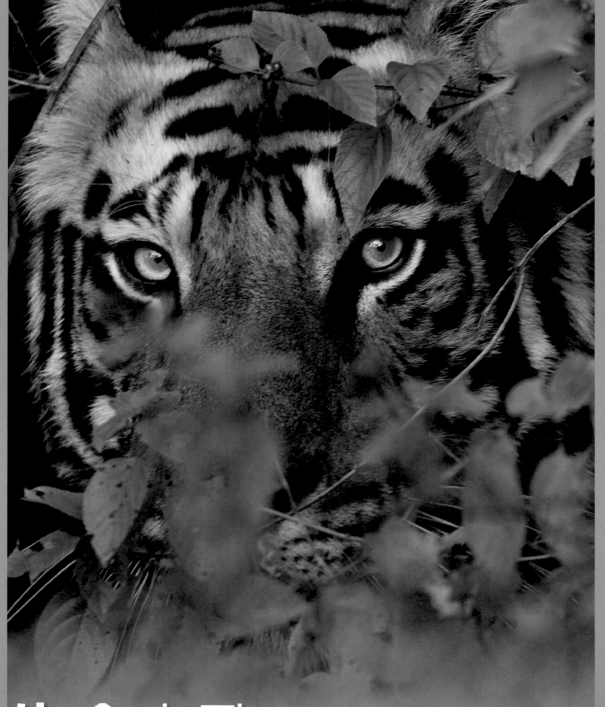

生命之歌
Wild Lives of Wildlife

「動物非常倚賴身體語言來溝通，」《國家地理》雜誌野生動物攝影師法蘭斯 · 藍汀 (Frans Lanting) 曾這麼說。《國家地理》雜誌刊登野生動物照片已有超過一個世紀的時間，這些照片展現了動物肢體語言可以傳達出的每一個動作——從攤趴在地的姿勢開始，因為許多早期的野生動物照片描繪的是狩獵的戰利品。然而，隨著時間演進，帶著更精良裝備的攝影師開始拍出一張張生動的動物活動影像——跟蹤、覓食、求偶、竄逃。被相機捕捉到的動物有各式各樣的姿勢，無論是慵懶休憩、勢均力敵、警覺、憤怒、準備爆發攻擊或撤退。

這些照片解開了動物行為的謎題，也為地球枯萎中的生命之樹留下記錄。動物的面貌在學會努力下愈來愈清晰之際，「野外街頭攝影」也逐漸興起：《國家地理》雜誌攝影師不斷重新解讀動物的身體語言，甚至以讓人驚訝的創新方式描繪逐漸消逝的生物，讓我們更深入了解和我們共享地球的所有生命。

"Animals communicate a lot with body language," *National Geographic* wildlife photographer Frans Lanting once observed. For more than a century the magazine has published photos of wild creatures expressing every gesture a body can convey—starting with prostration, for many early pictures depicted slain trophies of the hunt. As the years passed, however, photographers with improved equipment have captured dramatic images of living bodies flowing with motion—stalking, feeding, courting, fleeing. Animals have been detected at languid rest or in tense equipoise, gaze alert, nostrils aflare, ready to explode in charge or retreat. Such images unlock mysteries of behavior even as they document the planet's ever withering tree of life. As the Society has brought animals into sharper focus, a kind of "street photography of the wild" side has likewise emerged: *Geographic* photographers have been reading the body language of animals anew, depicting even vanishing creatures in startlingly novel ways, helping humans better understand all the creatures that share this planet with us.

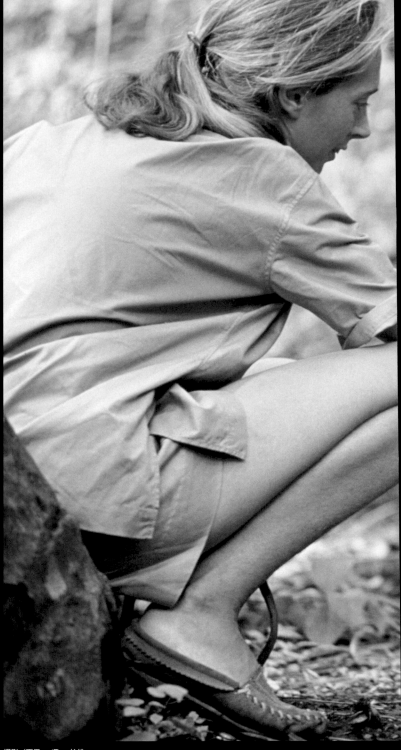

坦尚尼亞
TANZANIA | 1964 年

「你覺得我在這裡不應該高興嗎？這是我孩提時期夢想的非洲，而且我有機會在這裡發覺從前沒有人知道的新鮮事。」

珍 · 古德與甫出生的弗林特之間流露的自然情感，讓整個世界變得更親近。學會同意贊助毫無經驗的珍 · 古德研究黑猩猩，協助促成了一場知識革命，以全新角度來理解人類，也讓人類更加認識自己。珍 · 古德的確有驚人發現：她看到黑猩猩獵食其他動物，也看到黑猩猩拔光枝上的葉子，再將樹枝插入白蟻丘，釣出美味點心。這些發現表示，黑猩猩不但懂得使用工具，也會製作工具。

"Can you wonder that I should be happy here? It is the Africa of my childhood dreams, and I have the chance of finding out things which no one has ever known before."

With one touch of nature, Jane Goodall and newborn Flint made the whole world kin. By agreeing to sponsor the chimpanzee studies of an inexperienced Jane Goodall, the Society helps effect a revolution in our understanding of ourselves as a species.

Her discoveries were startling: She had seen chimpanzees stalk, kill, and eat other animals. She had watched them strip the leaves from twigs, insert the sticks into termite mounds, and fish out delectable snacks. This meant chimps were not only using tools but fashioning them as well. □

攝影／雨果 · 馮 · 拉維
Photography/ Hugo van Lawick

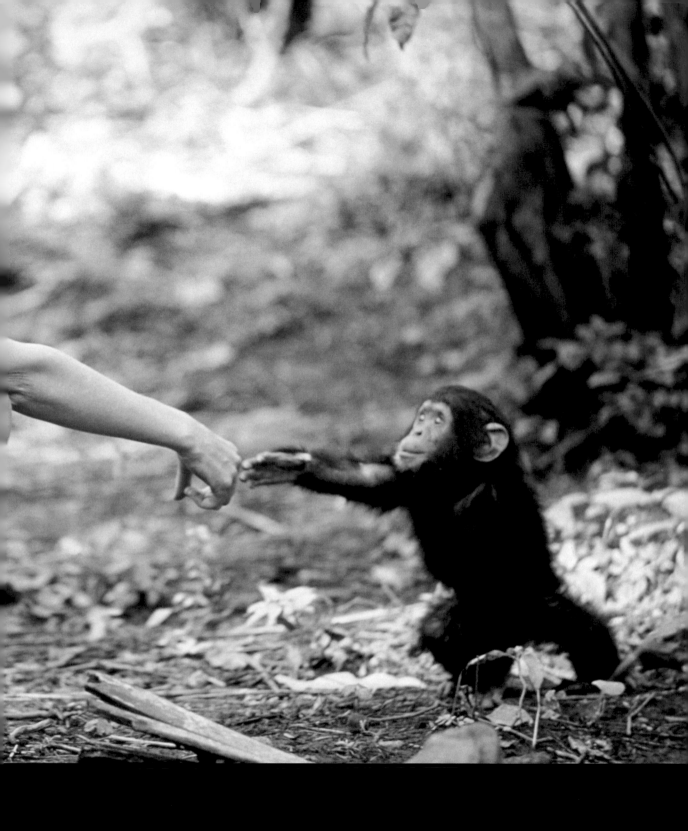

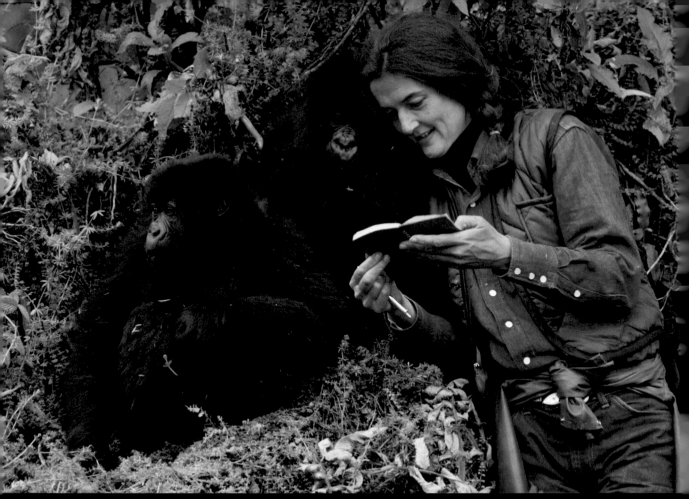

攝影／鮑伯 · 坎貝爾
Photography/ Bob Campbell

▲ 盧安達，維龍加山脈比蘇奇火山公園
PARC DES VOLCANS, MOUNT VISOKE, VIRUNGA MOUNTAINS, RWANDA | 1969 年

動物學家黛安 · 弗西近 20 年動盪不安的研究生涯，主要都由國家地理學會所贊助。這張照片攝於維龍加山脈卡里梭克附近，弗西身旁的是兩隻孤兒大猩猩蔻蔻和帕克。

但當盜獵者殺害了弗西最喜歡的大猩猩迪吉特，也把這位科學家變成了復仇天使。弗西向盜獵者發動了一個女人的戰爭，搗毀他們的圈套、破壞他們的森林營地、甚至綁架這些盜獵者。弗西因此製造了太多敵人，導致她在 1985 年 12 月 27 日於卡里梭克的小木屋內遭到謀殺。這宗罪案一直沒有偵破。

Zoologist Dian Fossey was sponsored largely by the National Geographic Society for two tempestuous decades. She is with Coco and Pucker—two orphaned gorillas—near Karisoke in the Virunga Mountains.

When poachers killed Fossey's favorite gorilla, Digit, they transformed the scientist into an avenging angel. She waged a one-woman war on the poachers, tearing up their snares, wrecking their forest camps, even kidnapping them. And making too many enemies: Fossey was murdered inside her Karisoke cabin on December 27, 1985. The crime has never been solved. □

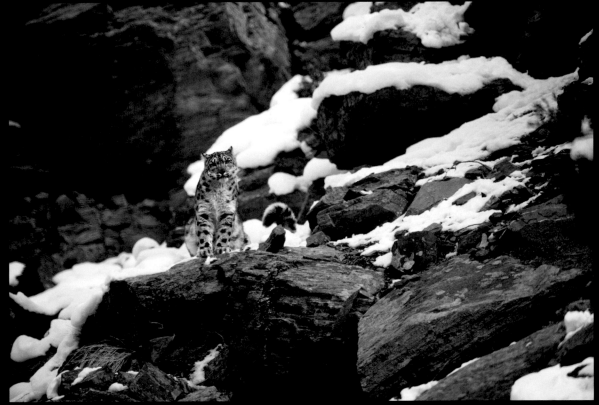

攝影／喬治 · 夏勒
Photography/ George B. Schaller

▲ 巴基斯坦
PAKISTAN | **1970 年**

在興都庫什山，行蹤飄忽不定的雪豹看著博物學家喬治 · 夏勒拍下牠的照片——這是這種傳說中的「鬼貓」最早被公開刊登的照片之一。

經過數週的跟蹤與觀察，夏勒拍下第一批「喜馬拉雅鬼貓」的照片，並刊登在雜誌上。當這些解析度不甚理想的照片出現在 1971 年 11 月號時，世人基本上對雪豹一無所知，親眼看過雪豹的西方科學家還不到五人。然而在短短十年間，學會的資助就讓生物學家羅德尼 · 傑克遜得以在尼泊爾針對夏勒眼裡如同峭壁間飛掠的「一縷青煙」的雪豹，展開深入的研究。

An elusive snow leopard in the Hindu Kush watches naturalist George Schaller take her picture—one of the first ever published of the legendary "ghost cat."

After weeks of stalking and watching, Schaller snapped the first photographs ever published of the "ghost cat of the Himalaya." When those grainy images appeared in the November 1971 *National Geographic*, virtually nothing substantial was known about snow leopards. Fewer than five Western scientists had ever seen one in the flesh. Within a decade, however, Society funding would allow biologist Rodney Jackson to undertake the first thorough study, in Nepal, of the creature that had struck Schaller as a "wisp of cloud" gliding among the crags. □

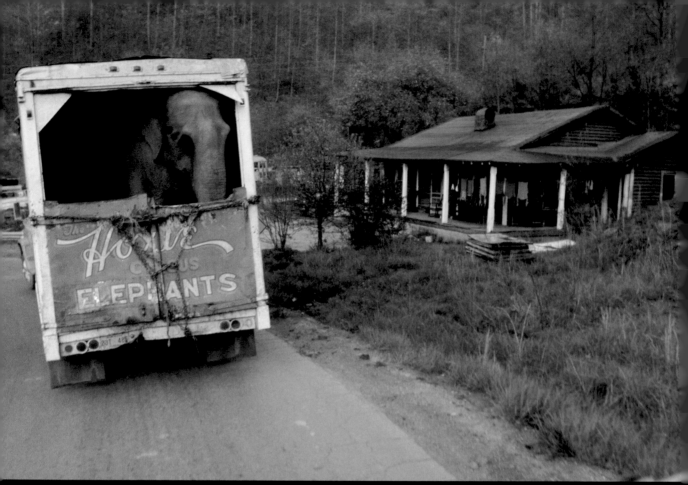

攝影／強納生 · 布萊爾
Photography/ Jonathan Blair

▲ **美國，肯塔基州**
KENTUCKY, US │ **1972 年**

「霍克西兄弟大馬戲團」巡迴演出的途中來到了美國中西部心臟地帶，載著大象的卡車駛過肯塔基州的一條小路。

1970 年代，布萊爾成為國家地理學會的特約攝影師，也開始專門拍攝冒險故事，足跡從美東的柏克夏高地一路行至地中海。他在執行攝影任務時發展出水下攝影的新技巧，其中，〈I-52 潛艇最後潛航〉的拍攝工作讓他在大西洋創下潛水 5180 公尺的世界紀錄。

An elephant travels a back road in Kentucky as the Hoxie Bros. Gigantic 3-Ring Circus wanders through the heartland.

During the 1970s, Blair established himself as a contract photographer with the *National Geographic* Society and began specializing in adventure stories that took him from the Berkshires to the Mediterranean. He also developed new skills in underwater photography while working on stories including "The Last Dive of I-52," which took him to a record-breaking 17,000 feet (5,180 meters) beneath the Atlantic. □

弗雷德與諾拉 · 厄克特夫婦的團隊，發現了他們追尋已久的北美洲大樺斑蝶度冬地。每到冬天，北美東部的大樺斑蝶都會飛到墨西哥馬德雷山脈上的少數幾處高海拔冷杉林中過冬。

厄克特和太太諾拉在 1937 年開始追蹤這些蝴蝶。他們的財務吃緊，若不是國家地理學會伸出援手，兩人已經因為缺乏資金而幾乎打算放棄研究。學會的五年贊助計畫讓厄克特夫婦重整旗鼓，再次出發。結果在 1975 年年初，該研究計畫的義工在墨西哥的馬德雷山上愈爬愈高之後，終於找到數量龐大到令人難以置信的大樺斑蝶。

Fred and Norah Urquhart's team discovers the long-sought wintering grounds of the eastern population of North America's monarch butterflies in a handful of fir forests high in Mexico's Sierra Madre mountains.

In 1937 Urquhart and his wife, Norah, started tracking the butterflies. Financing the operation on a shoestring, they were close to quitting for lack of funds when *National Geographic* stepped in. Five years of Society support allowed the Urquharts to straighten up and fly right. As a result, in early 1975, members of their volunteer team, climbing ever higher in Mexico's Sierra Madre, found the monarchs in mind-boggling numbers. □

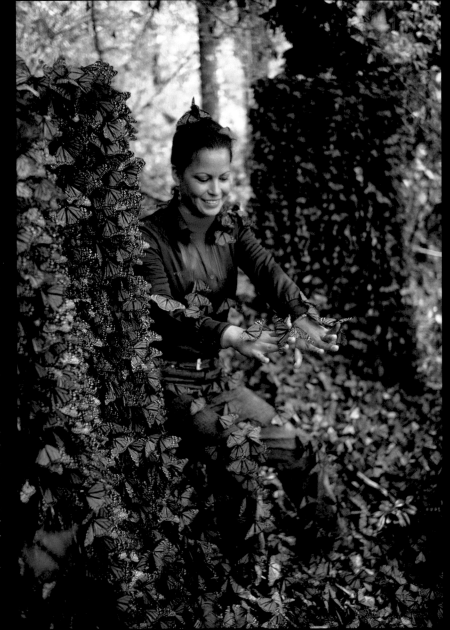

攝影／亞伯特 · 莫德維
Photography/ Albert Moldvay

▲ 墨西哥，馬德雷山脈
SIERRA MADRE, MEXICO | 1976 年

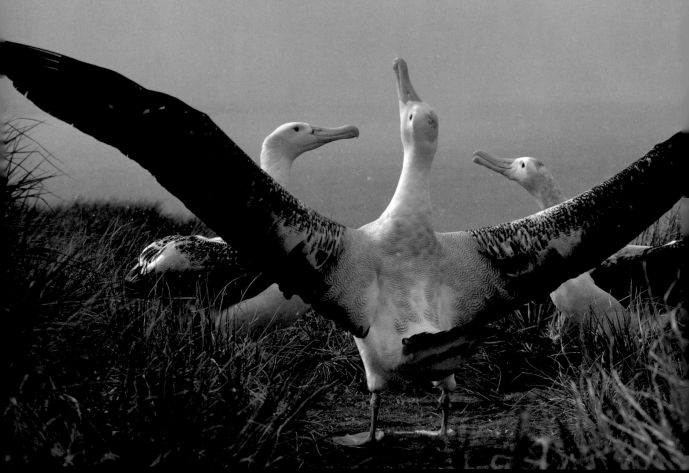

攝影／戴斯及珍 · 巴特列
Photography/ Des & Jen Bartlett

▲ **南喬治亞島**
SOUTH GEORGIA ISLAND | 1977 年

漂泊信天翁返回像阿根廷外海的南喬治亞島這樣的島嶼上求偶，一旦配對成功，就一輩子不離不棄，可能長達 50 年之久。這種海鳥擁有鳥類中最寬的翼展長度，一般在 2.5 到 3.5 公尺之間。他們經常待在海上，只有在繁殖與育雛時才會在陸地出現。
戴斯和珍 · 巴列特夫妻是著名的野生動物紀錄片導演兼製作人。珍原本是澳洲網球選手，兩人結婚後夫唱婦隨，她成為傑出的靜態攝影師，並與戴斯走遍世界各地拍攝野生動物，成了動物紀錄片界最成功也最知名的夫妻檔。

Wandering albatrosses return to islands such as South Georgia to court mates—with whom they may bond for 50 years. The seabird has the largest wingspan of any living bird, typically ranging from 2.5 to 3.5 meters. They are rarely seen on land, preferring to stay out on the ocean except to mate and raise their young.
Des and Jen Bartlett are acclaimed director-producers of wildlife documentaries. Jen had been an up-and-coming Australian tennis star before she married Des. However, she easily adapted to life on the road and became a brilliant stills photographer, working alongside Des; the two became the most successful and well-known couple in the world of wildlife filmmaking. □

西班牙加里西亞省的山丘上，被聚攏在一起的野馬相互競奪霸權。不久之後，在一年一度的「剃獸節」中，牠們的鬃毛和尾巴就會在徒手的馴馬師將牠們壓倒在地後剪下來。這些鬃毛會被用來製作精緻畫筆，賣掉鬃毛的收入則捐給當地的教堂。

Wild stallions battle for supremacy during a roundup in the hills of Galicia Province, Spain. Their manes and tails will soon be sheared at the annual "Rapa das Bestas" (cropping the beasts) festival after they have been wrestled to the floor. The horse hair is then used for fine paint brushes and the profits from these hair sales go to the local church. □

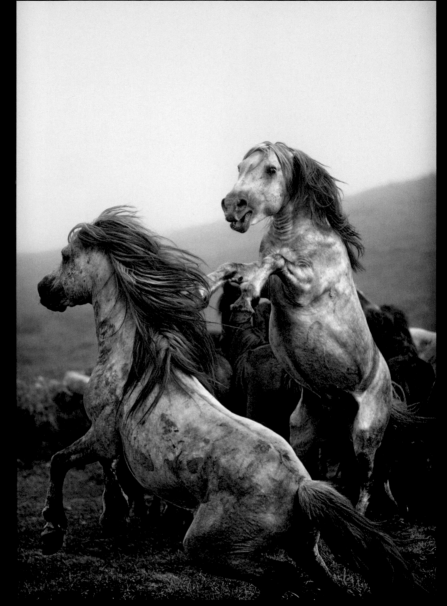

攝影／大衛・亞倫・哈維
Photography/ David Alan Harvey

▲ **西班牙，薩布切多**
SABUCEDO, SPAIN | **1978 年**

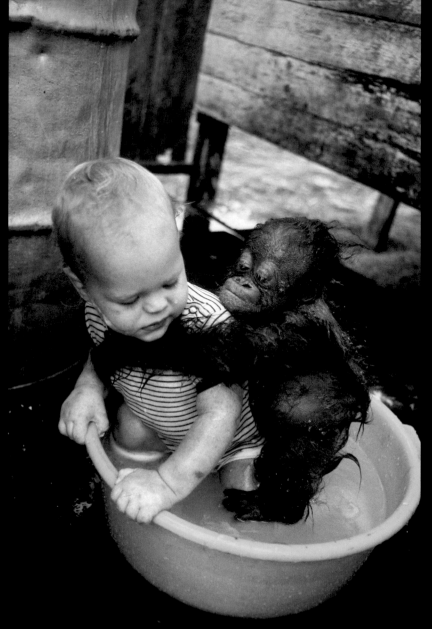

害怕腳下泡泡的紅毛猩猩寶寶，緊緊攀在一歲的小嬰兒賓提身上。賓提是靈長動物學家碧露蒂‧高地卡斯的兒子。照片攝於她從事研究的婆羅洲丹戎普丁保留區。

1971 年，碧露蒂‧高地卡斯和攝影師夫婿羅德‧布林達莫爾搬進了一間位於丹戎普丁保留區的茅草小屋，開始進行第一個以紅毛猩猩為對象的長期研究。世人對這些通常獨來獨往的猿類所知相當有限，從來沒有人看過牠們下樹。然而，高地卡斯卻觀察到牠們在地上覓食，偶爾甚至會跑到草地上。

Anxious about the suds below, a young orangutan clings tight to Binti, the one-year-old son of primatologist Biruté Galdikas, at Borneo's Tanjung Puting Reserve.
In 1971 Biruté Galdikas and her photographer husband, Rod Brindamour, settled into a thatched hut in the Tanjung Puting Reserve and began the first long-term study of orangutans. So little was known about these apes—they tended to lead solitary lives— that they had never been seen coming down from the trees. Galdikas, however, observed them foraging on the ground and occasionally even in grasslands. □

攝影／羅德‧布林達莫爾
Photography/ Rod Brindamour

▲ 婆羅洲，丹戎普丁保留區
TANJUNG PUTING RESERVE, BORNEO | 1980 年

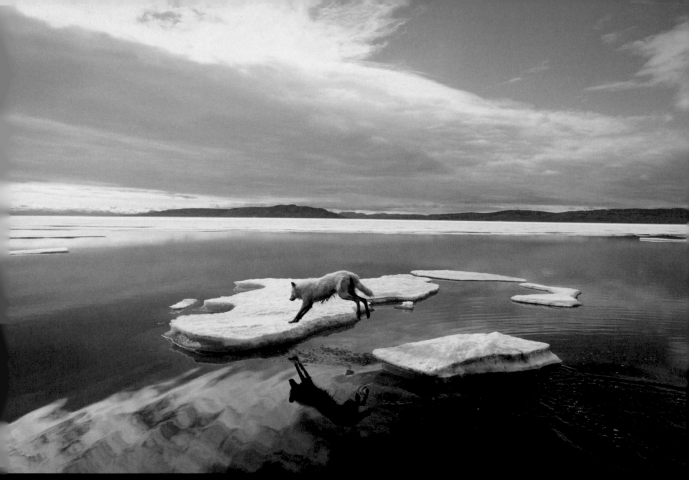

攝影／吉姆 · 布蘭登堡
Photography/ Jim Brandenburg

▲ **加拿大**
CANADA | **1986 年**

在知名野生動物攝影師吉姆 · 布蘭登堡研究過的所有動物中，狼向來是他的最愛——然而，在 20 年間，他只拍出了七張好照片。布蘭登堡曾坦言：「拍得好的狼照片真正說明了什麼是『可遇而不可求』。」

布蘭登堡和生物學家大衛 · 梅克在加拿大偏遠的艾厄士米爾島發現了一群幾乎從來沒人看過的北極狼。讓兩人大感意外的是，這群狼接受了他們，因此他們有一整個光輝的夏天幾乎就和這群狼一起生活在巢穴中。這是他們職業生涯中極精釆的一頁：有機會近距離觀察並拍攝狼群的日常生活。

Of all the animals the celebrated wildlife photographer had studied, wolves had always been his favorites—yet in 20 years he had made only seven good pictures of them. "Good photographs of wolves could define elusiveness," Jim Brandenburg once admitted.

Brandenburg and biologist L. David Mech discovered, on Canada's remote Ellesmere Island, a pack of arctic wolves with almost no previous exposure to humans. To the pair's astonishment, the pack accepted their presence, and for one glorious summer the two men practically joined the animals in their den. It was the highlight of their careers: the chance to observe, and photograph, the daily lives of wolves up close. □

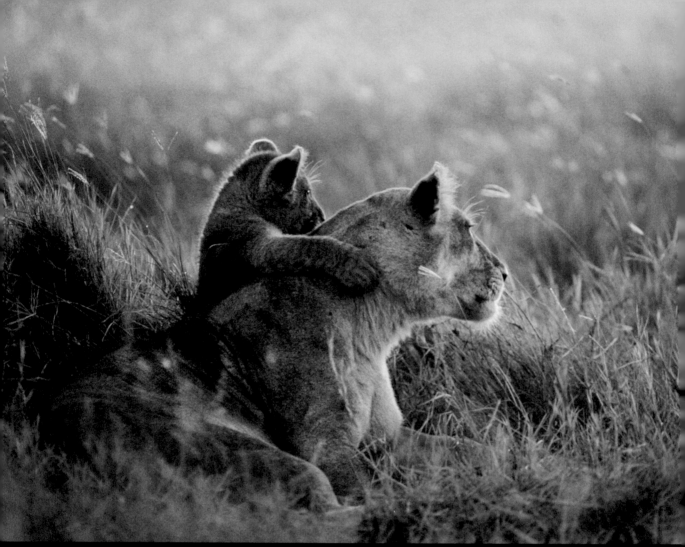

攝影／岩合光昭
Photography/ Mitsuaki Iwago

▲ 坦尚尼亞 | 1986 年
TANZANIA

在坦尚尼亞的塞倫蓋蒂草原上，一隻幼獅將前掌搭在母獅肩頭的模樣，像極了人類的姿勢。這張照片在
1986 年 5 月號刊登之後，許多母親寫信到學會總部，想要索取這張照片。
岩合光昭在他著名的野生動物攝影師父親岩合德光在加拉巴哥群島拍照時擔任助手後，決定投身攝影，此後
四十多年來持續以鏡頭記錄動物影像。他是唯一作品曾兩度登上《國家地理》雜誌封面的日本攝影師。

A lion cub drapes a paw over its mother's shoulder in a startlingly humanlike gesture on Tanzania's
Serengeti Plain. Many a human mother wrote to Society headquarters seeking a copy of this photo after
its May 1986 appearance.
Mitsuaki Iwago decided to become a photographer after assisting his father—himself a noted wildlife
photographer—on assignment at the Galapagos Island, and has been documenting animals for more than
40 years. He was the first Japanese photographer to have his work twice appear on the cover of *National
Geographic*. □

美國，喬治亞州，奧克弗諾基國家野生動物保護區
OKEFENOKEE NATIONAL WILDLIFE REFUGE, GEORGIA, US | 1992 年

喬治亞州的奧克弗諾基國家野生動物保護區內，一隻短吻鱷在富含單寧的淺水中曬太陽。河水的桃花
心木色澤來自腐敗植物釋放的單寧酸，在陽光照映下會呈現黑咖啡的顏色，這裡的河流因此也稱為黑
水河。

奧克弗諾基（Okefenokee）在北美原住民語言中指「冒泡的水」或「顫抖大地的國度」。這座沼澤
以居住在其中的兩棲類與爬蟲類著稱，為數眾多的短吻鱷是其中之一。成年的短吻鱷身長達 2.4 至 3.6
公尺，重可超過 200 公斤，這種原始的爬蟲類曾經因為獵人捕殺、也因為鱷魚皮可用於做鞋子和皮包
而瀕臨絕種。

An American alligator suns in the shallow, tannin-rich waters of the Okefenokee National Wildlife
Refuge in Georgia. The mahogany-red hue of the water which, when reflective looks like black
coffee, is caused by the acid released from decaying vegetation, giving rise to the term "blackwater
river"

Named by Native Americans for "bubbling waters" or "land of trembling earth", the Okefenokee
Swamp is known for its amphibians and reptiles, including an abundance of American alligators.

An adult alligator can reach 8–12 feet in length and weigh up to 500 pounds. The primitive reptile
was nearly hunted to extinction for sport and for its leathery hide, which is used for shoes and
purses. □

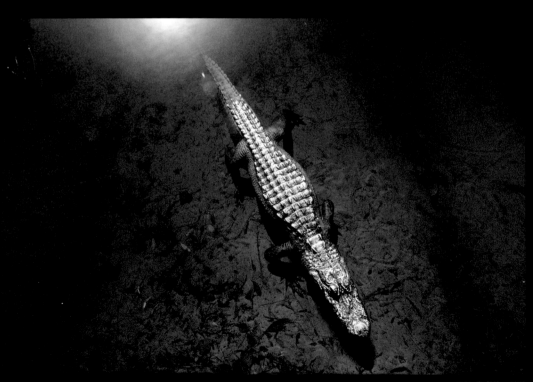

攝影／梅莉莎‧法蘿
Photography/ Melissa Farlow

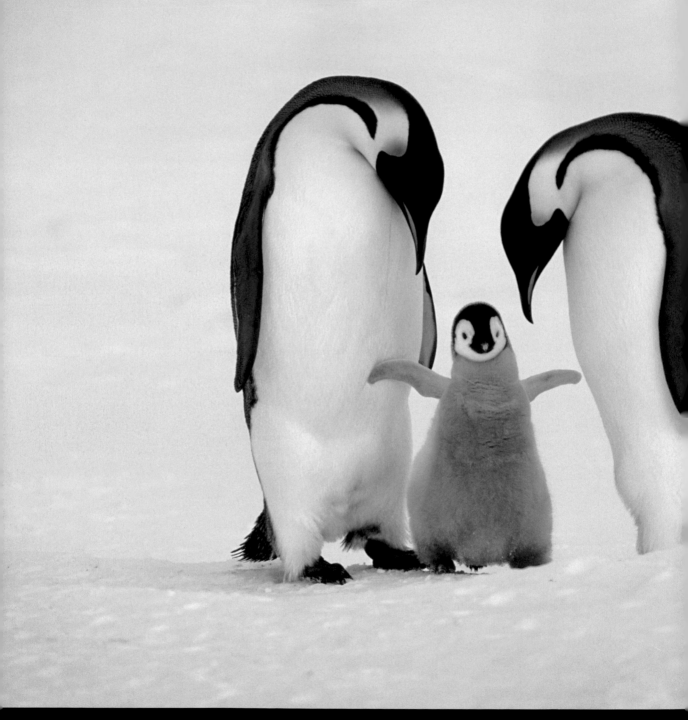

攝影／法蘭斯 · 藍汀
Photography/ Frans Lanting

◀ **南極洲**
ANTARCTICA │ **1995 年**

春末時分，皇帝企鵝的聚居地擠滿了正在育雛的企鵝父母和小企鵝，年紀大一點的小企鵝則是一群一群地到處遊蕩，還有綿延不斷的一長串成年企鵝，在大海和聚居地之間奔波來回。皇帝企鵝不是靠眼力認出彼此：親鳥和小鳥靠著叫聲來團圓。對小鳥來說，能否聽出自己雙親的叫聲是攸關生死的大事。對法蘭斯 · 藍汀來說，了解這種行為，就是拍到經典畫面的關鍵。

In late spring, emperor penguin colonies are crowded with parents brooding young chicks while older chicks wander about in groups, and a constant procession of adults shuttles back and forth from the open sea. Emperor penguins do not find each other by sight: Parents and chicks reunite by calling. For a chick, it is crucial to know its parents' voices. For Frans Lanting, knowing this behavior was a crucial step in the creation of a classic image. □

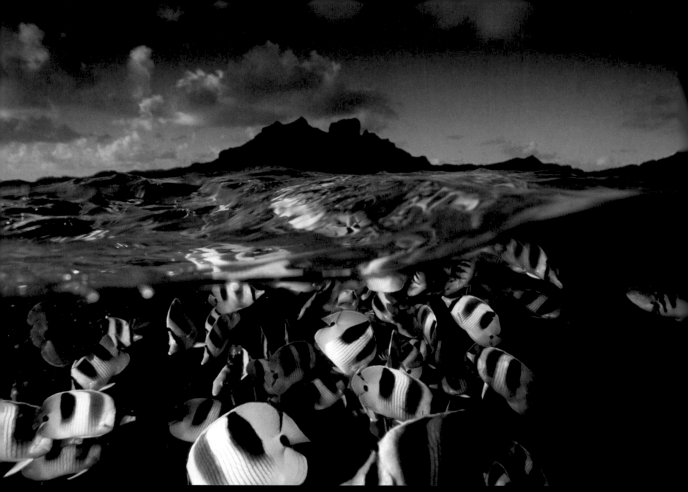

攝影／大衛 · 都必烈
Photography/ David Doubilet

▲ 法屬玻里尼西亞，土木土群島
TUAMOTU ARCHIPELAGO, FRENCH POLYNESIA │ 1996 年

一群蝴蝶魚在水面附近游動。鮮豔的色彩和條紋，讓蝴蝶魚（蝴蝶魚科）成為
漂亮的水族缸魚類，廣受歡迎，但其實很多種蝴蝶魚都需要特殊的照顧和飼養
環境。

無論大衛 · 都必烈的鏡頭以什麼為目標，他拍出來的海洋生物永遠都是散發
著光芒、彷彿是具有啓示性的藝術品。透過數十篇文章的攝影工作，都必烈累
積了許多令人印象深刻的照片，同行因此封他為「海洋界的奧杜邦」。

A school of Butterfly fish swims near the surface of the water. Their vivid
colors and markings make butterfly fish (Chaetodontidae) attractive aquarium
fish, but many species require special attention and maintenance.

Whatever the target of David Doubilet's lens, his portraits of marine creatures
have never failed to be luminous, revelatory works of art. In the course of
photographing scores of articles, Doubilet has amassed so many memorable
images that peers deem him the Audubon of the sea. □

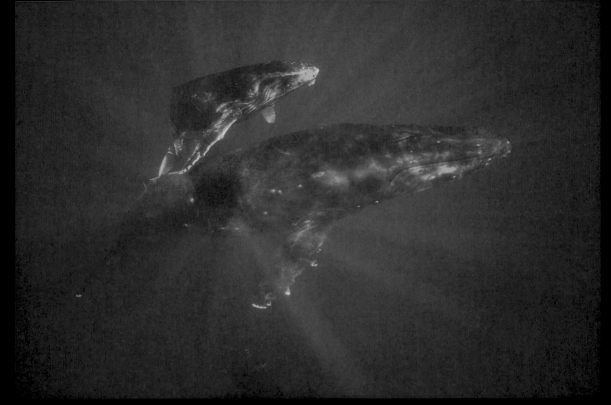

攝影／夫利普 · 尼克林
Photography/ Flip Nicklin

▲ 美國，夏威夷　｜　1997 年
HAWAII, US

一對大翅鯨母子優游於夏威夷水域中。

攝影師夫利普 · 尼克林曾與作家道格 · 查德維克與肯尼斯 · 布勞爾合作採訪以虎鯨、藍鯨與大翅鯨為題的雜誌專題報導。大翅鯨歌曲複雜的和聲仍持續困惑研究者，但沒有人懷疑這種生物的智慧。尼克林曾在浮潛時遇到一隻成年大翅鯨，牠輕輕地以前鰭將尼克林托到自己眼前，查德維克因而在 2007 年 1 月的《國家地理》雜誌中寫道，「誰又能說這不是一隻和人類同樣有著大腦袋的哺乳動物，伸出了牠的好奇之手呢？不正像是黑猩猩或大猩猩第一次伸出手去碰觸研究人員的手那樣的神奇片刻嗎？」

A Humpback whale mother and her calf.

Photographer Flip Nicklin has worked with writers Doug Chadwick and Kenneth Brower to report for the *Geographic* on orcas, blue whales, and hump-backs. The complex harmonics of humpback songs may have continued to perplex researchers, but no one doubted the creatures' intelligence. One adult whale gently swept the snorkeling Nicklin toward its eye with a fin, Chadwick recounted in the January 2007 issue: "Who's to say this wasn't a case of a fellow big-brained mammal reaching out in wonder and curiosity, as in the electric moments when a chimpanzee or gorilla first touched a researcher's hand?" □

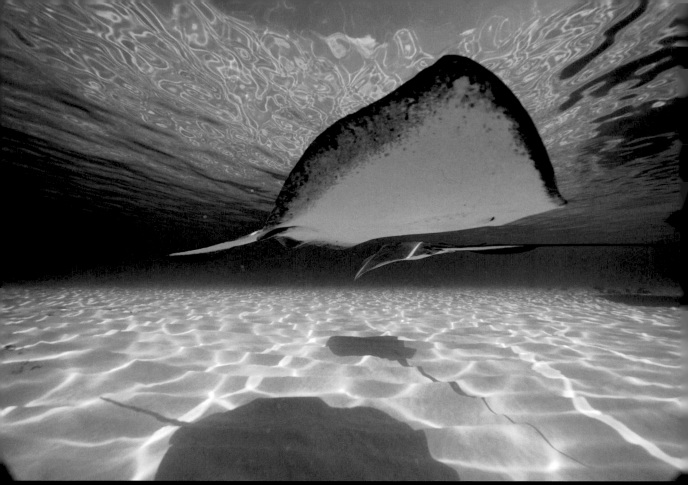

攝影／比爾 ‧ 寇特辛格
Photography/ Bill Curtsinger

▲ 大開曼島
GRAND CAYMAN | **1999 年**

兩條美洲魟優雅地游過加勒比海地區大開曼島附近白沙綿延的清淺水域。這種魚通常成雙成對出現。
比爾 ‧ 寇特辛格專注於拍攝水底與自然史題材，為《國家地理》雜誌拍攝過 33 篇報導。寇特辛格和
查克 ‧ 尼克林在 1970 到 1980 年間成為第一批在鯨魚原生的大海中拍攝這種海洋哺乳動物的攝影師。
《國家地理》雜誌將兩人送到阿根廷瓦爾德斯半島，跟著羅傑 ‧ 佩恩博士進行開創性的個體識別工作，
利用鯨魚尾鰭的特殊記號來辨識南露脊鯨個體。

Two southern stingrays, often found in pairs, glide over white-sand shallows near Grand Cayman
Island.
Specializing in underwater and natural history subjects, Bill Curtsinger has photographed thirty-three
articles for *National Geographic* Magazine. During the 1970s and '80s Curtsinger and Chuck Nicklin
were among the first to photograph whales in their native element. The *Geographic* had sent the pair
to Península Valdés, Argentina, where Dr. Roger Payne was pioneering the identification of individual
southern right whales by the unique marks on fluke or fin. ◻

一隻水母漂浮在水面下。

從 1970 至 80 年代，著名水底攝影師大衛 · 都必烈鏡頭下的珊瑚礁、魚類與其他海洋生物的影像，以讓人屏息的方式將科學和藝術結合在一起。無論是在紅海和海洋生物學家尤金妮 · 克拉克一起拍攝珊瑚礁花園，或是游過太平洋綴滿第二次世界大戰碎屑的砂質海底，都必烈拍出來的作品，總是帶給讀者躍然入海的感覺。他的目標是為世界的海洋創造一種視覺聲音，幫助人們理解我們下方這片隱形世界驚人的美麗和它正默默遭受的破壞。

A jellyfish hovers in the water.

Throughout the 1970s and '80s, acclaimed underwater photographer David Doubilet's depictions of reef, fish and other marine life married science to art in breathtaking fashion. Whether he was working Red Sea coral gardens with marine biologist Eugenie Clark or swimming over sandy Pacific bottoms littered with the encrusted debris of World War II, Doubilet always surfaced with images that pulled readers out of their chairs and into the sea.

Doubilet's personal challenge is to create a visual voice for the world's oceans and to connect people to the incredible beauty and silent devastation happening within the invisible world below. □

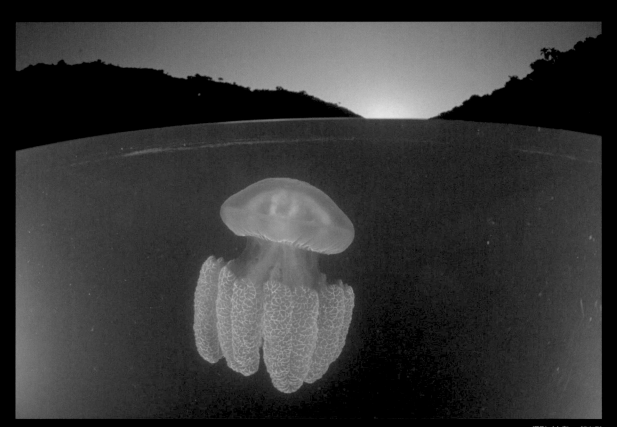

攝影／大衛 · 都必烈
Photography/ David Doubilet

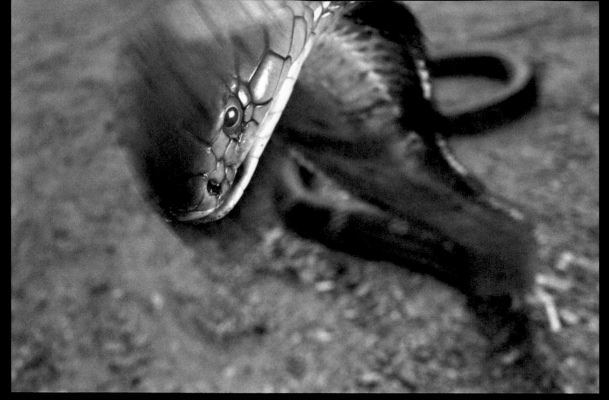

攝影／馬提亞斯 · 克魯姆
Photography/ Mattias Klum

▲ **泰國，邦恩客薩昂村**
BAN KHOK SA-NGA, THAILAND | **2001 年**

泰國的這條眼鏡王蛇受到刺激，張開了頸部，準備發動攻擊──但這是因為牠無處可退了，才會有這樣的行為，一般而言，眼鏡王蛇在碰到狀況時寧願選擇撤退、而不是正面迎擊。

克魯姆曾接下《國家地理》雜誌委託的許多拍攝任務，前往納米比亞、泰國和印度。如果問這位瑞典人最喜歡去哪裡拍照，他會毫不遲疑地回答：叢林樹冠層。克魯姆花了將近一年的時間（1995-96），在婆羅洲的樹頂等待「有趣的東西滑行經過」，也曾在中美洲的雨林巨木枝條上度過許多夜晚，拍到前所未見的夜行哺乳動物蜜熊的影像。

Its hood flared in agitation, a king cobra in Thailand prepares to strike—its final answer, for the snake prefers flight to fight.

Among his many Geographic assignments, Mattias Klum has photographed in Namibia, Thailand, and India. But ask the Swede to name his favorite hangout and he doesn't hesitate: It's jungle canopies. Klum spent most of a year (1995–96) in the treetops of Borneo, waiting for "interesting things to come slithering by". In Central America, Klum spent numerous nights high in the branches of rain forest giants, capturing unprecedented images of a nocturnal mammal called the kinkajou. ☐

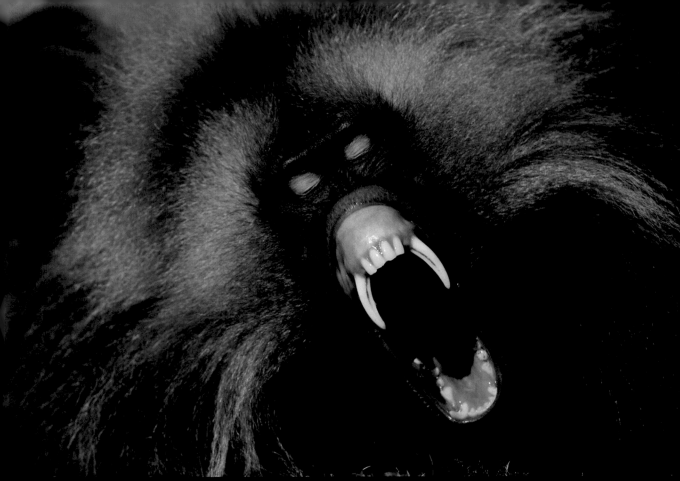

攝影／麥可 · 尼可斯
Photography/ Michael Nichols

▲ 衣索比亞，瑟門山國家公園
SIMEN MOUNTAINS NATIONAL PARK, ETHIOPIA | 2002 年

齜牙咧嘴的獅尾狒看似兇惡，但牠們其實是草食動物，一般都在衣索比亞的草原上覓食。
以拍攝野生動物及生態聞名的麥可 · 尼可斯，曾被稱為「攝影界的印第安那瓊斯」，四度獲世界新聞攝影比賽的自然與環境類首獎肯定。從 1999 到 2002 年，尼可斯紀錄了生態保育學家麥可 · 費伊橫越非洲的大穿越探險。費伊徒步走了 3219 公里，從剛果最深的雨林，走到加彭的大西洋海岸，研究非洲最後的一片廣袤荒野。尼可斯在這段長征中的作品不僅刊登在 2001 年的《國家地理》雜誌，也讓當時的加彭總統決定設立國家公園保護這些最後的荒野。

A gelada baboon, usually content to graze grasslands in Ethiopia, bares its fangs.
Dubbed "The Indiana Jones of Photography" early in his career, Nichols is known for his wildlife images and has won first prize four times for nature and environment stories in the World Press Photo competition. From 1999 to 2002 Nichols documented conservationist Mike Fay's Megatransect expedition across Africa. Fay walked 2,000 miles (3,219 kilometers) on foot from Congo's deepest rainforest to the Atlantic coast of Gabon, studying Africa's last great wilderness. Nichols's work from this undertaking resulted in the decision by the then Gabon President to establish national preserves along Fay's route and can be seen in the 2001 *National Geographic* magazine articles. □

日本，長野縣，地獄谷
JIGOKUDANI, NAGANO PREFECTURE, JAPAN │ 2003 年

在日本本州的地獄谷溫泉裡，一隻獼猴正在替同伴理毛。自 1963 年起，獼猴每年冬天都會到這座覆雪山間的溫泉取暖。

雷曼以他對婆羅洲纏勒植物的研究獲哈佛大學博士學位，不過，這位訓練有素的生物學者，作為攝影師也同樣出色。他累積了驚人的野生動物肖像作品──褶虎、飛蛙、懶猴、長鼻猴與其他雨林住民──而且往往都是夜間在樹冠層拍攝的。雷曼曾記錄下全球數十種數量正在減少的犀鳥，以及新幾內亞島上的每一種極樂鳥。

A macaque grooms his companion in the Jigokudani hot springs of Honshu. The monkeys have headed for this haven in the snowbound mountains every winter since 1963.

Though he had earned a Ph.D. from Harvard for his work on Borneo's strangler figs, Tim Laman was as superb a photographer as he was a biologist. He has since compiled a striking portfolio of animal portraits—flying geckos, flying frogs, flying lemurs, proboscis monkeys, and other denizens of the rain forest—taken mostly in the canopies and often at night. Laman has documented dozens of the world's declining hornbills and every species of New Guinea's birds of paradise. □

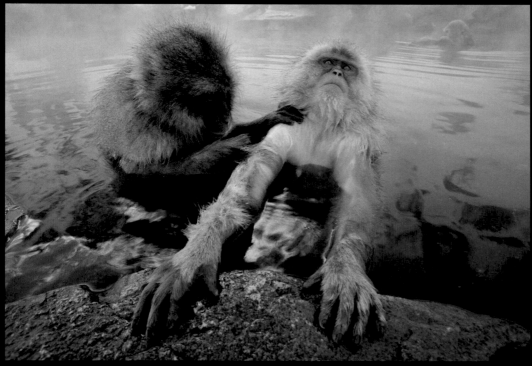

攝影／提姆・雷曼
Photography/ Tim Laman

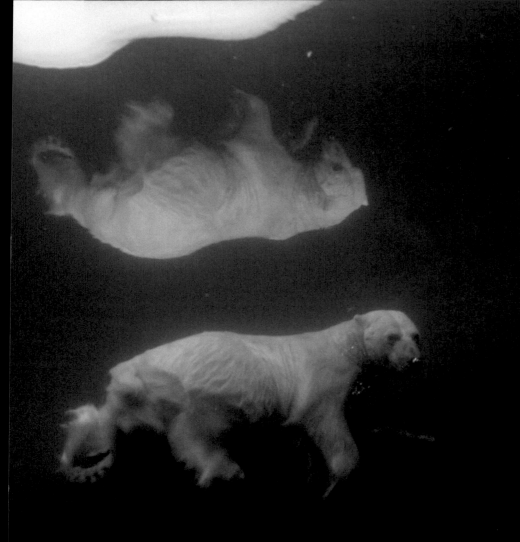

攝影／保羅 · 尼克蘭
Photography/ Paul Nicklen

▲ 加拿大，奴納武特 | 2004 年
NUNAVUT, CANADA

北極熊在水中潛行，身影倒映在冰冷的海水中。潛泳是牠們經常用來奇襲獵物的戰術。
全球暖化使得極區冰雪逐漸消融，保羅 · 尼克蘭以他的相機記錄這片冰雪世界的面貌，希望透過他的作品激發全球對野生動物議題的認識。
「我總說自己是翻譯跟解釋的人，」尼克蘭說。「我把科學家告訴我的事翻譯出來。如果沒有了冰，我們就準備要失去整個生態系了。希望透過我拍攝的照片，能夠讓大家了解這些物種和冰的關係是多麼地密切。要引起大眾的注意，其實只需要一幅有力的影像就已足夠。」

His image mirrored in icy water, a polar bear travels submerged—a tactic often used to surprise prey. Paul Nicklen uses his camera to reveal the nature of a world melting away under human-induced global warming. Through his work, he hopes to generate global awareness about wildlife issues.
"I call myself an interpreter and a translator," says Nicklen. "I translate what the scientists are telling me. If we lose ice, we stand to lose an entire ecosystem. I hope we can realize through my photography how interconnected these species are to ice. It just takes one image to get someone's attention." □

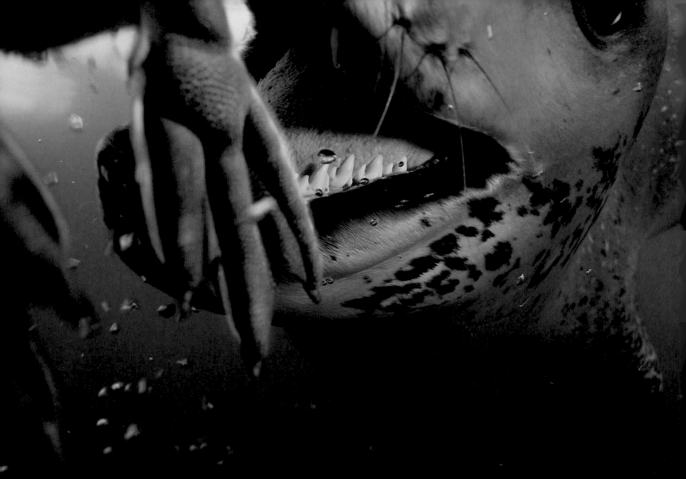

攝影／保羅 · 尼克蘭
Photography/ Paul Nicklen

南極洲
ANTARCTICA | 2006 年

一隻 454 公斤的雌豹斑海豹想把一隻活生生的小企鵝餵給攝影師保羅 · 尼克蘭吃。
尼克蘭致力於為受到全球暖化威脅的動物發聲。自 1995 年專攻極地攝影以來,他在南極洲和豹斑海豹在冰中潛游、在攝氏零下 40 度低溫中橫越幾百公里陸地,也從輕航機上空拍,拍下一張張近距離影像,讓世人得見這些極地動物的真實面目。
童年時和加拿大極區的因紐特人一起生活的獨特體驗,以及西北地方生物學家的專業背景,讓他能承受地球上最險峻嚴苛的環境,而他也希望透過自己的工作,喚起全球觀眾對野生動物議題的關注。

A thousand-pound female leopard seal attempts to feed photographer Paul Nicklen a live penguin chick.
Nicklen is committed to giving the animals threatened by global warming a voice. Whether he is ice diving among leopard seals in Antarctica, covering hundreds of miles of terrain in minus 40°F temperatures, or mastering aerial shots from his ultralight plane, Paul Nicklen has specialized in photographing polar regions since 1995, revealing, often through very close encounters, the world of these polar animals.
A unique childhood among the Inuit in Canada's Arctic and a professional background as a biologist in the Northwest Territories enable him to take on the most inhospitable places on our planet, and he hopes to generate global awareness about wildlife issues through his work. □

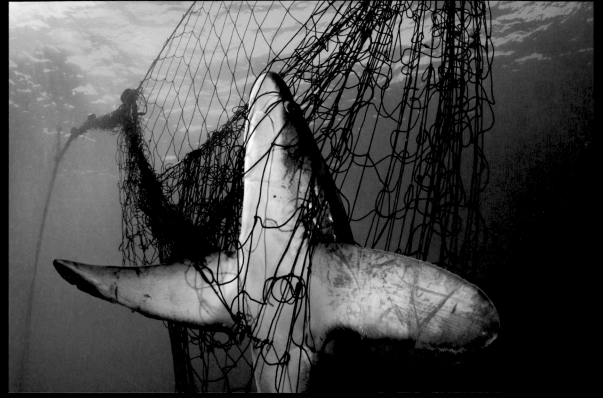

攝影／布萊恩 · 史蓋瑞
Photography/ Brian Skerry

▲ 墨西哥，加利福尼亞灣
GULF OF CALIFORNIA, MEXICO | 2005 年

一條長尾鯊困在墨西哥加利福尼亞灣中的流刺網裡，走到了生命的盡頭。

管理不善加上過度捕撈，已使全球魚群數量下降到危險低點。而伴隨著這些慘澹數據的，經常是布萊恩 · 史蓋瑞驚人的水下攝影作品。史蓋瑞是《國家地理》雜誌最亮眼的一位新興水底攝影師，自 1998 年起擔任雜誌特約攝影師。史蓋瑞在水中攝影領域中最獨特的一點，就是他的拍攝對象極為多元。幾乎一年到頭都在執行任務的他，常常要到南轅北轍的環境中出差，有時是熱帶的珊瑚礁，有時又必須在極冰底下潛游。

A thresher shark meets death in a gill net in Mexico's Gulf of California.

Thanks to mismanagement and overharvesting, global fish stocks have dropped to dangerous lows. Such grim statistics were marshaled alongside spectacular images made by Brian Skerry, the latest and most luminous of the *Geographic*'s underwater photographers. Since 1998 he has been a contract photographer for the magazine.

Unique within the field of underwater photography is Skerry's ability to pursue subjects of great diversity. His nearly year-round assignment schedule frequently finds him in environments of extreme contrast from tropical coral reefs to diving beneath polar ice. □

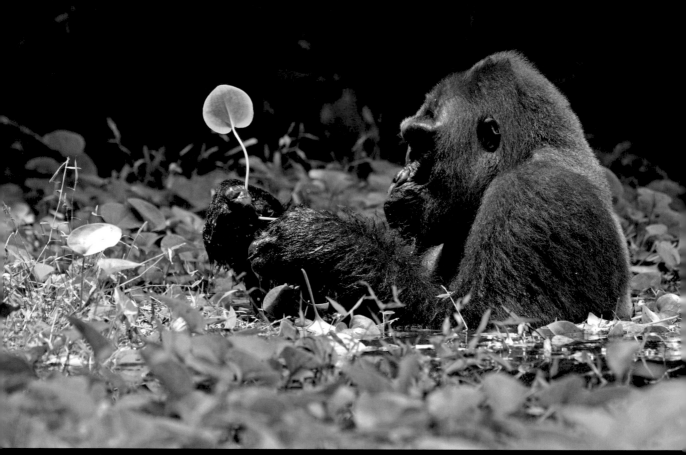

攝影／伊恩 · 尼可斯
Photography/ Ian Nichols

▲ **非洲，剛果**
CONGO, AFRICA | **2008 年**

這隻成年雄性大猩猩是一個大猩猩群體的大家長。為了慰勞自己的辛苦，他在沼澤裡泡了好幾個小時，有條不紊地拔掉植物的根、將上面的土漂洗一番，才放進嘴裡咀嚼。伊恩 · 尼可斯為《國家地理》雜誌拍攝剛果的西部低地大猩猩時，拍下了這張照片。

尼可斯於 2003 年首度和父親麥可 · 尼可斯一起前往非洲加彭，並擔任野生動物保育協會鯨魚團隊的攝影志工。在艱困環境下拍照的確是很大的挑戰，但也很成功，因為他不僅累積了作品，也培養出審美眼光。

Needing fuel for his efforts, the silverback of a lowland gorilla family soaks in a swamp for hours, methodically stripping and rinsing dirt from herb roots before munching.
Ian Nichols captured this shot while on assignment for *National Geographic* magazine, photographing lowland gorillas in Congo.
Ian Nichols first began work in Gabon in 2003 with his father, Michael Nichols. While in Gabon, Ian Nichols volunteered as a photographer for the WCS Whale Team. Photographing under difficult conditions proved challenging and successful as he developed a body of work as well as an aesthetic vision. □

攝影／馬克 ‧ 莫菲特
Photography/ Mark W. Moffett

▲ 緬甸
BURMA | **2006 年**

守株待兔：一隻花螳螂若蟲擬態成一朵花的雄蕊，以引誘獵物上鉤。
20 多年來，號稱「昆蟲學界印第安那瓊斯」的馬克 ‧ 莫菲特在《國家地理》雜誌上發表了各種昆蟲照片。對莫菲特來說，世界上沒有比螞蟻更狡猾的昆蟲。莫菲特在叢林樹冠層和森林地面都遊刃有餘，因為他在全世界各地拍攝過各式各樣的螞蟻：偽牙針蟻、編織蟻、鬥牛蟻、鐮顎蟻、行軍蟻、悍山蟻、鈍針蟻、甚至於在樹枝間懸掛滑翔而且在從樹冠層墜落時能利用膜狀降落傘安全著陸的祕魯看門蟻。

Hover, pray, eat: A juvenile flower mantis mimics the stamens of a flower in Burma in a bid to lure prey.
For more than 20 years Mark Moffett—the "Indiana Jones of entomology"—has been filling the magazine's pages with pictures of insects. To Moffett, there's no insect wilier than an ant. Moffett feels at home in both jungle canopy and on forest floor, having photographed all sorts of ants all over the world: dinosaur ants, weaver ants, bulldog ants, scythe-jawed ants, army ants, slavery ants, dracula ants, and even Peruvian turtle ants that hang glide from branch to branch, surviving falls from the canopy by floating down via a membranous parachute. □

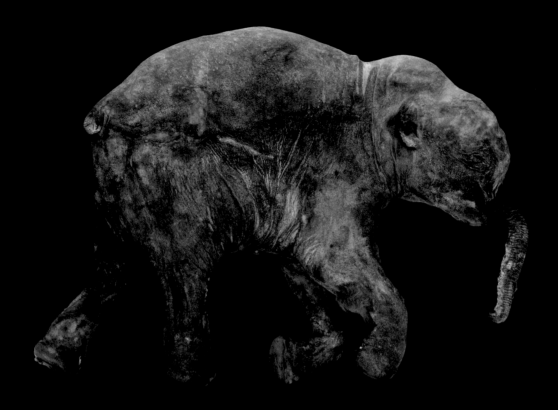

影像提供／國際猛獁象委員會
Source/ International Mammoth Committee

▲ **俄羅斯，聖彼得堡**
SAINT PETERSBURG, RUSSIA | **2007 年**

2007 年，一隻體型相當於大型犬的猛獁象幼崽，在西伯利亞的泥沼中埋藏了 4 萬年後終於出土。這隻被暱稱為「柳芭」的小猛獁象只有一個月大，仍然保有眼睛、象鼻和毛髮，而且體內器官和皮膚的保存狀態幾乎完美。
《國家地理》雜誌在 2009 年 5 月刊登了一篇名為〈冰封的猛獁象寶寶〉的文章，詳細記錄了科學家對柳芭進行的研究。藉著先進的科學儀器，科學家不但希望能了解柳芭的身體狀況，也試圖解開柳芭的死亡之謎。

In 2007, a baby mammoth, about the size of a large dog, surfaced in Siberia after spending 40 millennia entombed in mud. Nicknamed Lyuba, the month-old calf still possessed eyes, trunk, and hair, while her internal organs and skin were in nearly perfect shape.
In May 2009 the Geographic published "Ice Baby", documenting the research being conducted by scientists. With state-of-the-art equipment, scientists hoped not only to understand Lyuba's physical condition, but also unravel the mystery of her death. □

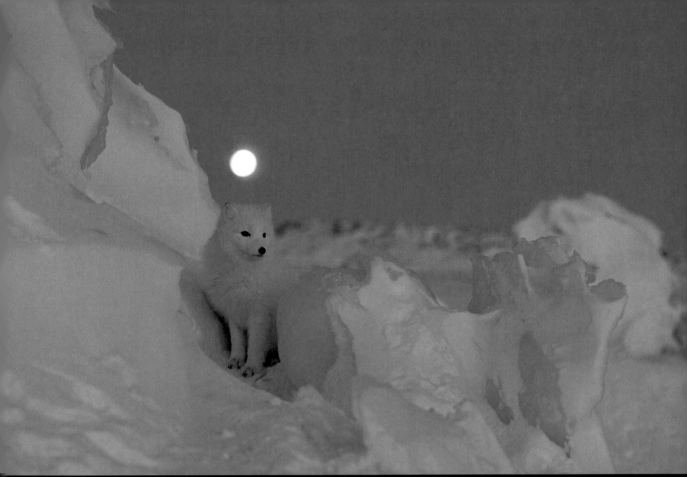

攝影／諾爾伯特 · 洛辛
Photography/ Norbert Rosing

▲ 加拿大，曼尼托巴省
MANITOBA, CANADA | 2007 年

在加拿大曼尼托巴省邱吉爾市附近，冬夜的皎潔月色與一身雪白的北極狐相映成趣。北極狐這一身皮毛是北極動物中最保暖的，能抵禦攝氏零下 50 度的低溫。在夏季，厚重的白色皮毛會變成和周圍凍原一樣的棕色。

諾爾伯特 · 洛辛是富有熱情的自然與野生動物攝影師，致力於拍攝北極地區、北美的景觀與德國的國家公園。洛辛第一次替《國家地理》雜誌拍攝的封面故事，是刊登在 2000 年 12 月號的〈有熊初生〉。從那時候開始，他還為雜誌拍攝了麝牛、海象、白頭海鵰、雪狐和其他許多不同的主題。

Winter moonlight becomes an arctic fox near Churchill, Manitoba. The fox has the warmest pelt of any animal found in the Arctic and can endure temperatures as low as -50 ˚C. The thick white fur will turn as brown as the surrounding tundra when summer arrives.

Norbert Rosing is a passionate nature and wildlife photographer with special dedication to the Arctic, North American landscapes, and the national parks of Germany. Rosing's first cover story in *National Geographic* magazine, "Bear Beginnings: New Life on the Ice," was published in December 2000. Since then he has also covered musk oxen, walruses, bald eagles, and snow foxes for the magazine, among other subjects. □

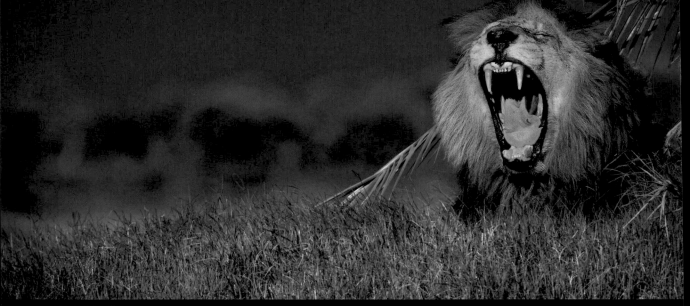

攝影／貝芙莉 · 休貝爾
Photography/ Beverly Joubert

▲ 波札那，奧卡凡哥河三角洲，杜巴平原 | 2008 年
DUBA PLAINS, OKAVANGO DELTA, BOTSWANA

波札那奧卡凡哥河三角洲的杜巴平原上，一頭非洲獅子張開大嘴打哈欠。
駐會探險家德瑞克與貝芙莉 · 休貝爾夫婦發起了「大貓行動」，透過這個計畫提升大眾對大貓數量急遽減少的認識並籌募研究資金。不到半個世紀，光是獅子的數量已從原本將近 50 萬下降到約 2 萬隻。德瑞克在 2009 年呼籲：「如果真要找出一個採取行動的時間點，那就是現在。」
沒人比這對南非夫婦檔更了解這一點。他們在野地紮營，甘願用古老的長頸鹿骨盆當臉盆，幾乎與叢林融為一體，因而能隨時隨地跟蹤並拍攝野生生物。

African lion yawning while near a palm in Duba Plains, Okavango Delta. Botswana.
In an attempt to stem the drastic decline of the world's big cats, Society Explorers-in-Residence Dereck and Beverly Joubert spearhead the Big Cats Initiative, a campaign to raise awareness and fund research.
In half a century lions alone had fallen from nearly half a million to perhaps 20,000. "If there was ever a time to take action," announced Dereck in 2009, "it is now."
No one knew that better than the South African couple. The couple had chosen to spend most of their days under canvas in the wild, content to use an old giraffe pelvis as their washbasin. Becoming virtually one with the bush, they were able to follow and film wildlife day and night. □

非禮勿言？一隻五個月大的圈養山魈用手掩著嘴巴。
喬 ‧ 沙托爾以他所拍攝的野生動物照片著稱，他以相機為武器，致力於保護自然地區以及仰賴這些地區支持的棲地。為國家地理拍照已經超過 20 年的沙托爾懷抱一個使命：他要記錄所有受到威脅的物種與景觀，希望讓世人看到一個值得拯救的世界。用他的話來說：「若是以為我們可以消滅一個又一個的物種、摧毀一個又一個的生態系而不會影響到人類自身，那就太愚昧了。我們若是拯救了這些物種，其實也拯救了我們自己。」

A captive, five-month-old mandrill covers its mouth with its hand.
Best known for his photographs of wildlife, Joel Sartore wields his camera in the battle to conserve natural spaces and the habitats they support. With over 20 years of experience as a *National Geographic* photographer, Sartore is on a mission to document endangered species and landscapes in order to show a world worth saving. In his words, "It is folly to think that we can destroy one species and ecosystem after another and not affect humanity. When we save species, we're actually saving ourselves." □

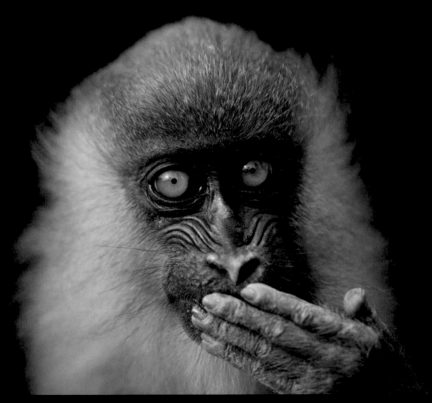

攝影／喬 ‧ 沙托爾
Photography/ Joel Sartore

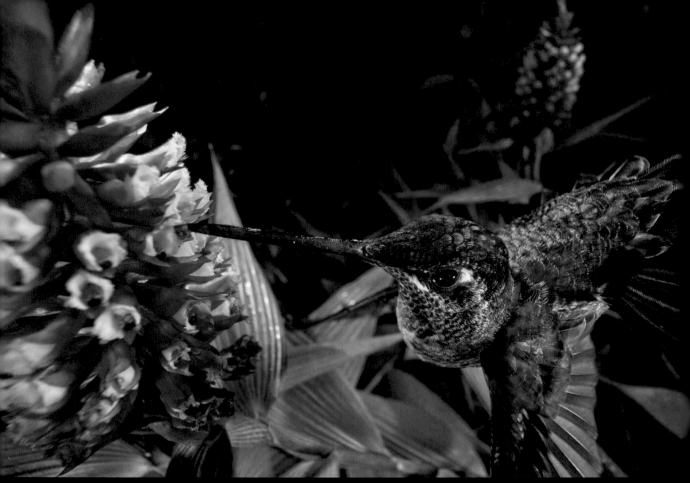

攝影／克里斯帝安 · 齊格勒
Photography/ Christian Ziegler

▲ 巴拿馬，切羅彭塔
CERRO PUNTA, PANAMA | **2008 年**

非常有耐心的傳粉者，以及更有耐心的攝影師，共同成就了這張珍貴的照片。克里斯帝安 · 齊格勒在巴拿馬西部的高海拔雲霧森林裡，花了一個星期的時間，觀察一隻大蜂鳥和一株埃倫蘭之間的互動。大約每 40 分鐘，這隻蜂鳥就會嗡嗡飛過，看看有沒有新的小花打開，然後用鳥喙沾取花蜜品嚐。齊格勒表示，為了「替這隻鳥、這朵花和背景打光，並且將鳥的動作停格，我用了六個頻閃燈。相機以遙控方式觸發，因為這種鳥很害羞，對相機充滿警覺。」齊格勒最後在一個有雨的傍晚拍到這張照片。

A patient pollinator—and an even more patient photographer—made this rare image possible. Christian Ziegler spent a week in the high cloud forests of western Panama, watching the dance between an *Elleanthus* orchid and an aptly named magnificent hummingbird.
About every 40 minutes the bird would buzz by to see what new florets had opened, then dip its beak and sample the nectar. In order "to illuminate the bird, the flower, and the background, and to freeze the bird's movement," says Ziegler, "I used six strobes. The camera was triggered with a remote control from a distance because the bird was quite shy and suspicious of the camera." Ziegler finally got this image late on a rainy afternoon. □

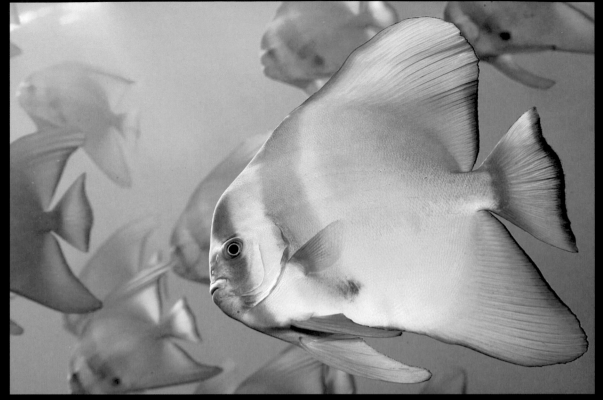

攝影／布萊恩‧史蓋瑞
Photography/ Brian Skerry

▲ 日本，博寧群島，向島
MUKO-JIMA, BONIN ISLANDS, JAPAN　│　2008 年

下顎突出的尖翅燕魚在日本向島外海攝食浮游生物，這種魚在世界各地的海域都很常見。

在執行任務的時候，攝影師布萊恩‧史蓋瑞曾經住在海底，連續好幾個月待在漁船上，駕駛各種稀奇古怪的交通工具，包括雪地摩托車、獨木舟、甚至搭上固特異的飛船，只為了拍到好照片。

30 年來，他待在水中的總時數已經超過一萬小時。

Jut-jawed denizen of the sea, a longfin spadefish, a familiar figure in the world's oceans, hovers for plankton off Japan's Muko Jima island.

While on assignment photographer Brian Skerry has lived on the bottom of the sea, spent months aboard fishing boats, and traveled in everything from snowmobiles to canoes to the Goodyear blimp to get the picture.

He has spent more than 10,000 hours underwater over the last 30 years. ☐

▶ 南非，岡斯灣
GANSBAAI, | **2009 年**
SOUTH AFRICA

南非岡斯灣外海，一隻大白鯊破水而出。
鯊魚的數量在過去四分之一世紀中銳減。即
使是大白鯊也一樣遭受威脅，儘管人們到頭
來才發現這些鯊魚其實是出於好奇而非為了
獵食，才常會在南非的岡斯灣浮出水面、盯
著目瞪口呆的遊客看。大衛 · 都必烈和國
家地理頻道的約翰 · 布列達曾在這裡部署
了金屬製的「海豹攝影機」，也就是偽裝成
大白鯊最喜歡的獵物的水下攝影機。在兩人
收回這些裝置的時候，它們的偽裝外殼早就
被鯊魚尖銳的牙齒咬得滿目瘡痍。

A great white shark breaks the surface of
the sea off Gansbaai, South Africa.
Shark numbers have declined precipitously
in the past quarter century. Even great
white sharks were threatened, though
they were finally showing themselves to
be as curious as they were carnivorous,
frequently surfacing off Gansbaai, South
Africa, to gaze at gawking tourists. There
David Doubilet and National Geographic
Television's John Bredar deployed metal
"seal-cams" —underwater cameras
disguised as the sharks' favorite prey.
When the pair retrieved the devices, their
camouflaged housings were thoroughly
raked by shark-tooth punctures. □

攝影／大衛 · 都必烈
Photography/ David Doubilet

攝影／保羅 · 尼克蘭
Photography/ Paul Nicklen

▲ **加拿大**
CANADA | **2011 年**

在英屬哥倫比亞海岸青翠的溫帶雨林深處，保羅 · 尼克蘭為《國家地理》雜誌 2011 年 8 月號的封面拍到了這隻身覆白色毛皮、俗稱為「靈熊」的柯莫德熊。

這種熊是美洲黑熊的變異個體，天生白色的毛皮來自基因突變，同一個基因在人類身上掌管的是白皙的皮膚與紅色毛髮。住在沿岸的「第一民族」（加拿大境內的北美洲原住民）相當尊敬這種熊類動物，從不捕殺。在皮草貿易盛行於英屬哥倫比亞期間，這些部落甚至拒絕談論柯莫德熊的存在，也因此保護了牠們的族群，讓柯莫德熊能存續下來。

Deep within the verdant temperate rain forest of coastal British Columbia, Paul Nicklen captured this remarkable image of an all white Kermode, or spirit bear, for the cover of the August 2011 *National Geographic*.

A variant of the North American black bear, spirit bears are born with a mutation on the same gene responsible for fair skin and red hair in humans. First Nations groups living along the coast treat the spirit bear with reverence; it is never hunted. In the days when the fur trade dominated British Columbia, the tribes refused to even speak of the animals, thereby protecting the population and allowing it to thrive. □

▶ 印度，班德哈夫國家公園
BANDHAVGARH
NATIONAL PARK, INDIA
2011 年

班德哈夫國家公園內透過樹葉向外窺看的
雄虎。這個保護區內的動物族群密度相當
高：包括花豹在內有將近 60 隻貓科動物，
和其他野生動物一起在此地生活。

因為從小翻閱《國家地理》雜誌而受到啓
發的攝影師溫特爾，曾經擔任尼克・尼可
斯的助手，之後才展開他畢生的事業：翔
實記錄世界的大型貓科動物、研究這些大
貓的科學家，以及相關的保育議題。溫特
爾的作品常出現在《國家地理》雜誌中，
他的照片有一種衝擊力，總能撼動人心，
為野生動物保育爭取到經費。

A male tiger peers through the leaves in
Bandhavgarh National Park. The refuge
is home to a dense population: nearly 60
cats, including leopards, along with other
wildlife.

Inspired by leafing through *Geographic*s
as a boy, photographer Steve Winter
had been an assistant to Nick Nichols
before embarking on his life's work: a
thoroughgoing documentation of the
world's big cats, the scientists who
study them, and the conservation issues
surrounding them. His photographs, many
of them published in the magazine, have
had the kind of impact that helps secure
funding for wildlife protection. □

攝影／史帝夫・溫特爾
Photography/ Steve Winter

人文探索
Peoples and Cultures

國家地理學會誕生於探索的年代，深入陌生國度，報導各地民族的生活方式，正是國家地理撰述與攝影師的一大使命。他們帶回來的探索成果，除了反映美國社會對其他文化的認知，也見證了一個不斷變遷的世界。

國家地理攝影師帶著相機與一份細膩的文化感探索這片土地。他們捕捉了地球每個角落令人驚豔的各種景致，視角廣大，這些風景、市集、熟悉的景致以及未知的視野，全都被賦予了嶄新鮮活的生命。

單純地記錄無法完整詮釋國家地理學會開拓視界的野心。早在20世紀初期，學會贊助希拉姆 · 賓漢（Hiram Bingham）前往壯觀的「印加失落之城」馬丘比丘進行發掘，開啓了學會對考古學的恆久熱忱。而在美洲考古方面，學會因為派出許多目前已蔚為經典的探險隊而站穩領導地位。從美國西部峽谷到非洲草原，從沉船殘骸散落的海床到在空中飛翔的奇異鳥類，國家地理學會盡全力支持各式各樣的田野調查與探索計畫。

The National Geographic Society was born in the age of exploration. Venturing deep into strange lands, reporting on the ways of life of different peoples around the world, was the great mission of the writers and photographers of *National Geographic* magazine. What they brought back from these adventures reflects how American society understood other cultures, and bears witness to an ever changing world.

The photographers explored this world with cameras in hand and a keen cultural sensibility. They captured stunning scenes from every corner of the earth; the landscapes, bazaars, familiar scenes and unknown visions are brought to life vividly through their lens.

The Society's ambition to broaden horizons was not limited to simply documenting the explorations and adventures. The decision to sponsor Hiram Bingham's excavation of the spectacular "lost city of the Incas," Machu Picchu, marked the birth of the Society's abiding passion for archaeology. In New World archaeology, the Society dispatched many now classic expeditions, establishing itself at the forefront of the field. From the canyons in the American west and African grasslands, to sea beds scattered with the debris of shipwrecks, to exotic birds soaring high in the skies, *National Geographic* has supported, and continues to support, all kinds of exploration, adventure and field projects.

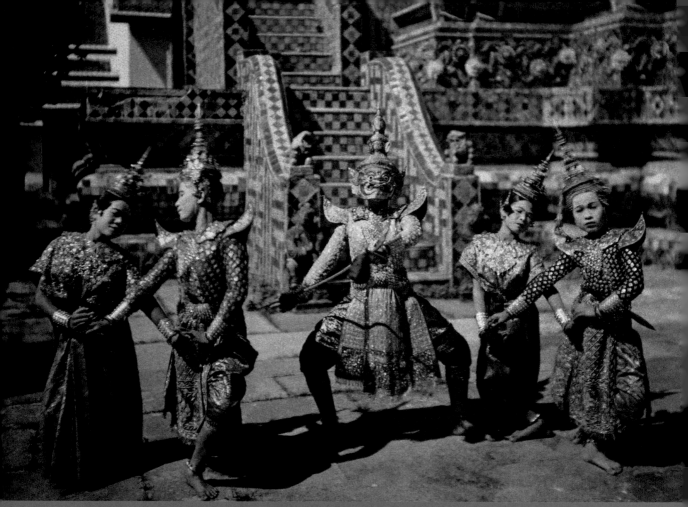

攝影／W・羅伯特・摩爾
Photography/ W. Robert Moore

▲ 暹羅 ｜ 1930 年代左右
SIAM ｜ CIRCA 1930s

舞者在一座寺廟外重現帕鑾王的生平故事。在一個大多數人只能窩在扶手椅上
幻想旅行的年代，《國家地理》雜誌把精采的世界帶進讀者家中──而且撰稿
人本身的故事往往也非常精采。
羅伯特・摩爾是 1930 年衣索比亞皇帝海爾・塞拉西加冕典禮上唯一一位以
Autochrome（一種彩色玻璃板，也就是最早的彩色「底片」）拍照的攝影師。
摩爾開玩笑地說，他是唯一能夠直接向這位「猶大之獅」下令而且對方立刻服
從的人──因為摩爾說的是：「不要動。」

Dancers reenact incidents in the life of Phra Ruang outside a temple. At a
time when most people could travel only by armchair, the Geographic brought
home the world in color—often through contributors colorful in their own right.
W. Robert Moore had been the sole cameraman to shoot Autochromes at
the 1930 coronation of Emperor Haile Selassie of Ethiopia, where, he would
jokingly relate, he was the only person who could give the Lion of Judah a
direct order and be instantly obeyed—for he had told him, "Hold still." □

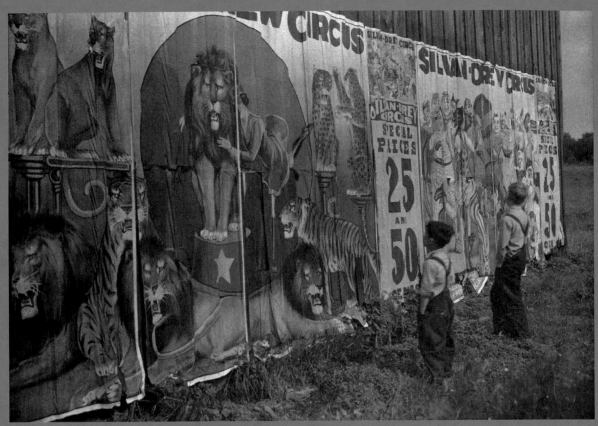

攝影／雅各‧蓋耶
Photography/ Jacob Gayer

▲ 美國俄亥俄州，布里斯托維爾附近 ｜ **1931 年**
NEAR BRISTOLVILLE, OHIO

在俄亥俄州布里斯托維爾，美國中西部的兩名男孩以仿如諾曼‧洛克威爾畫中人物的姿勢站立在海報前，沉浸在馬戲團即將到鎮上表演的消息中。

並不是每位拍照的「國家地理人」都屬於外國編輯部的作者群，有些人專攻攝影，只有在記賬和填寫標題卡的時候才會拿起鉛筆。在北極、拉丁美洲和加勒比海拍攝了許多 Autochrome 彩色照片的雅各‧蓋耶，就是其中之一。

Two midwestern youngsters strike Norman Rockwell poses as they soak in the news that the circus is coming to town—in this case, Bristolville, Ohio. Not every "Geographic man" who snapped pictures was on the Foreign Editorial. Some used a pencil only to fill out expense accounts and caption cards, for they were exclusively cameramen. Jacob Gayer, who made Autochromes in the Arctic, Latin America and the Caribbean, was one of them. □

攝影／路易 · 馬登
Photography/ Luis Marden

▲ 瓜地馬拉
GUATEMALA | 1936 年

頭戴草帽的瓜地馬拉小男孩試圖把一隻火雞引誘到身旁。

路易 · 馬登是所謂的「三項全能」職員，有本事在遙遠的外地一手包辦寫文章、拍照，以及製作 16 釐米的演講用影片等工作。

馬登獻身學會半世紀，被稱為國家地理人的縮影。他興趣廣泛，從航空到海底探險都一網打盡，因為他既是飛行員，也是早期的水肺潛水者。他每次出任務，總會帶回一些新發現的蘭花或從前未知的海蚤。

A young Guatemalan boy in a straw hat tried to coax a turkey to him.

Luis Marden was the so-called "triple threat" staff men, able to write articles, shoot pictures, and make a 16-mm lecture film, all while living in faraway countries.

A Society stalwart for half a century, Marden in turn would come to be called the "epitome" of the National Geographic man. His interests ranged from aeronautics—he was a pilot—to undersea exploration, for he was also a pioneering scuba diver. He routinely returned from assignments with some newly discovered orchids or a previously unknown sea flea. □

穿著繽紛衣裳的女孩，讓拉文塔這座面目猙獰、額頭刻滿美洲豹牙裝飾的奧梅克巨石頭像看來柔和許多。

與散布在中美洲、壯觀但早已廣為人知的馬雅遺址相比，讓史密森學會美洲民族學研究局長馬修‧史特林更感好奇的，是墨西哥叢林中有一座巨石頭像露出於地面的傳聞。因此，史特林於1938年在國家地理贊助下，組織了調查隊前往塔巴斯哥和維拉克路茲的荒野，後續又七度遠征。史特林在這裡挖出11座巨大石造頭像，以及已經埋藏15個世紀之久的奧梅克文明的完整證據。

Gaily clad girls tame a grim Olmec head from La Venta, its brow bristling with carved jaguar's teeth.

Rumors of a giant stone head protruding from the floor of the Mexican jungle intrigued Matthew Stirling, chief of the Smithsonian's Bureau of American Ethnology, more than the spectacular but well-known Maya sites scattered throughout Central America. So in 1938 he mounted the first of eight *National Geographic*–sponsored expeditions to the wilds of Tabasco and Veracruz. There he excavated 11 colossal stone heads and evidence of an entire civilization—the Olmec—that had lain buried for 15 centuries. □

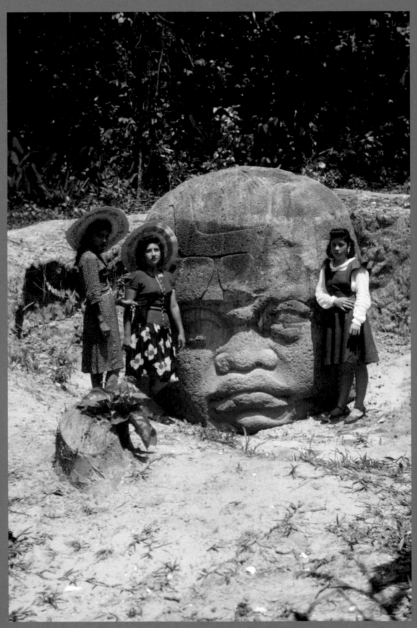

攝影／理查‧史都華
Photography/ Richard H. Stewart

▲ 墨西哥　| 1940 年代左右
MEXICO | CIRCA 1940s

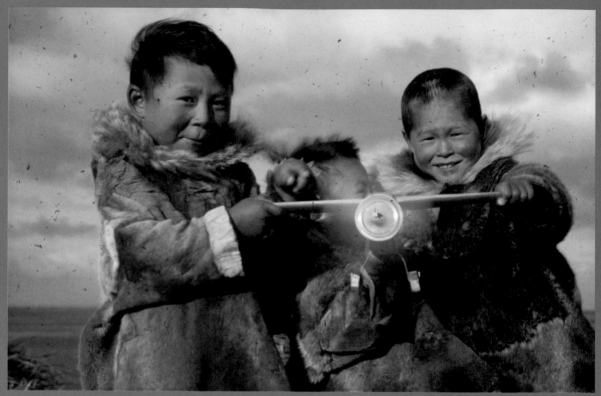

攝影／阿莫斯 · 伯格
Photography/ Amos Burg

▲ 美國阿拉斯加，努尼瓦克島 | 1942 年
NUNIVAK ISLAND, ALASKA

白令海偏遠的努尼瓦克島上，愛斯基摩男孩炫耀著他們製作的飛機。當時，航空服務是島民的生活命脈。

阿莫斯 · 伯格是美國著名的河流探險家，曾多次乘著木筏探索各大河流，包括哥倫比亞河、科羅拉多河、育空河，甚至英國的運河系統。歷時最久的航程長達 135 天，共航行 6759 公里。

1940 年代，伯格走遍全球拍攝教育影片，也替《國家地理》雜誌撰文。二次大戰時，美國中情局的前身「戰略服務辦公室」請求伯格在南美時擔任臥底。伯格接受了任務，但他後來抱怨祕密行事害他消化不良。

Eskimo boys show off the plane they made on remote Nunivak Island in the Bering Sea. Air service was a lifeline to their world at the time.

Amos Burg was a famous American river explorer who made multiple canoe voyages of major American rivers including Columbia River, Colorado River, Yukon River and even England's canal system. The longest journey, 4,200 miles, took 135 days to complete.

Throughout the 1940s, Burg traveled around the world making educational films as well as writing articles for *National Geographic*. During WWII the OSS (Office of Strategic Services), a forerunner of the CIA, asked Burg to work undercover while in South America. He accepted the assignment, but later complained that being secretive caused him indigestion. □

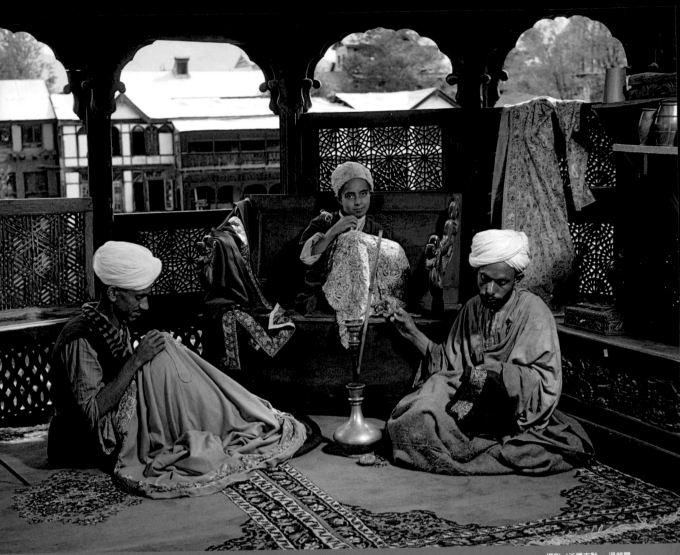

攝影／沃爾克默 · 溫策爾
Photography/ Volkmar Wentzel

▲ 印度 | 1947 年
　INDIA

在斯林耶加俯瞰喀什米爾谷的一座露臺上，包著頭巾的絲綢織工共享一支水煙。
來自德國德勒斯登的攝影師沃爾克默 · 溫策爾於 1937 年加入《國家地理》雜誌團隊。儘管雜誌社的工作讓
他得以行遍世界，但他在印度脫離英國獨立前夕在該國展開的漫長旅程，始終是他一生的最愛。
溫策爾將美軍救護車改裝成行動暗房兼臥室，在車身側面用英文、印地語和烏爾都語寫著「國家地理學會攝影
調查車」，從喀什米爾一路漫遊到科羅曼德。所到之處，大門無不為他敞開。

Working on a balcony overlooking the Vale of Kashmir, turbaned silk weavers in Srinagar share a water pipe.
A native of Dresden, Germany, Volkmar Wentzel had joined the Geographic in 1937, and though
assignments for the magazine would take him all over the world, his Indian odyssey—coming on the eve of
that country's independence from the British—remained his lifelong favorite.
Driving about in a surplus U.S. Army ambulance that he had converted into a rolling darkroom / bedroom—
"National Geographic Society Photo-Survey Vehicle" emblazoned in English, Hindi, and Urdu on its side—
Wentzel wandered from Kashmir to Coromandel. Gates opened for him everywhere. □

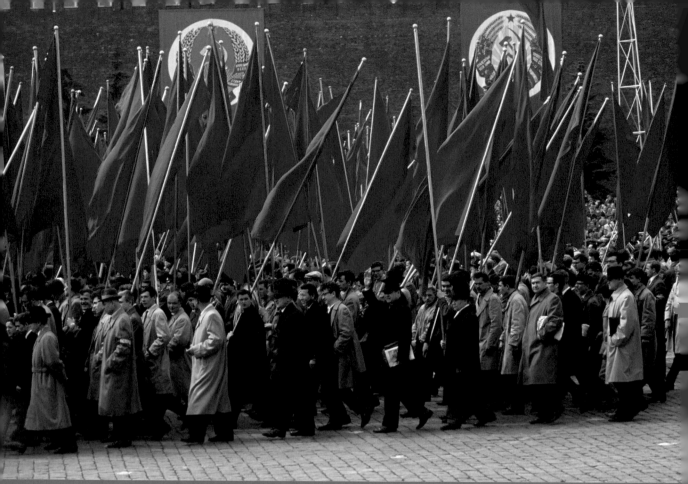

攝影／狄恩 · 孔傑
Photography/ Dean Conger

▲ 蘇聯
SOVIET UNION | 1964 年

五一勞動節遊行的工人穿過紅場，從狄恩 · 孔傑的鏡頭前走過。
狄恩 · 孔傑是《國家地理》雜誌 1960 年代活力十足的新生代攝影記者之一，在 1964 年對神祕的蘇聯展開了長期報導。他對冷戰時期的蘇聯報導無人能比；為了採訪，他不只凍傷鼻子和手指，也曾陪著東道主乾了一杯又一杯的伏特加，因此有時「幾乎沒辦法拍照」。
1960 年，學會還將孔傑與攝影師路易 · 馬登出借給美國國家航空暨太空總署，協助進行太空計畫的彩色攝影工作。

National Geographic staff photographer Dean Conger, one of a dynamic new cadre of photojournalists at the magazine in the 1960s, began long term coverage of the secretive Soviet Union in 1964. Delivering unrivaled coverage of the Cold War Soviet Union, he not only suffered a frostbitten nose and fingers; he also had to keep pace with his hosts vodka for vodka, making picture-taking "barely possible at times."
In 1960, Conger and fellow photographer Luis Marden were lent by the Society to NASA so that a color record of the space program could be made. □

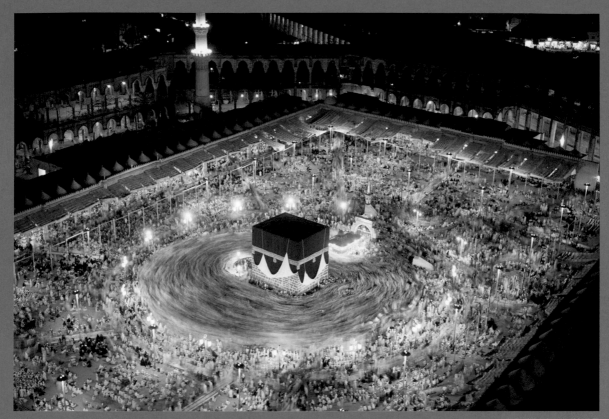

攝影／湯瑪士 ‧ 亞伯柯隆畢
Photography/ Thomas J. Abercrombie

▲ **沙烏地阿拉伯，麥加** | 1965 年
MECCA, SAUDI ARABIA

「來自伊斯蘭教至聖之城的問候與祝福，」1965 年 4 月，改信伊斯蘭教的湯瑪士 ‧ 亞伯柯隆畢寫信給編輯梅爾維爾 ‧ 葛羅夫納。他獲得沙烏地阿拉伯當局許可，得以拍攝麥加朝聖大典。
「我方才有幸目睹、拍攝、並親自參與了人類印象中最令人感動的體驗之一，一年一度的麥加朝聖。」亞伯柯隆畢從他在清真寺附近下榻的旅館屋頂拍下這張長時間曝光的照片，看著全都身穿白衣的信徒環繞卡巴天房，「與行星和原子和諧同步。」他最珍貴的紀念品是從披覆在卡巴天房上的黑色布幔取下的一小塊布。

"Greetings and best wishes from Islam's holiest city," Muslim convert Thomas Abercrombie wrote Melville Grosvenor in April 1965. Abercrombie was permitted by Saudi Arabian authorities to photograph the pilgrimage to Mecca.
"I've just had the singular honor to witness, to cover photographically, and to participate in one of the most moving experiences known to man, the annual pilgrimage to Mecca." Making this time exposure from the roof of his nearby hotel, Abercrombie watched the faithful, dressed anonymously in white, circle the Kaaba "in harmony with the planets and the atoms." His most prized possession would be a piece of the black curtain draping the sacred structure. □

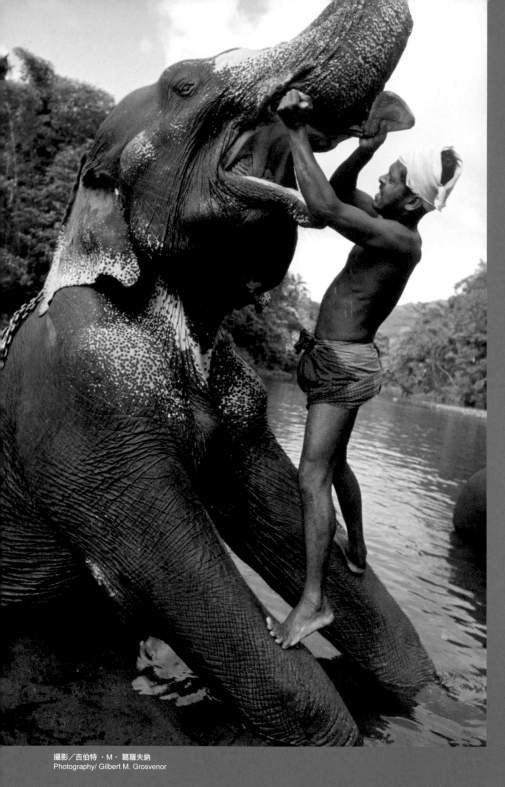

吉伯特·M·葛羅夫納
Photography/ Gilbert M. Grosvenor

▲ 錫蘭
CEYLON │ 1965 年

吉伯特·M·葛羅夫納還是年輕的攝影記者時，拍下這名象伕替大象清理象牙的照片。吉伯特·M·葛羅夫納是國家地理學會與教育基金會的榮譽主席，至今仍繼續任職於兩者的理事會。他於 1970 至 1980 年間擔任《國家地理》雜誌總編輯，並於 1980 至 1996 年間擔任國家地理學會總裁，也是家族中擔任此職位者的第五代。1975 年，由於憂心美國學生對地理知識的缺乏，葛氏推出以兒童為對象的《國家地理世界》月刊，也就是目前的《國家地理兒童》雜誌。1985 年，他啟動一項計畫，旨在改善美國的中小學地理教育。

As a young photojournalist Gil Grosvenor photographed this mahout, an elephant trainer, cleaning his charge's tusks. Gilbert M. Grosvenor is Chairman Emeritus of the National Geographic Society and of its Education Foundation, and continues to serve on the boards of both. He was Editor of *National Geographic* magazine from 1970 to 1980 and served as President of National Geographic from 1980 to 1996, the fifth generation of his family to have served in that position. In 1975, concerned about the lack of geographic knowledge among students, Grosvenor created *National Geographic World*, a monthly magazine for children, now known as *National Geographic Kids*. In 1985 he launched an effort to improve geography education in the nation's classrooms. ❑

佩戴木槿花裝飾的雅浦島島民，為戴維‧博耶表演「棍子舞」。到了 1960 年代，已有一群手持尼康相機的年輕攝影記者成為《國家地理》雜誌的員工，其中許多人經過嚴格的報社工作訓練，甚至曾在韓國擔任戰地攝影師。他們擁有所謂的「國家地理的眼光」，會避開刻意擺出的姿態，盡可能利用現場的自然光拍攝，且偏好描繪真實人物從事實際任務的紀實感性。不僅如此，他們願意接下的任務包羅萬象，從偏遠的國度到科學計畫，再到蓬勃發展的州際公路系統都在內。戴維‧博耶就是其中一位。

Decked in hibiscus blossoms, a Yap Islander performs a stick dance for photographer Dave Boyer's camera.

By the 1960s a stable of young Nikon-toting photojournalists, many of them trained in demanding newspaper work, some of them former combat photographers in Korea, had been lured onto the magazine's staff. They had what was called the "Geographic eye," eschewing posed setups, shooting with available light whenever possible, and favoring a documentary sensibility that portrayed real people engaged in real tasks. What's more, they would take on assignments ranging from faraway countries to scientific projects to the burgeoning interstate highway system. Dave Boyer was one of them. □

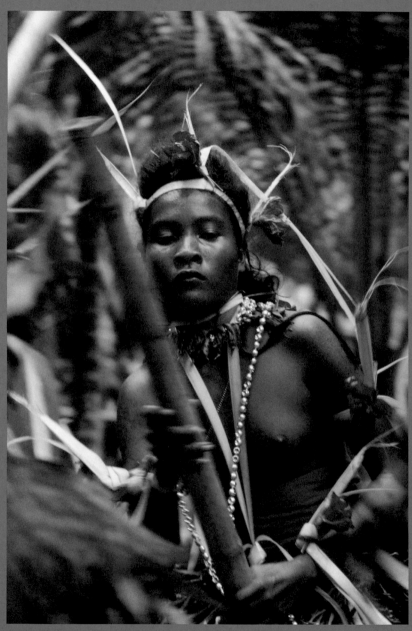

攝影／戴維‧博耶
Photography/ Dave Boyer

▲ 密克羅尼西亞
MICRONESIA | 1967 年

喀布爾的市場裡，身著一襲傳統「查連」的婦女頭上頂著一籠金翅雀。

身為外國編輯部人員的亞伯柯隆畢，常常被派任到世界最偏遠的角落執行困難且危險的任務。最讓他著迷的是中東地區伊斯蘭教宣禮員誦唸召喚詞的聲音，為此，他自學阿拉伯文，改信伊斯蘭教，也讓這些沙漠與廣場市集成了他的主要拍攝對象。

亞伯柯隆畢於 1955 年加入國家地理學會的攝影部門，在學會服務了 38 年。

Covered by a traditional chadri, an Afghan woman balances caged goldfinches at a market in Kabul.

As a fully fledged member of the Foreign Editorial Staff, Abercrombie was entrusted with difficult and dangerous assignments in the world's far corners. Enchanted above all by the muezzin call of the Middle East, he taught himself Arabic, and then— converting to Islam—made those deserts and bazaars his principal beat.

Abercrombie joined the National Geographic Society's Photography Division in 1955 and worked with the Society for 38 years. □

攝影／湯瑪士 · 亞伯柯隆畢
Photography/ Thomas J. Abercrombie

▲ 阿富汗，喀布爾
KABUL, AFGHANISTAN | 1968 年

攝影／溫菲爾德 · 帕克斯
Photography/ Winfield Parks

▲ **義大利，羅馬**
ROME, ITALY │ 1969 年

溫菲爾德 · 帕克斯利用縮時攝影手法拍下古羅馬圓形競技場，也捕捉了現代羅馬惡名昭彰的交通狀況。
帕克斯在 1961 年加入《國家地理》雜誌，此後旅行全球約 40 萬公里，走過歐洲、亞洲、中東、中美
和南美洲 40 個國家。帕克斯的攝影生涯中有各式各樣的冒險，有次一個埃及士兵看到他躺在沙地上、
相機舉在眼前等著拍日出，還以為他是間諜，把他給逮捕了。他曾在西印度群島從迫降的飛機中毫髮無
傷地爬出來，也曾在新加坡頭下腳上地掛在 600 公尺高處的直升機上，只為了拍一張想要的照片。

Winfield Parks's time-lapse shot of the ancient Colosseum captures the notorious traffic of modern Rome.
Parks joined *National Geographic* in 1961 and since then has traveled nearly a quarter million miles through 40 countries in Europe, Asia, the Middle East, and North and South America.
There were many adventures for Parks during his photographing career. Once an Egyptian solider arrested him as a spy after finding him lying in the sand, camera poised, waiting for the moment for a sunrise photograph. He had emerged unhurt from the crash landing of a plane in the West Indies. Once he even hung upside down form a helicopter, 2,000 feet in the air, to get the pictures he wanted in Singapore. ☐

攝影／奧蒂斯 · 英博登
Photography/ Otis Imboden

▲ **美國，佛羅里達州，甘迺迪太空中心** | **1969 年**
KENNEDY SPACE CENTER, FLORIDA

1969 年 7 月 16 日，在佛羅里達州甘迺迪太空中心，群眾舉起手遮擋陽光，看來彷彿在集體敬禮，其實是在觀看阿波羅 11 號發射升空，朝月球前進。
隨著太空時代來臨，學會向美國國家航空暨太空總署提供了特殊的攝影協助。學會的攝影師為水星、雙子星與阿波羅等太空計畫拍下了許多代表性的照片。拍攝這張照片的奧蒂斯 · 英博登也曾和狄恩 · 孔傑一起為第一個進入地球軌道的美國太空人約翰 · 葛倫拍下了無可比擬的照片。

Hands shielding eyes as if in collective salute, a crowd watches Apollo 11 lift off for the moon from Florida's Kennedy Space Center on July 16, 1969.
As the space age dawned, the Society provided special photographic assistance to NASA. *National Geographic* photographers made many iconic images of the Mercury, Gemini, and Apollo projects. Otis Imboden, together with Dean Conger, also took unrivaled photographs of John Glenn after his return from Earth orbit. Glenn was the first American astronaut to orbit the Earth. □

攝影／喬治 · 莫布利
Photography/ George Mobley

▲ **挪威北部**
NORTHERN NORWAY | 1971 年

一個拉普人家庭在他們的帳棚裡準備餐點。拉普人又稱薩米人（Sami），是歐洲地區分布最北的原住民。拉普人的傳統維生方式包括漁、獵與牧羊，但最為人所知的還是半遊牧式的放牧馴鹿。

喬治 · 莫布利擔任《國家地理》雜誌攝影師長達 33 年。他熱愛戶外活動，是實至名歸的冒險家。他對北極地區深深著迷，曾多次到格陵蘭、北歐、西伯利亞和加拿大北部進行拍攝採訪任務。

A Lapp family prepares a meal in their tent. The Lapp, or Sami people, are the northernmost indigenous people of Europe. The Lapp have a variety of livelihoods, such as fishing, hunting, sheep herding and the most well-known semi-nomadic reindeer herding.
For 33 years George Mobley was a staff photographer for *National Geographic* magazine. His love of the outdoors has led to a well-deserved reputation as an adventurer. His long enchantment with the Arctic regions of the Earth led to a variety of assignments in Greenland, Scandinavia, Siberia and northern Canada. □

攝影／狄恩 · 孔傑
Photography/ Dean Conger

▲ **俄羅斯，莫曼斯克** | **1977 年**
MURMANSK, RUSSIA

在俄羅斯北極圈以北的莫曼斯克，兒童聚集在紫外燈周圍以避免漫長冬季所可能引發的維生素 D 缺乏症。

狄恩 · 孔傑於 1959 年加入國家地理學會擔任攝影師，深入當時的蘇聯超過 30 次，替《國家地理》雜誌、也為國家地理學會的《走過俄羅斯》一書拍攝照片。此番努力為他贏得美國海外記者俱樂部的卓越獎，以及密蘇里大學、美國國家攝影記者協會和尼康共同頒發的理解世界獎。

Children gather around an ultra-violet lamp to stave off vitamin D deficiency during a long winter in Murmansk, above Russia's Arctic Circle.

Dean Conger joined the National Geographic Society as a staff photographer in 1959. He made more than 30 trips to what was then the Soviet Union, photographing for *National Geographic* magazine and for the National Geographic book *Journey Across Russia*. That effort won him a citation of excellence from the Overseas Press Club and the World Understanding Award from the University of Missouri in partnership with the National Press Photographers Association (NPPA) and Nikon. □

攝影／威廉 · 阿拉德
Photography/ William A. Allard

▲ **祕魯** | **1982 年**
PERU

一輛計程車在視線不佳的急轉彎處撞死了六頭綿羊，讓小牧童難過得哭了起來。對自給自足的農家來說，這是很大的打擊。照片刊出後，各地讀者慷慨解囊，共捐出約 7000 美元，不但彌補了他們的損失，也令攝影師阿拉德甚感欣慰：「我的照片在某個人的生命中帶來了真實改變。」

威廉 · 阿拉德是專拍人物的攝影師。在他那一代的攝影師當中，他也是少數幾位所有作品都是彩色相片的攝影師。自 1964 年起，他為《國家地理》雜誌拍攝過大約 40 篇報導，作品也出現在不少由學會出版的圖書中。

A young shepherd's grief overwhelms him moments after a taxi rounded a blind curve and killed six of his sheep—which represented his family's economy. Readers donated some 7,000 dollars to help replace the sheep after the picture was published. "Here was a situation in which a picture I made made an actual difference in someone's life," says Allard.

William Allard is a photographer of people, and one of the few photographers of his generation whose entire professional body of work is in color. He has contributed as a photographer to some 40 *National Geographic* magazine articles, as well as to a number of National Geographic books since 1964. □

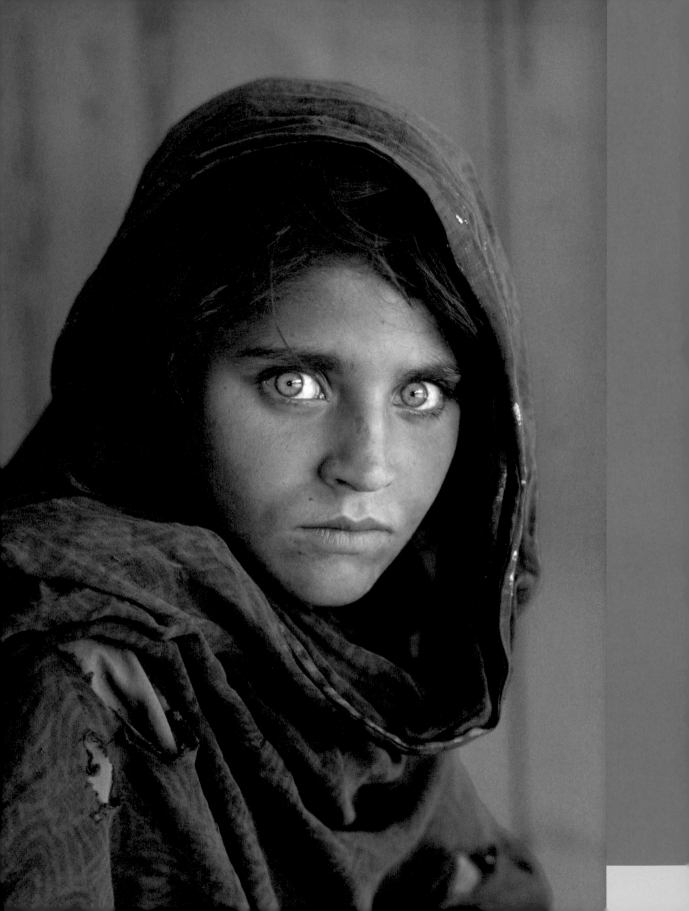

阿富汗
AFGHANISTAN | 1984 年

史提夫 ‧ 麥凱瑞拍攝的這張震撼人心的影像在 1985 年 6 月登上雜誌封面。少女海綠色的雙眸充滿惶恐，將戰地的悲愴表露無遺。

能欣賞這張照片要感謝當時的總編輯比爾 ‧ 加瑞特的慧眼獨具：是他把這張彩色幻燈片從一堆被淘汰的照片裡撿回來，使它成為雜誌有史以來最出名的封面照片。

國家地理學會的人都稱她「阿富汗少女」。17 年間，沒有人知道她的名字，直到 2002 年，麥凱瑞重返阿富汗，在各方探詢之後終於找到她──莎爾巴特 ‧ 古拉，是普什圖人，當時還是小女孩的她如今已經有三個女兒。

This stunning photo by Steve McCurry was the cover of *National Geographic*'s June 1985 issue. The girl's sea-green eyes told the world her plight in the war. Editor Bill Garrett had a fabulous eye: It was he who plucked this Kodachrome frame from a pile of rejects and made it the most famous cover image in the magazine's history.

She became known around *National Geographic* as the "Afghan girl," and for 17 years no one knew her name—until Steve McCurry returned to Afghanistan in 2002 and found her. Her name is Sharbat Gula, and she is Pashtun; just a girl in 1984, she was the mother of three daughters in 2002. □

攝影／史提夫 ‧ 麥凱瑞
Photograph/ Steve McCurry

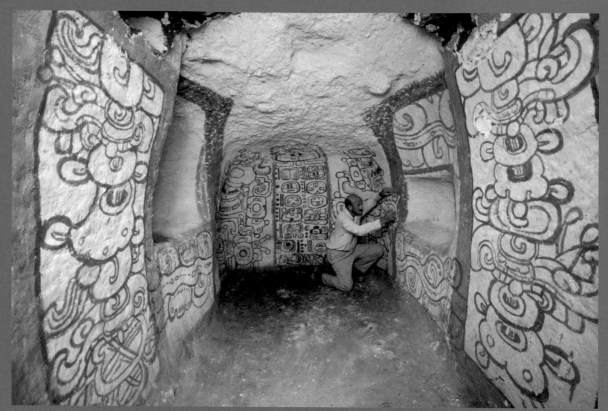

攝影／喬治 · 莫布里
Photography/ George F. Mobley

▲ 瓜地馬拉
GUATEMALA | 1984 年

考古學家迪克 · 亞當斯在藍河遺址一號墓檢視複雜的壁畫。他在瓜地馬拉北部的藍河馬雅遺址發現了這座沒被偷盜過的墓葬。周圍的叢林早已完全將藍河遺址吞噬，因此直到 1962 年才被發現。而這只是受到學會贊助的新世界考古學者驚人的發現之一。尋找未受破壞的古墓，也成了受學會贊助的考古學家最重要的目標。
拍攝這張照片的攝影師喬治 · 莫布里，擔任《國家地理》雜誌攝影師 33 年來拍過許多主題，包括甘迺迪時期的白宮和智利阿連德政府的瓦解。

Archaeologist Dick Adams examines the complex wall murals found in the unlooted Tomb One at Rio Azul, in northern Guatemala. The surrounding jungle had engulfed the Mayan site so completely that it wasn't discovered until 1962. It was only one of many spectacular finds being made by Society-supported New World archaeologists. Finding unlooted tombs became a paramount objective for Society-sponsored archaeologists.
For 33 years George Mobley was a staff photographer for *National Geographic* magazine. His assignments ranged from covering the White House during the Kennedy years to documenting the collapse of the Allende government in Chile. □

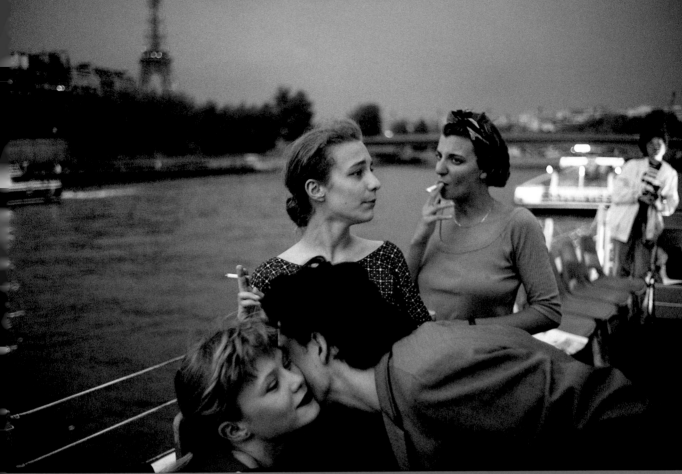

攝影／大衛 • 亞倫 • 哈維
Photography/ David Alan Harvey

▲ **法國，巴黎**
PARIS, FRANCE | **1989 年**

學生艾力克 • 熱内斯特和茱莉 • 包德在慶祝學業結束的塞納河遊船上互吻臉頰。大衛 • 亞倫 • 哈維在進行法國青少年的攝影報導時拍下了這張照片：「這張照片最能代表他們的文化，因為畢業典禮才剛結束，背景還看得到河水與巴黎鐵塔。」
這張照片對他個人也有特殊意義，因為「拍攝地點非常接近法國攝影師布列松的故居。」初學攝影時，哈維曾經想仿效布列松的街頭攝影，但最終他遠離了這種風格，也從黑白轉向彩色攝影。「布列松想要隱身鏡頭後，但我不想，」哈維說。「我想融入、成為拍攝群體的一員，我認為我在法國拍攝的照片做到了這一點。」

Students Eric Geneste and Julie Bhaud exchange les bises on a Seine River cruise celebrating the end of school. "This picture is the most representative of the culture because it's just after graduation, and you have the water and the Eiffel Tower in the background," says Harvey, who took this picture for a story about French teenagers.
The picture also carried a special meaning for him personally, because "it's taken very near where the famous French photographer Henri Cartier-Bresson lived." He had wanted to emulate the street photography of Cartier-Bresson when he first started, but eventually moved away from that and also away from black-and-white toward color photography. "Cartier-Bresson wanted to be invisible, but I don't," he says. "I want to be an integrated member of the group, and I think I achieved that with the photos in France."□

▶ **法國，巴黎**
PARIS, FRANCE │ **1989 年**

詹姆斯·斯坦菲爾德以這張女孩在羅浮宮玻璃金字塔前跳起來、腳跟相碰的複雜構圖，捕捉了法國兩百年國慶舉國歡欣昂揚的風采。

有些國家地理攝影師將紀實攝影帶往了藝術創作的方向，斯坦菲爾德就是其中之一，專以壯闊的歷史為題。斯坦菲爾德以記錄世界的不同角落、事件與文化為使命，報導過的主題包括伊朗國王的加冕、前哥倫布時期的印第安墓葬被盜掘掠奪黃金、巧克力的力量與誘惑以及英國溫莎堡內的貴族生活等等。

Photographer James Stanfield nailed France's celebration of its bicentennial with this complex shot of a girl kicking up her heels before the glass pyramids of the Louvre. Some of the *National Geographic* photographers were taking documentary realism in artistic directions. Tackling sweeping historical epics, Jim Stanfield was one of those photographers. Stanfield's mission has been to document the world's places, events, and cultures. He has covered subjects including the coronation of Iran's shah, the robbing of pre-Columbian Indian gravesites in search of gold, the power and allure of chocolate, and royal life in England's Windsor Castle. □

攝影／詹姆斯·斯坦菲爾德
Photography/ James Stanfield

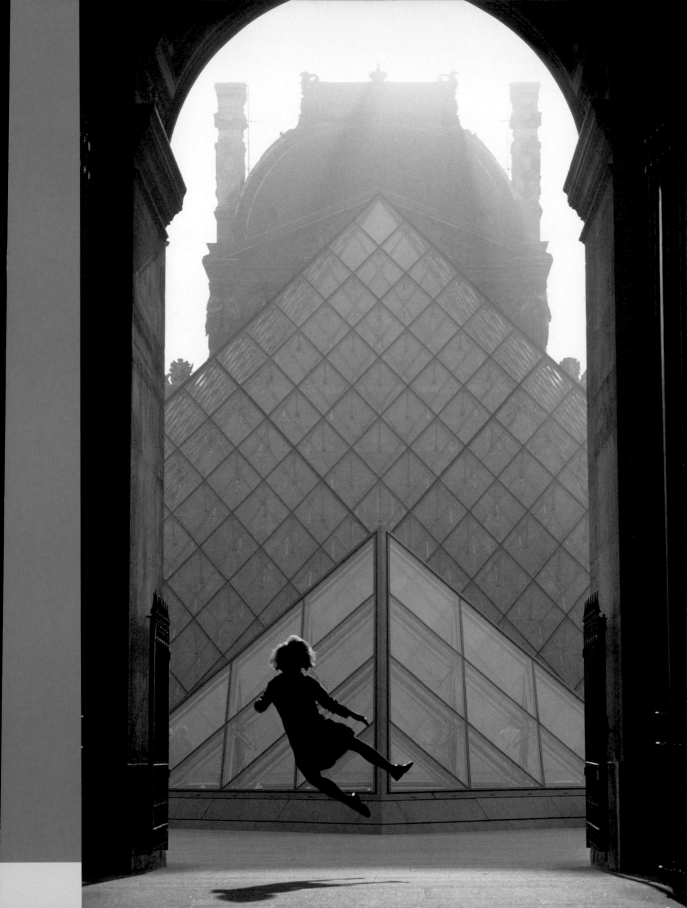

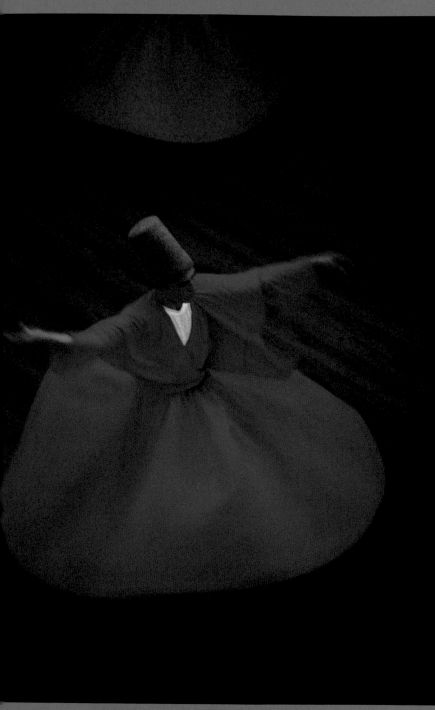

攝影／雷薩
Photography/ REZA

在伊斯坦堡的梅夫拉納苦行僧學校，
蘇非派的神祕主義者隨著誦經的節奏
迴旋起舞，雙手呼求著天與地。
雷薩是定居巴黎的伊朗裔攝影師，他
的人脈關係成為敲門磚，讓他得以在
中東各地進行採訪。是他說服了格達
費上校，才讓《國家地理》雜誌獲得
前所未有的機會，進入利比亞採訪一
篇刊登於 2000 年雜誌中的報導。
2000 年末，雷薩與作家塞巴斯蒂
安 · 榮格爾前往阿富汗採訪傳奇性
的阿富汗反抗軍領導人「潘傑希爾之
獅」，艾哈邁德 · 沙阿 · 馬蘇德，
兩人也是採訪馬蘇德的最後幾位西方
記者之一。

Hands entreating sky and earth,
a Sufi mystic whirls to the rhythm
of divine incantations at Istanbul's
dervish school of Mevlana.
Reza, a Paris-based, Iranian-born
photographer whose connections
have opened doors all over the
Middle East, persuaded Colonel
Qaddafi to grant the Geographic
unprecedented access to Libya for a
2000 story.
On assignment in late 2000, Reza
and writer Sebastian Junger were
among the last Western journalists
to interview legendary Afghan
resistance leader "Lion of Panjshir",
Ahmad shah Massoud. □

澳洲的牧場主人約翰 · 弗萊瑟和他的
孫女阿曼妲在他占地 2430 平方公里的
牧牛場上思考著人生。

山姆 · 亞柏 40 年的攝影生涯都致力
於紀實攝影，並與《國家地理》雜誌的
其他一些攝影師共同將紀錄寫實主義帶
往了藝術的方向，他鏡頭下的紐芬蘭就
融入了一種內在自省式的美感。

亞柏從 1970 年開始與國家地理學會合
作，拍攝過各種文化與荒野相關主題，
照片出現在 20 多篇文章中。他也在世
界各地傳授攝影知識並舉辦攝影展。

Australian rancher John Fraser
and his granddaughter, Amanda,
contemplate life on his 600,000-
acre cattle station in Queensland.
Sam Abell has dedicated his 40-year
career to documentary photography,
and was among *National Geographic*
photographers who took documentary
realism in artistic directions, infusing
Newfoundland with a contemplative
beauty.

Abell has worked with the National
Geographic Society since 1970
and has photographed more than
20 articles on various cultural and
wilderness subjects. He has also
lectured on photography and exhibited
his images to audiences throughout
the world. □

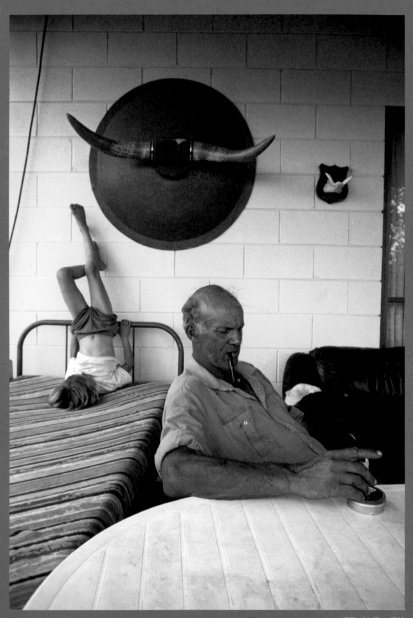

攝影／山姆 · 亞柏
Photography/ Sam Abell

▲ 澳洲，昆士蘭
QUEENSLAND, AUSTRALIA | 1996 年

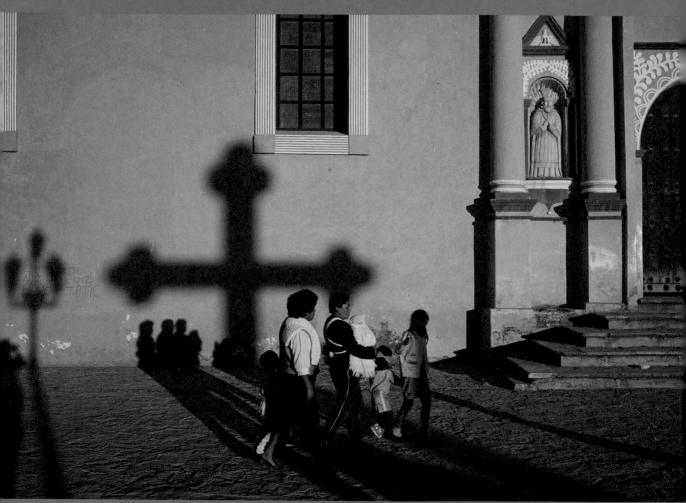

攝影／托馬薛 ‧ 托馬薛夫斯基
Photography/ Tomasz Tomaszewski

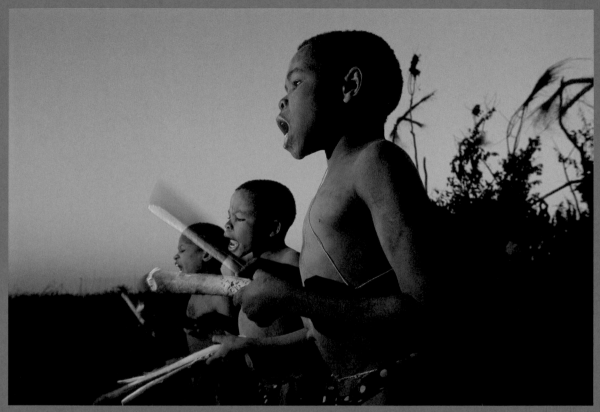

攝影／克里斯 · 強斯
Photography/ Chris Johns

◀ **墨西哥，嘉帕斯州**　│　**1996 年**
CHIAPAS, MEXICO

在嘉帕斯州的聖克里斯托巴德拉斯卡薩斯，一個墨西哥家庭從十字架的陰影下走過，前往天主教堂做禮拜。自由攝影師托馬薛 · 托馬薛夫斯基 1953 年生於共產統治下的波蘭華沙，攝影生涯之初主要為當地雜誌拍攝照片，同時也與《團結工聯週報》及地下媒體合作。他的作品後來登上許多國際出版品。

Shadowed by a cross, a Mexican family makes its way to worship at a Catholic church in San Cristóbal de las Casas, Chiapas.
Tomasz Tomaszewski, a freelance photographer, was born in Warsaw, Poland, in 1953. He started his photographic career with Polish magazines and worked with *Solidarity Weekly* as well as the underground press. His pictures have also appeared in international publications. ☐

▲ **尚比亞，盧庫盧**　│　**1996 年**
LUKULU, ZAMBIA

三比西河上游盧庫盧村的盧瓦勒族男孩，以傳統歌曲和鼓聲迎接黎明到來。拍下這張照片的克里斯 · 強斯於 2005 年成為《國家地理》雜誌總編輯。強斯在最初展開記者生涯的時候是攝影師，在曾經拍攝的 20 篇報導中，有八篇成為封面故事。
克里斯 · 強斯的代表作品，是他拍攝的非洲與當地野生動物的影像。他曾帶領讀者深入三比西河，探討布希曼人為保存文化傳統的掙扎，也為非洲瀕危的野生動物提供了重要的記錄。

Boys of the Luvale tribe greet the dawn with traditional songs and drumming in the village of Lukulu on the upper Zambezi River. The photographer, Chris Johns, became Editor in Chief of the magazine in 2005. Johns had begun his own journalism career as a photographer, having shot 8 cover stories out of his 20 assignments.
Chris Johns' defining images are of Africa and its wildlife. He has taken readers down the Zambezi River, examined the Bushmen's ongoing struggle for cultural survival, and provided important documentation of Africa's endangered wildlife. ☐

攝影／安妮 · 葛瑞菲斯
Photography/ Annie Griffiths

在耶路撒冷，下了勤務的以色列士兵和兩位正統派猶太教徒一起使用公共電話。戰爭與和平、現代與傳統，在這幅景象中鮮活並呈。

安妮 · 葛瑞菲斯是最早為國家地理拍攝的女性攝影師之一，在她傑出的專業生涯中，她曾在超過 100 個國家進行拍攝任務，為國家地理學會完成數十個雜誌與書籍拍攝計畫，主題涵蓋阿拉伯的羅倫斯、約旦古城佩特拉、雪梨、紐西蘭、和耶路撒冷等。

行遍世界的葛瑞菲斯，即使當了媽媽也沒有放慢腳步。她帶著兩個女兒在身邊，繼續執行遠方的任務，並於 2008 年出版了回憶錄《一臺相機、兩個孩子和一隻駱駝》。

An off-duty Israeli soldier shares the phone with two Orthodox Jews in Jerusalem.

One of the first women photographers to work for *National Geographic*, Griffiths has photographed in more than a hundred countries during her illustrious career. She has worked on dozens of magazine and book projects for the National Geographic Society, including stories on Lawrence of Arabia, Petra, Sydney, New Zealand, and Jerusalem.

Even the births of her two children didn't slow her down. She simply carried both kids and career on her far-flung assignments, and in 2008 published *A Camera, Two Kids and a Camel*, a memoir about creating a meaningful life. □

攝影／喬安娜 · 皮尼歐
Photography/ Joanna Pinneo

▲ **馬利** | **1997 年**
MALI

一家人在午後小睡,身上覆了一層從乾枯湖床吹來的沙子。
皮尼歐是國際知名的攝影記者,投身新聞攝影已經超過 20 年,曾在全球超過 65 個國家工作過。她為《國家地理》雜誌拍攝過很多主題,第一篇是刊登在 1992 年六月號的〈誰是巴勒斯坦人?〉,之後她報導的主題包括了移民、索諾蘭沙漠、氣候變遷……等。這張圖阿雷格族家庭在沙中小睡的照片攝於西非,刊登在《國家地理女性攝影師》一書的封面。

Covered by a blanket of sand from a dry lake bed, a family naps in the middle of the afternoon.
A photojournalist for more than 20 years, Joanna Pinneo enjoys an international reputation and has worked in more than 65 countries. She has photographed many subjects for *National Geographic* magazine, beginning with "Who Are the Palestinians?" in June 1992 and going on to include immigration, the Sonoran Desert, climate change, and many others. Her photograph of this Tuareg family, napping in the sands of West Africa, graces the cover of the book *Women Photographers at National Geographic*. □

攝影／史提夫 ‧ 麥凱瑞
Photography/ Steve McCurry

◀ **斯里蘭卡**
SRI LANKA │ **1995 年**

三名身著傳統服裝的斯里蘭卡漁夫蹲踞在木樁上釣魚，和諧一致的動作如同蒼鷺般優雅。

自由攝影師史提夫 · 麥凱瑞替《國家地理》雜誌拍照的前 15 年，作品總帶有旅印英國作家吉卜林的感覺：橫跨印度的鐵路旅行、吹拂孟買或緬甸的季風、造訪開伯爾山口附近的丘陵地部落、以及假扮成普什圖人冒險穿過戰火不斷的阿富汗前線。雖然麥凱瑞也曾經拍下飽受戰爭蹂躪的貝魯特與巴格達，甚至好萊塢的日落大道，不過他最著名的照片仍是在巴基斯坦難民營拍下的「阿富汗少女」。

With the grace of synchronized herons, three Sri Lankans clad in traditional saram fish the ocean from wooden perches off the island's southern coast.

There's a Rudyard Kipling feel to many of the assignments freelance photographer Steve McCurry shot for the magazine in the first 15 years of his *Geographic* work: railroad journeys across India, monsoons sweeping over Bombay or Burma, visits to hill tribes near the Khyber Pass, and sorties, disguised in Pashtun garb, across the troubled Afghan frontier. Though McCurry also photographed war-ravaged Beirut and Baghdad—and even Hollywood's Sunset Boulevard—he made his most famous picture in Pakistan: the Afghan Girl. □

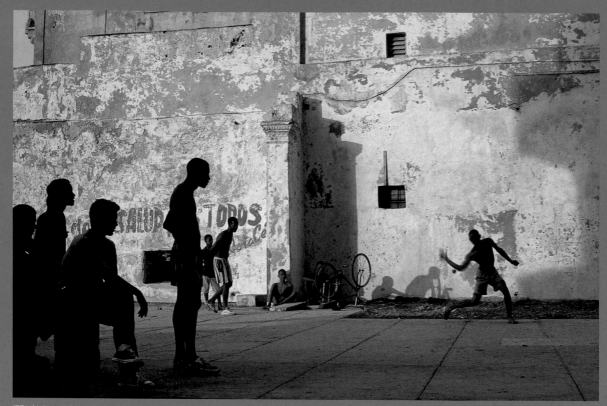

攝影／大衛・亞倫・哈維
Photography/ David Alan Harvey

▲ 古巴，哈瓦那 | 1998 年
HAVANA, CUBA

哈瓦那青年在街頭打棒球。

他們稱之為棒球，但打擊手是以手擊球，隊友則蓄勢待發準備衝向一壘──這也是這個「棒球場」上唯一的壘
包。攝影師大衛・亞倫・哈維說：「從某方面而言，與其說這是棒球，還比較像英國的板球。」但古巴人確
實熱愛棒球，這些少年也為島國最受歡迎的美國進口品加上了地方特色。

哈維於 1996 年首度造訪古巴時，就遇上古巴軍方擊下「自由古巴」的飛機，並爆發反美示威。這非但沒有影
響他的心情，他反而因為在街頭看到的充沛活力而開啓了對古巴長期的熱愛。之後他又數度造訪，並出版了古
巴攝影專書。

Young men play baseball in Havana.

They call it baseball, but the batter hits the ball with his hand, and a teammate is poised for a mad dash to
first base—which also happens to be the only base on this "field." "In some ways," says photographer David
Alan Harvey, "it's more like the British game of cricket than baseball." But it is baseball that is Cuba's sports
passion. And these youngsters have put a decidedly local twist on Cuba's most beloved American import.

Harvey first visited Cuba in 1996. He had no sooner arrived than the Cuban military shot down planes piloted
by Free Cuba aviators, and anti-American riots broke out. Instead of dampening his spirits, the energy in
the streets fed the beginning of a love affair with Cuba. Harvey has since made several trips to Cuba and
produced a book on the subject. □

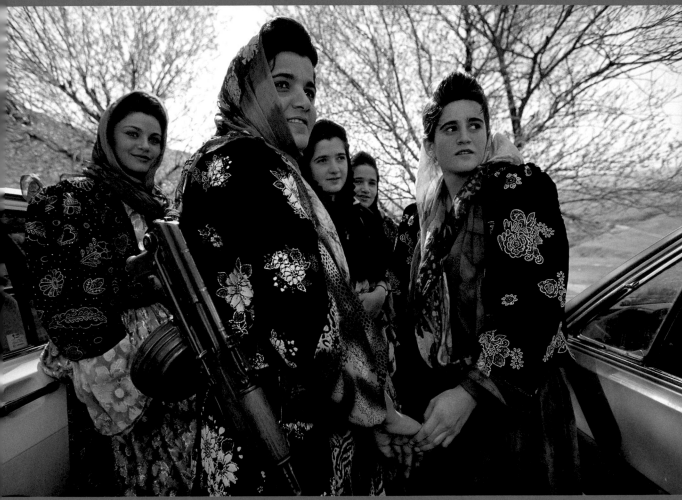

攝影／麥可 · 山下
Photography/ Michael Yamashita

▲ **伊拉克，賈迪恩**
JUNDIAN, IRAQ | **1999 年**

雖然是開心的場合，但對伊拉克賈迪恩這些婚禮賓客來說，戰爭永不可能真正結束。

這張照片是麥可 · 山下在亞洲進行馬可波羅東遊的報導時所拍攝。由於攝影主題與政治無關，麥可在伊拉克境內幾乎得以自由前往任何地方。他在伊拉克拍攝的照片後來刊登於雜誌以該國為主題的報導中，「那是第一次與第二次波灣戰爭之間，唯一以伊拉克為主題的大篇章，」他回憶。

麥可 · 山下是亞洲專家，拍攝過的主題包括越南、湄公河、馬可波羅東遊記、萬里長城、南北韓之間的非武裝地區等。

Despite the happy occasion, war is never over for these wedding guests in Jundian, Iraq.

The photo was taken when Mike Yamashita was on assignment in Asia for his coverage of Marco Polo's epic journey. He was allowed practically free access in the country due to the non-political angle of the story. "It was the only big story shot on Iraq between the First Gulf War and the Second Gulf War," he recalls.

Specializing in Asia, Yamashita has covered Vietnam, the Mekong River, Marco Polo's journey to China, the Great Wall, and the DMZ between North and South Korea. □

攝影／麥可‧山下
Photography/ Michael Yamashita

為了重現馬可波羅東遊的足跡，麥可·
山下來到敦煌著名的鳴沙山前，卻發現有
成百上千遊客和駱駝聚集，擴音喇叭不絕
於耳。他驅車往東移動到沙丘背面，看到
這幅景象，利用背光和曝光不足的效果，
讓六名騎乘者的身影恰好遮住駱駝身上的
號碼，拍下這幅彷彿是馬可波羅的駱駝隊
穿越塔克拉瑪干沙漠的畫面。

麥可·山下擔任《國家地理》雜誌攝影
師超過 30 年。他以重溯著名旅行家的足
跡著稱，曾拍攝過的主題包括馬可·波
羅、鄭和與日本俳句大師松尾芭蕉。

Retracing Marco Polo's travels in the
East, Michael Yamashita arrived at
the famous sand dune, only to find
thousands of tourists and hundreds of
camels and the blare of loudspeakers.
He drove east to the back of the dune
and suddenly saw this image in his
mind's eyes. Looking toward the setting
sun, he back lit the camels and under
exposed slightly, making the 6 riders a
silhouette to hide the numbers on the
camel's sides, creating an image that
recalls Marco Polo's caravan crossing
the Taklimakan Desert.

Michael Yamashita has been shooting
for the *National Geographic* magazine
for over 30 years. His particular specialty
is in retracing the paths of famous
travelers, resulting in stories on Marco
Polo, the Chinese explorer Zheng He,
and the Japanese poet Basho. ☐

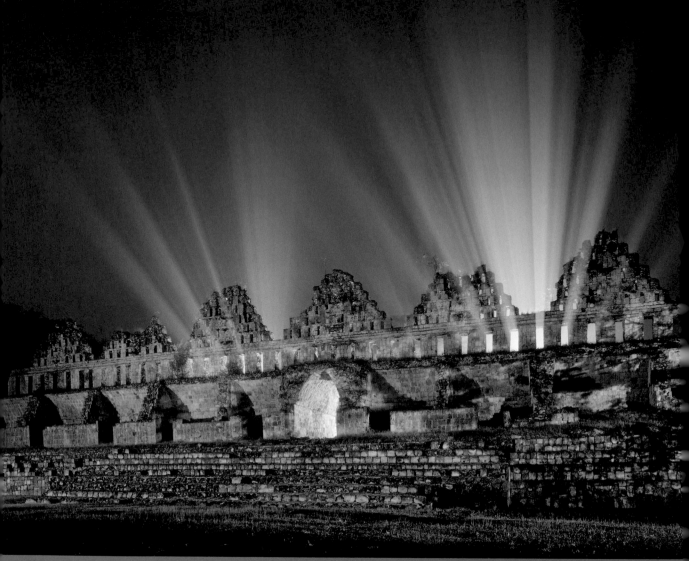

攝影／西蒙 · 諾福克
Photography/ Simon Norfolk

墨西哥，猶加敦半島 | 2007 年
YUCATAN, MEXICO

傾頹的馬雅金字塔和城市遺址因為太常被拍攝而成了平庸無奇的旅遊海報景點。因此，西蒙 · 諾福克決定採用新的拍攝手法——在夜間攝影，並以幾乎像為電影場景打光的方式來照明。這意味著他必須把設備拖運到偏遠的地方，並希望現場有電源供應這些燈光所需。
諾福克肯定受到了馬雅諸神的眷顧：他非但用底片（而非數位感光元件）捕捉到這些建築傑作的豐富細節，幾個拍攝地點若隱若現的薄霧，更為影像增加了景深與氣氛。諾福克的作品都是精心策畫的結果，因此「拍的時候我其實就知道拍出來會是什麼樣子。」

The crumbled pyramids and ruined cities of the Maya have been photographed so often that they have become the humdrum fare of travel posters. So Simon Norfolk opted for a new approach—shooting ruins in the dark and lighting them almost like a movie set. That meant hauling equipment into remote sites and hoping that power would be available for the lights. The Maya gods must have smiled on Norfolk: Not only did he capture the rich detail of these masterpieces on film—not on a digital sensor—but a light fog at a few locations added depth and mood to the images. Norfolk plans his shots so meticulously that "I had a good sense of what the pictures looked like when I took them."□

以色列耶路撒冷舊城區的亞美尼亞天主教教堂中，這對老少二人組攜手合作，在復活節彌撒上生動地演出一曲管風琴二重奏。

艾德・卡什致力於記錄我們這個時代的重大社會與政治議題。他曾說：「我投入的攝影主題，必須能激起我對人性與世界現狀的熱情，而我也深信靜態影像具有改變人心的力量。」

伊拉克戰爭期間，卡什不畏危險前往伊拉克的庫德斯坦（庫德族人生活地區），他第一次前往是在 1990 年首度為《國家地理》雜誌攝影，主題就是沒有國家的民族——庫德族人的困境。

An intergenerational duet brings alive a piece of organ music played at Easter Mass in the Armenian Catholic Church of Jerusalem's Old City, Israel.

Ed Kashi is dedicated to documenting the social and political issues that define our times. "I take on issues that stir my passions about the state of humanity and our world, and I deeply believe in the power of still images to change people's minds," he says.

During the Iraq war, Ed Kashi revisited Iraqi Kurdistan, the subject of his first Geographic coverage in 1990. □

攝影／艾德・卡什
Photography/ Ed Kashi

▲ 以色列，耶路撒冷
JERUSALEM, ISRAEL │ 2008 年

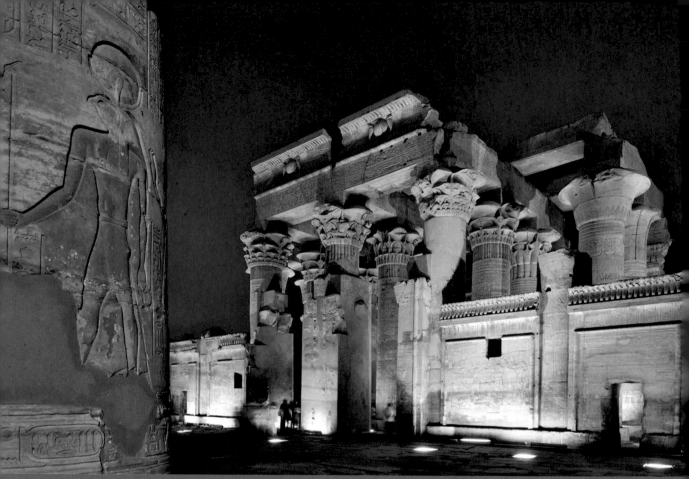

攝影／肯尼斯 • 加瑞特；國家地理圖片
Photography/ Kenneth Garrett; National Geographic Stock

▲ **埃及，考姆翁布神殿** | 2009 年
KOM OMBO, EGYPT

埃及考姆翁布有一座極為罕見的雙神廟，頂端有著蓮花雕飾的神廟石柱，矗立在遊客面前。這座神廟的祀奉對象為索貝克（鱷魚神）和荷魯斯（隼神）。

肯尼斯 • 加瑞特擅長捕捉世界各地的考古學、古生物學和古文明主題相關影像，曾經拍攝的主題包括馬雅神祇、冰人、埃及金字塔、佛羅勒斯人、圖坦卡門王等等，以及一系列關於人類起源的報導。

Columns topped with carved lotus flowers tower above visitors to the unusual double temple of Kom Ombo in Egypt. It honored both Sobek (the crocodile god) and Horus (the falcon god). Specializing in archaeology, paleontology, and ancient cultures worldwide, Garrett's other articles include "La Ruta Maya," "The Iceman," "Death on the Nile: Saqqara," "Lost World of the Little People: The People Time Forgot," "The New Face of King Tut: His Life and Death," and a series on the dawn of humans. □

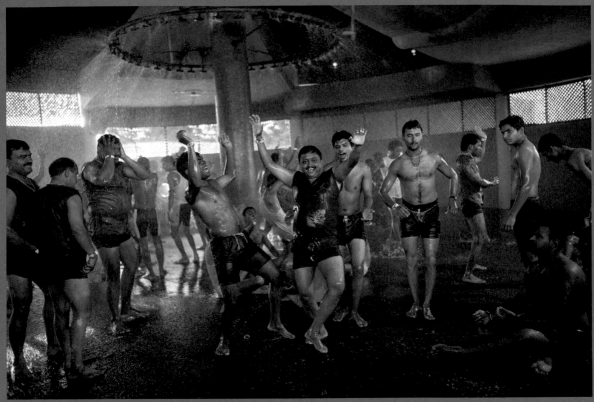

攝影／琳賽 · 阿達里奧
Photography/ Lynsey Addario

▲ 印度，舍爾第 | 2009 年
SHIRDI, INDIA

遊客在舍爾第附近的「溼樂園」裡陶醉於戲水樂趣的畫面，
被琳賽 · 阿達里奧的鏡頭捕捉下來，搭配一篇以水為題
的報導。阿達里奧在替其他出版品執行任務時曾兩次遭到
綁架，幸好在她為《國家地理》雜誌拍攝另一篇文章〈面
紗下的抗爭：阿富汗婦女〉的時候，平安無事地完成了任
務，她也因為該則報導獲得了海外記者俱樂部頒獎肯定。

Guests at the Wet 'N' Joy theme park near Shirdi revel in
a good soaking, as caught by the lens of Lynsey Addario
for an article on water.
Lynsey Addario, who has been kidnapped twice on
assignment for other publications, fortunately covered
another article for *National Geographic*, "Veiled Rebellion:
Afghan Women", without incident and went on to win an
Overseas Press Club award for the story. □

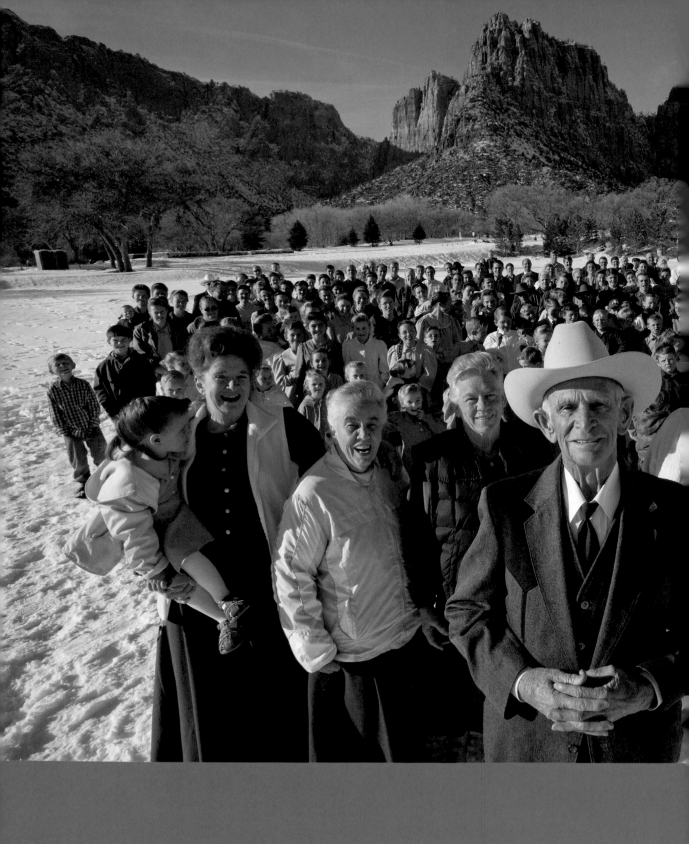

攝影／史蒂芬妮 · 辛克萊
Photography/ Stephanie Sinclair

◀ **美國，猶他州，希爾戴爾** | 2010 年
HILDALE, UTAH, US

88 歲的喬 · 傑索普是基本教義派的耶穌基督後期聖徒教會（FLDS）長老，這是個備受爭議的教派，在摩門教禁止一夫多妻制之後分離出來。在猶他州的希爾戴爾，傑索普一直努力履行建立「天之家庭」的責任，有 5 個太太、46 個子女，以及 239 個孫子女。

史蒂芬妮 · 辛克萊在 2010 年替《國家地理》雜誌製作了〈一夫多妻〉的專題報導，以及 2011 年的少女新娘專題，是過去幾年間加入雜誌團隊的年輕新血。

At 88, Joe Jessop is an elder of the Fundamentalist Church of Jesus Christ of Latter-Day Saints (FLDS), the controversial sect that split from the Mormon Church after it banned plural marriage. In Hildale, Utah, he has tried to fulfill his duty to build up his "celestial family"—5 wives, 46 children and 239 grandchildren.

In the past few years, a younger generation has placed their imprimatur on the Magazine. One of them is Stephanie Sinclair, who published her "Polygamists" story in 2010, followed by her 2011 story on child brides. □

攝影／琪卓 · 卡哈納
Photography/ Kitra Cahana

▲ **美國，德州，奧斯丁** | **1996 年**
AUSTIN, TEXAS, US

這張照片出現在《國家地理》雜誌一篇關於青少年心智的報導中，比肩接踵的潮流青年身上撒滿螢光顏料、沉浸在一片黑光之中。「如果你不跳舞，那就只是全身淋滿顏料站在那兒。」照片中的青年奧斯汀 · 布朗說。琪卓 · 卡哈納是紀實與藝術攝影師，也是《國家地理》雜誌最年輕的攝影師之一，作品專門探討重要的社會、人類學與心靈主題。

Wall-to-wall hipsters doused in Day-Glo paint and bathed in black light color the magazine's coverage of the downtown scene in Austin, Texas. "If you weren't dancing, you were just standing there covered in paint," Austin Brown (center) said.
One of the youngest photographers of *National Geographic* Magazine, Kitra Cahana is a documentary and fine art photographer whose work explores important social, anthropological, and spiritual stories. □

攝影／茉蒂 · 科布
Photography/ Jodi Cobb

▲ **英國，倫敦，諾丁丘**
NOTTING HILL, LONDON, UK | 2011 年

諾丁丘街頭，華麗的服裝彷彿一條盤旋飛舞的藍色隧道，在隧道中心的，就是穿著它的遊行者。

諾丁丘是倫敦著名的優雅住宅區，附近有熱鬧的波多貝羅市集，也是電影「新娘百分百」的拍攝地點。諾丁丘嘉年華是歐洲最大的街頭嘉年華，起源於 1964 年，居住在英國的非裔加勒比海移民藉此歡慶他們的文化與傳統，而其最早的發源可回溯至 19 世紀早期、加勒比海國家為了慶祝廢除奴隸制度與買賣的嘉年華。

An elaborate costume formed a swirling tunnel of blue, with the occupant at its core during a parade at Notting Hill.

Notting Hill is an elegant residential area in London. Nearby is the famous Portobello Market; the movie *Notting Hill* was also filmed on location here. The Notting Hill Carnival is the largest street festival in Europe, originating in 1964 as a way for African-Caribbean communities to celebrate their own cultures and traditions. At the roots of the Notting Hill Carnival are the Caribbean carnivals of the early 19th century, which were all about celebrating the abolition of slavery and the slave trade. □

走進科學
Science of the Times

如何跟上科技發展的腳步，走在時代尖端？
《國家地理》雜誌攝影師和編輯一直都在面對這個
問題，無論是報導亞歷山大 · 葛拉漢 · 貝爾在
1900 年代早期進行的四面體風箏實驗，在 1983 年
探討讓人驚奇的電腦晶片，或是在 2010 年解釋什
麼是奈米科技。基本的問題在於，科技日新月異，
更替極為迅速：在 20 世紀早期看來充滿希望與未
來主義觀感的照片，現在早已褪去光環，成了純粹
懷舊的圖像。因此，以投射出希望為目的的照片，
例如展現賽璐珞或火箭動力彈射座椅之奧妙的雜誌
照片，逐漸 —— 也必然 —— 讓位給了一種更寫實、
更具新聞性的手法。然而，整體看來，學會在科技
領域的出版成績，代表著學會對於記錄「這個世界
和其中的一切」這項使命的最純粹表達。在接下來
的另一個 125 年中，國家地理學會將繼續報導科學
家為了解世界，並嘗試讓世界更加美好，而做出的
不懈追求。

How do you stay perched on the cutting edge
of tomorrow? *National Geographic* photographers
and editors have wrestled with that question
through all our yesterdays, whether they were
covering Alexander Graham Bell's experiments
with tetrahedral kites in the early 1900s, exploring
the amazing computer chip in 1983, or explaining
nanotechnology in 2010. The basic problem is that
technology dates quickly: Certain photos from the
early 20th century have a hopeful, futuristic feel
that has since faded to sheer nostalgia. Magazine
images of the wonders of celluloid or rocket-
powered ejection seats, for example, projected a
hopeful quality that gradually—and necessarily—
ceded ground to a more realistic, journalistic
approach. Viewed collectively, however, the
Society's publishing record in the fields of science
and technology represents the purest expression
of its avowed mission to document the "world
and all that is in it." For the next 125 years, it is
hoped, *National Geographic* will continue to report
on scientists' ceaseless quest to understand that
world—and, perhaps, to reshape it for the better.

攝影／賀伯特 · 龐汀
Photography/ Herbert G. Ponting

▲ 南極洲
ANTARCTICA | **1911 年**

愛德華 · 阿特金森博士是一位合格護士與寄生蟲學家。他在羅伯特 · 法爾肯 · 史考特上尉遠征南極的隊伍中擔任隨行醫生，並在基地營實驗室裡工作。在 1910 到 1912 年的探險中，史考特與其他四位探險隊員雖然在 1 月 17 日成功抵達南極點，但在返程中因為飢餓、疲憊與極度寒冷而全部喪命。部分的遺體、筆記和相片在八個月後被由阿特金森帶領的搜救隊找到。

攝影師龐汀在探險隊啟程前往南極點後不久登上回程的探險船，準備在返回文明世界後將他拍攝的大量照片整理成遠征隊的故事——當時他還不知道，這段故事將以悲劇收場。

Dr. Edward Atkinson—staff surgeon, registered nurse, and parasitologist—works in his lab during Capt. Robert Falcon Scott's fateful expedition to reach the South Pole from 1910 to 1912. During this venture, Scott led a party of five which reached the South Pole on 17 January 1912. On their return journey, Scott and his four comrades all died from a combination of exhaustion, starvation and extreme cold. Some of the bodies, journals and photographs of the polar team were discovered by a search party eight months later. Ponting, who took this picture, had left the camp for civilization shortly after the polar team set off. He was going to organize the pictures he took to tell the story of the expedition—not knowing that the story would end in tragedy. □

圖片提供／美國國家標準與技術中心
Source/ National Institute of Standards and Technology

▲ **美國，華盛頓特區**
WASHINGTON, D.C., US | **1915 年**

一把熊熊大火，燒掉了美國華盛頓特區標準局認定為不符合標準的測量器具；這張照片出現在一篇以標準局在科學研究方面的努力為題的文章中。

成立於 1901 年的標準局是現在美國國家標準與技術中心的前身，為全美歷史最悠久的物理科學實驗室之一。當年，美國國會成立標準局是為了移除對美國工業競爭力的一大阻礙：二流的度量儀器與設備，讓美國遠遠落後英國、德國與其他競爭對手。今天美國國家標準與技術中心的使命則是透過測量科學、標準與科技的進展，推動創新與工業競爭力。

A bonfire of "short" measures—that is, those found faulty by Washington, D.C.'s Bureau of Standards—blazes high in an article on the bureau's scientific endeavors. The bureau, now known as the National Institute of Standards and Technology (NIST), was founded in 1901 and is one of the oldest physical science laboratories in the US. Congress established the agency to remove a major handicap to U.S. industrial competitiveness at the time—a second-rate measurement infrastructure that lagged behind the capabilities of England, Germany, and other economic rivals. Today, the NIST's official mission is to promote U.S. innovation and industrial competitiveness by advancing measurement science, standards, and technology. □

攝影／威拉德 · 卡爾沃
Photography/ Willard R. Culver

▲ **美國，賓夕凡尼亞州** | **1939 年**
 PENNSYLVANIA, US

梅隆研究院的科學家示範如何用紫外線軟化牛肉，顯示化學也可以用來解決很生活化的問題。紫外線能夠引發化學反應並導致許多物質產生螢光，因此在現代社會中應用非常廣泛，除了醫學用途外，也可用於殺菌、防治蟲害、辨別偽鈔等。

梅隆工業研究院在 1913 年由安德魯 · 梅隆與李察 · 梅隆創設，為私人企業進行特約研究。1967 年，由於企業委託獨立機構進行工業研究的做法逐漸式微，梅隆研究院與卡內基技術學院合併為卡內基梅隆大學。

Demonstrating the power of chemistry to solve a prosaic problem, scientists at the Mellon Institute use ultraviolet rays to tenderize beef. Because of its ability to cause chemical reactions and excite fluorescence in materials, ultraviolet light has a wide range of useful applications in modern society; it can be used in medicine, for disinfection and as optical sensors.

Founded in 1913 by Andrew W. Mellon and Richard B. Mellon, the Mellon Institute of Industrial Research conducted research for firms on a contractual basis. Declining use of independent research institutes for the outsourcing of corporate industrial research led Mellon Institute to merge with the Carnegie Institute of Technology in 1967 to form Carnegie Mellon University. ☐

攝影／安東尼 · 史都華
Photography/ B. Anthony Stewart

▲ **美國，新墨西哥州** | **1940 年**
NEW MEXICO, US

「現代火箭之父」羅伯特 · 戈達德博士被好友查爾斯 · 林白說服，首肯讓《國家地理》雜誌記者進入他位於新墨西哥州羅斯威爾的工作室。圖中，戈達德正在調整火箭的轉向葉片。戈達德是美籍教授、物理學者與發明家，設計建造了世界上第一架液態燃料火箭，並於 1926 年 3 月 16 日成功發射升空。
攝影師安東尼 · 史都華是他那一代最多產的《國家地理》雜誌攝影師，發表過的照片遠遠超過他掛名的 100 篇報導所能涵蓋。

Persuaded by his friend Charles Lindbergh to grant the magazine access, Dr. Robert Goddard—father of the modern rocket—adjusts a steering vane in his Roswell, New Mexico workshop. Goddard, American professor, physicist, and inventor, is credited with creating and building the world's first liquid-fueled rocket, which he successfully launched on March 16, 1926.
B. Anthony Stewart was the most prolific *National Geographic* photographer of his generation, having many more pictures published than accounted for by the mere 100 stories that carried his byline. □

美國，新墨西哥州，洛色拉莫士
LOS ALAMOS, NEW MEXICO, US | 1958 年

新墨西哥州洛色拉莫士國家實驗室中，彷彿觸手一般的高壓電線集中到「捏縮效應」核融合室，以研究氘（亦稱「重氫」）的反應。照片出自《國家地理》雜誌 1958 年〈你與聽話的原子〉一文，報導核能科學及技術的發展現狀。洛色拉莫士國家實驗室隸屬於美國能源署，是全世界最大的科學技術研究中心之一，創設於二次大戰期間，用於發展核子武器，轟炸廣島與長崎的原子彈就是在此研發。目前的研究領域非常多元，包括國家安全、太空探索、可更新能源、醫藥和奈米科技等等。

Tentacles of tension, high-voltage wires converge in a "pinch effect" nuclear fusion chamber used to study the behavior of deuterium in Los Alamos, New Mexico. This image was part of an article—"You and the Obedient Atom"—published by the *National Geographic* in 1958 on the state of nuclear science and technology.

One of the largest science and technology institutions in the world, Los Alamos National Lab is overseen by the United States Department of Energy. The laboratory was founded during World War II to coordinate the scientific research to develop the first nuclear weapons; the atom bombs used in the attacks on Hiroshima and Nagasaki were developed here. Nowadays, the lab conducts multidisciplinary research in fields such as national security, space exploration, renewable energy, medicine and nanotechnology. □

攝影／安東尼 · 史都華
Photography/ B. Anthony Stewart

攝影／羅伯特 · 希森
Photography/ Robert F. Sisson

◄ **美國，亞利桑那州，梅薩** | 1963 年
NEAR MESA, ARIZONA, US

在亞利桑那州梅薩進行的飛機座椅彈射逃生系統測試中，假人和座椅被 2268 公斤的火箭推力射出，衝上 122 公尺高的空中。

科技日新月異。當年未來感十足的照片，現在可能早已褪去光環，成為純粹懷舊的圖像。舊時雜誌中以科學為主題的照片總洋溢著希望，但這種特質逐漸——也必然讓位給了更寫實、更偏向新聞報導的風格。然而，整體看來，學會在科技領域的出版成績，代表著學會對於記錄「這個世界和其中的一切」這項使命的最純粹表達。

Boosted aloft by a 5,000-pound rocket thrust, a dummy pilot and seat soar 400 feet into the air in this test of an airplane's catapult escape system near Mesa, Arizona.

Technology dates quickly: Certain photos from earlier days have a futuristic feel that has since faded to sheer nostalgia. Magazine images of the wonders of science projected a hopeful quality that gradually—and necessarily—ceded ground to a more realistic, journalistic approach. Viewed collectively, however, the Society's publishing record in the fields of science and technology represents the purest expression of its avowed mission to document the "world and all that is in it." □

攝影／喬治・史坦梅茲
Photography/ George Steinmetz

▲ **美國，加利福尼亞州，舊金山**
SAN FRANCISCO, CALIFORNIA, US | **1996 年**

在這個高科技的裝置藝術中，特斯拉線圈（一種能夠讓普通電壓升壓的裝置）發出超過 100 萬伏特的電弧，穿過一棵聖誕樹，然後順著裡面關了一位物理學家的籠子，往下貫入舊金山這間閣樓的地板。

喬治・史坦梅茲最為人所知的就是他的探險與科學照片，他的目標在揭露這個世界上所剩無幾的祕密：偏遠沙漠、隱密文化，還有科學與科技上的最新發展。身為《國家地理》雜誌的熟面孔，史坦梅茲探討過的主題範圍廣泛，從全球原油探勘、機器人研究最新進展，到罕為人知的印尼伊里安查亞的樹屋民族。

More than a million volts arc from a Tesla coil, shoot through a Christmas tree, course down a cage holding a physicist, and bolt into the floor of a San Francisco loft in a high-tech art installation.

Best known for his exploration and science photography, George Steinmetz sets out to reveal the few remaining secrets in our world today: remote deserts, obscure cultures, and new developments in science and technology. A regular contributor to *National Geographic* magazine, Steinmetz has examined subjects ranging from global oil exploration and the latest advances in robotics to the little-known tree house people of Irian Jaya, Indonesia. □

走進科學 SCIENCE OF THE TIMES | 139

攝影／羅伯特 · 克拉克
Photography/ Robert Clark

美國
US | 2008 年

壁虎為什麼不會從牆上掉下來？
這隻壁虎的腳上有數百萬根細微的棘毛，每根又再分岔成數百根奈米棘毛；這些棘毛共同創造出一種微弱的分子鍵，讓壁虎可以牢牢地「黏」在玻璃板上。
壁虎移開腳的速度也同樣驚人。大壁虎只需要約2500 根剛毛（腳趾頭上的毛），就足以緊黏在天花板上。「如果 650 萬根剛毛全都同時黏住的話，」生物學家凱拉 · 奧騰說，「足以支撐 130 公斤。但壁虎卻能在幾毫秒時間裡、以小到無法測量的力道把腳移開。」這個現象，跟壁虎抬腳時剛毛的角度有關（約為 30 度）。

Why geckos don't fall off walls: Millions of microscopic hairs, each split into hundreds of nanohairs, create a faint intermolecular bond that enables this gecko to cling to a pane of glass.
Just as remarkable is how quickly it can let go. A tokay gecko needs only about 2,500 of its setae (toe hairs) to hold its body upside down. "If all 6.5 million setae were attached simultaneously," says biologist Kellar Autumn, "they could support 130 kilograms [287 pounds]. Yet the animals manage to remove their feet in milliseconds without measurable force"—a phenomenon related to the angle of the hairs (about 30 degrees) as the foot lifts off. □

攝影／泰倫 · 特納
Photography/ Tyrone Turner

▲ **美國，紐約，布魯克林**
BROOKLYN, NEW YORK, US | 2009 年

這張美國紐約與布魯克林大橋的熱影像，是《國家地理》雜誌以節能為主題的封面故事照片。紅色與黃色的區域代表高能量輸出。

這篇專文指出，在美國，節能的風氣已經從家庭節約用電逐漸形成，而且就從換一盞燈泡、開一扇窗戶、走路去搭公車或騎腳踏車上郵局開始。

泰倫 · 特納是《國家地理》雜誌特約攝影師，拍攝過的主題包括美國海岸、日益嚴重的颶風威脅、路易斯安那州消失中的溼地、卡崔娜颶風特刊、紐奧良的重建等等。

Red and yellow zones indicate high-energy output in this thermal image of New York and the Brooklyn Bridge, photographed for a *Geographic* cover story on saving energy. The movement for energy efficiency, the story notes, has already started from American homes— with the changing of a lightbulb, the opening of a window, a walk to the bus, or a bike ride to the post office.

As a contributing photographer for *National Geographic* Magazine, Tyrone Turner has produced stories on the coasts of the Unite States, increasing hurricane threats, the disappearing wetlands of Louisiana, a special issue on hurricane Katrina, and the rebuilding of New Orleans. □

美國，威斯康辛州，麥迪遜
MADISON, WISCONSIN, US | **2010 年**

科學專用睡帽：威斯康辛大學麥迪遜分校睡眠與意識研究中心的研究人員，在學生大衛 · 波瑟的頭部接上密密麻麻的電線，以進行關於睡眠不足的研究，增進科學家對生理時鐘的了解。波瑟玩了好幾個小時的電動遊戲之後才上床睡覺。在他睡覺的時候，腦電波網絡會持續監控之前因為電玩刺激而開始活動的特定腦部區域。

Night cap: Student David Poser is wired for a sleep-deprivation study at the Center for Sleep and Consciousness at the University of Wisconsin, Madison to help scientists advance our understanding of circadian rhythms. Poser played video games for several hours before going to bed. During sleep, the EEG net monitors the activity in specific brain regions previously activated by the video games. □

攝影／梅姬 · 史泰柏
Photography/ Maggie Steber

這隻仿生手能以前所未有的準確度模仿有血有肉的人手,透過使用者的神經衝動來控制,並利用 20 個馬達驅動。它的感應器甚至可以記錄觸感。

《國家地理》雜誌在 2010 年 1 月號報導了仿生科技如何能夠改變生命,不僅讓失聰或失明的人重新聽見、看見,也能讓只有一隻手臂的女子還是可以折衣服。科學家持續研究如何將機器與大腦連結起來,使得仿生四肢擁有愈來愈多原本只有人類四肢才具備的能力。

Mimicking a flesh-and-blood limb with unprecedented accuracy, this bionic hand is controlled by a user's nerve impulses and animated by twenty motors; its sensors even register touch. In the January 2010 story titled "A Better Life with Bionics", *National Geographic* reported on how the latest bionics technology is changing lives, helping people regain their hearing and sight, even allowing a one-armed woman to fold her shirts. As scientists work to link machine and mind, bionic limbs are gaining many of the capabilities of human ones.

攝影／馬克 · 希森
Photography/ Mark Thiessen

▲ 美國,維吉尼亞州,非德里堡
FREDERICKBURG, VIRGINIA, US ｜ 2010 年

距離地球 7500 光年的船底座星雲是一個活動劇烈的恆星孕育地。在太空人於 2009 年修復了高齡的哈伯太空望遠鏡之後,第一批傳回的影像中包括這張年輕的恆星在船底座星雲中閃爍的照片。

太空人修復了哈伯太空望遠鏡內的動力與控制系統,讓這個位於地球大氣以外的太空望遠鏡得以延長壽命;不僅如此,更換了新的儀器以後,哈伯太空望遠鏡能把宇宙的黑暗角落看得比以往更清楚,以尋找星系、恆星與行星形成的線索。

In May 2009, astronauts repaired power and control systems to give the Hubble Space Telescope several more years of life riding high above Earth's atmospheric haze.

In one of the first images from the venerable Hubble after astronauts revitalized it, young stars flare in the Carina Nebula, a roiling stellar nursery 7,500 light-years from Earth. With its new instruments, Hubble can see more clearly than ever into dark corners of the universe, searching for clues to how galaxies, stars, and planets formed. □

攝影/美國太空總署;歐洲太空總署;哈伯太空望遠鏡
Photography/ NASA; ESA; Hubble SM4 ERO Team

▲ 外太空
OUTER SPACE | 2010 年

攝影精粹
Simply Beautiful

國家地理之所以能夠成為全球紀實攝影的殿堂，除了因為這些作品所記錄的事件與主題的重要性之外，更是因為這些攝影作品對美學的追求與創新。

像任何一張好照片，國家地理的經典影像是光線、構圖與瞬間三大要素的結晶，然而國家地理的攝影標準，要比任何媒體都高。為了讓這三大要素都齊備，國家地理的攝影師有時經過數年的計畫，帶著上千公斤的器材，進行數千公里的旅程，然後再跋山涉水，耐心等待，在消耗數千卷底片（或裝滿數百張儲存卡），再重複幾次這樣的過程後，才能得到一張足以流傳久遠的畫面。

另一些時候，運氣將完美的畫面送到隨時有以待之的攝影師面前，讓他們能夠信手拈來經典之作。為國家地理工作超過三十年的攝影師麥可‧山下常說：「攝影師的工作包括要有好運氣。」而野生動物攝影大師法蘭斯‧藍汀則更願意用「機緣」(serendipity) 這個詞來取代運氣，「因為你要先準備充分，然後等待那個瞬間的發生。」

There is a reason why the pages of the *National Geographic* magazine have become hallowed ground for documentary photography. In addition to the significance of the events and subjects recorded by them, it is the aesthetic pursuit and innovation of these images that make them so remarkable. As in any good picture, the classic *National Geographic* image is the combination of the elements of light, composition and "the moment" —only, *National Geographic* demands more from the image than any other publication. To bring the three elements together, *Geographic* photographers sometimes have to plan for several years, travel for thousands of miles with more than a thousand kilograms of equipment in tow, traverse mountains and rivers, then patiently wait. Only after consuming thousands of rolls of film (or filling hundreds of memory cards), and after repeating this process several times, might the photographer obtain one image that will become a timeless classic. Other times, luck will deliver the perfect image to the photographer who is ready, enabling him or her to snap that classic work with incredible ease. As Michael Yamashita, a *National Geographic* photographer for more than 30 years now, often says, "A photographer is paid to be lucky." Master wildlife photographer Frans Lanting prefers "serendipity," "because you need to be fully prepared, and then wait for that moment to happen."

攝影／唐諾 · 麥克利什
Photography/ Donald McLeish

▲ 瑞士
SWITZERLAND | 1915 年

在這張手工上色痕跡明顯的彩色照片中，年輕的瑞士牧羊人正在餵食他負責照顧的羊。《國家地理》雜誌自 1910 年 11 月以比平常高出四倍的印刷成本首度刊登手工上色的照片後，深刻體會彩色影像魅力、但又必須控制成本的總編輯吉伯特 · 葛羅夫納開始在每年的「續訂大月」11 月大量使用彩色照片，儘管這種人工色彩有時幾乎可以用俗艷形容。不過，1914 年 7 月，《國家地理》雜誌刊登了一張「奧托克羅姆」（Autochrome，自動彩色，相對於手工著色而言）照片，此後不久就開始將世界「自然的色彩」帶給讀者。

A young Swiss goatherd feeds one of his charges in a notably hand-colored photograph. After the *National Geographic* first published hand-tinted pictures in its November 1910 issue—at four times the normal printing cost—Editor Gilbert H. Grosvenor, aware of the draw of color photos but also under pressure to control costs, resolved to flood his pages with color only in November, the big renewal month. In July 1914, however, an Autochrome, or "self-coloring" (as opposed to hand-tinted), photograph was published in *National Geographic*. The magazine was soon bringing the world in "natural colors" to its readers. □

「白雪皚皚的山峰和紅色的穀倉，倒映在寧靜的諾朗峽灣裡。」55 年前刊出的這張照片旁這麼描述。

昔日的國家地理主張「人性化的地理」。遙遠地域的照片裡一定要有人出現在其中以凸顯景觀的壯闊。而且這些人物的模樣與打扮看起來愈像當地人，出現在雜誌中的效果愈好。第二次世界大戰之前，這類型的旅遊攝影非常受歡迎。然而在戰爭結束後，大眾旅遊的時代來臨，這類刻意染上異國風情的照片就顯得過時而老套。新一代的攝影記者很快就將這種老式攝影風格譏為「明信片風景」。

"Snow-specked peaks and red barns hang upside down in tranquil Norang Fjord," read the caption to this photo published 55 years ago. "Humanized geography," it was once called at the *National Geographic*. Depictions of faraway places were never complete without the human figure to give them scale. And the more those figures looked the part, dressed the part, the better the picture played in the pages of the magazine.

That was the kind of photography that appealed to many people in the years before World War II. But after that conflict had ceased, and the age of mass tourism descended, pictures tinged with deliberate exoticism seemed quaintly old-fashioned. They were soon derided by a new generation of photojournalists as being "postcard views." □

挪威，諾朗峽灣
NORANG FJORD, NORWAY | 1957 年

攝影／安德魯・布朗
Photography/ Andrew H. Brown

攝影／茉蒂・科布
Photography/ Jodi Cobb

◀ **大溪地**
TAHITI | **1997 年**

大溪地是法屬玻里尼西亞的一部分，人民為法國公民，並以法語為官方語言。珊瑚礁、清澈的藍色潟湖與白色沙灘，每年都吸引數十萬觀光客前來。法國觀光客在搭乘獨木舟遊覽過潟湖風光後，由擁有強壯手臂與好客心腸的大溪地接待人員抱上岸去，這個畫面生動地說明了旅行有時也很沈重。不過，許多島民對法國人的熱情歡迎已經轉變為敵意，因為他們覺得，法國統治所帶來的負擔已經超過了好處。

Tahiti is part of French Polynesia; Tahitians are French citizens and French is the official language. The mesmerizing coral reefs, translucent aqua lagoons and white sand attract hundreds of thousands of tourists annually. In this picture, French tourists embody the burdens of travel as Tahitians with strong arms and obliging souls tote them ashore after a lagoon cruise on an outrigger canoe. But hospitality has turned to hostility among many islanders for whom the burdens of French rule outweigh the blessings. ☐

攝影／鮑伯 · 克里斯
Photography/ Bob Krist

義大利,托斯卡尼地區
TUSCANY REGION, ITALY | 1998 年

石造農舍與山丘上的橄欖園俯瞰著托斯卡尼地區雋永的景致。
《托斯卡尼豔陽下》的作者芙蘭西絲 · 梅耶思曾說,想在義大利展開美妙的冒險,就往前開吧。「避開大路,跟著衝動轉彎。一旦到了托斯卡尼的鄉間,就可能碰巧撞見有人在做臘腸、綁蒜頭,或是摘橄欖。」
攝影師鮑伯 · 克里斯曾為《國家地理》雜誌拍攝了數篇報導,他擔任《國家地理旅行家》特約編輯,為這份刊物拍攝了超過 30 個篇章。

A stone farmhouse and hillside olive grove overlook a timeless Tuscan landscape.
Frances Mayes, author of the bestseller *Under the Tuscan Sun*, once said that for a good adventure in Italy, just drive. "Avoid the main roads and turn on impulse. Once in the Tuscan countryside you might witness sausage-making, the braiding of garlic and onions, or olive picking."
National Geographic photographer Bob Krist has shot several articles for *National Geographic* magazine and more than 30 articles for *National Geographic Traveler*, where he is a contributing editor. □

一位熟悉當地的女子在布魯克林區裝潢風格強烈的雪伍德咖啡館內享受寧靜的午餐。這間小餐館是布魯克林的著名地標，牆上掛著的這位「全知先生」注意著週遭一切。蘇珊 · 修伯特是獲獎的旅行攝影師暨報導攝影師，自從2004 年成為特約攝影師以來，已為《國家地理旅行家》雜誌拍攝過 20 多個主題篇章。報導主題從加拿大到加勒比海、從德州到泰國都有。修伯特的專長是利用多種意象來捕捉一個地方的神韻。她對數位技術掌握很深，也熟悉多媒體技術，所以總是走在視覺故事的尖端。

A woman in the know enjoys a quiet lunch at Brooklyn's loudly decorated Sherwood Café. "The Man Who Knows" keeps watch at Sherwood Cafe, a landmark Brooklyn eatery. Award-winning travel and editorial photographer Susan Seubert has photographed more than 20 feature stories for *National Geographic Traveler* since joining the magazine as a contributor in 2004. Her subjects range from Canada to the Caribbean and Texas to Thailand. Seubert specializes in capturing a sense of place through her wide ranging imagery. Her in-depth knowledge of digital technologies and her multimedia skills keep her at the cutting edge of visual storytelling. □

攝影／蘇珊 · 修伯特
Photography/ Susan Seubert

攝影／琳恩 · 強森
Photography/ Lynn Johnson

緬因州的池塘裡，獨木舟船頭上放著一叢白色睡蓮，這是攝影師琳恩 · 強森在緬因州採訪〈自然療法〉一文時拍下的畫面。睡蓮根在傳統醫學中可以用來治療許多病痛，包括皮膚上的傷口和發炎，以及其他內科疾病。

「攝影師協助大眾正視他們無法正視、或不願正視的事物。」琳恩 · 強森說。「除非你能正視某件事情，否則你是不可能改變它的。你必須能夠正視、才有機會了解，最後才可能改變。」為採訪作準備的時候，她會閱讀大量的資料，聽別人談論相關主題。

「人——人與人之間的關係和經驗——比照片本身重要多了，」她說。「身為記者，我們的責任絕非操弄人，而是去讚揚他們和他們的故事。」

A tangle of white pond lilies sits in the front of a canoe in a Maine pond. Pond lily roots are used in traditional medicines to treat a range of disorders, including skin wounds and inflammation, both internal and external. Photographer Lynn Johnson shot this scene while on assignment for "Nature's Rx."

"Photographs help people look at things they may not be able or may not want to look at," says Johnson. "Until you can look at something, you can't change it. First you have to look at it, then you have a chance to understand it and can change it." She prepares for her assignments by reading a lot and listening to people talk about the subject.

"The people—the relationships and the experiences—are more important than the photographs," she says. "As journalists, our responsibility is not to manipulate people, but to honor them and their stories." □

攝影／吉姆 · 理查森
Photography/ Jim Richardson

▲ 蘇格蘭，赫布里群島
HEBRIDES, SCOTLAND | 2010 年

在斯開島的托洛特尼半島上，玄武岩尖柱高聳在拉榭海峽旁。斯開島是蘇格蘭西部外海赫布里群島中的一座。這些島嶼地勢險峻又具脫俗之美，數百年來，藝術家、科學家、詩人與旅人因為它而學得珍惜荒野。孟德爾頌的「芬格爾洞窟序曲」（又名赫布里群島序曲）就是在造訪這裡之後所譜下。

故鄉在英國的攝影師吉姆 · 理查森自 1984 年起開始為《國家地理》拍照。英國，尤其是蘇格蘭的人、文化和景觀，是對他而言特別具有個人意義的主題。

On Skye's Trotternish Peninsula, basalt pinnacles loom over the Sound of Raasay. Skye is one of the islands that make up the Hebrides, off Mainland Scotland's west coast. The islands, both stern and sublime, have taught centuries of artists, scientists, poets, and travelers to treasure the wild. It was during his visit here that German composer Mendelssohn began work on his *Hebrides Overture* (*Fingal's Cave*)。

Photographer Jim Richardson got his start with the *Geographic* in 1984. Richardson, whose family comes from Cornwall, England, holds a special place in his heart for the United Kingdom, especially the people, culture and landscapes of Scotland. □

攝影／法蘭斯 · 藍汀
Photography/ Frans Lanting

▲ 納米比亞，納米比－諾克陸夫國家公園 | 2011 年
NAMIB-NAUKLUFT NATIONAL PARK, NAMIBIA

猜猜看：這是畫還是照片？
攝影師法蘭斯 · 藍汀這張超現實的景觀照片發表之後，在許多人心裡引發了這樣的疑問。藍汀說明了
這張照片的拍攝經過：這是黎明時分的「死沼澤」，早晨溫暖的陽光照亮了點綴著白草的巨大紅色沙丘，
而黏土磐的白色岩床還在陰影中；岩床看起來是藍色的是因為映照著天空的顏色。最佳的瞬間在陽光完
全照到沙丘底部、即將移動到沙漠地面時來臨，等待已久的藍汀用長鏡頭拍下了這超現實的一幕。
1990 年脫離南非獨立的納米比亞，將野地保護寫進入憲法。如今，該國有將近一半土地都已納入保護，
包括納米比－諾克陸夫國家公園，這是非洲最大的野生動物保護區。

Quick: Is it a painting or a picture?
This was many people's reaction when this surreal landscape image was first published. The picture
was made at dawn at the Dead Vlei, says photographer Frans Lanting, "when the warm light of the
morning sun was illuminating a huge red sand dune dotted with white grasses while the white floor of
the clay pan was still in shade. It looks blue because it reflects the color of the sky above." The perfect
moment came when the sun reached all the way down to the bottom of the sand dune just before it
reached the desert floor. Lanting used a long telephoto lens to capture the scene.
In 1990 the new nation of Namibia wrote wilderness protection into its constitution. Today nearly half
of its land is set aside, including the Namib-Naukluft National Park, the largest game park in Africa. □

攝影／史蒂芬 · 阿爾瓦雷斯
Photography/ Stephen Alvarez

▲ **復活節島**
EASTER ISLAND | 2011 年

復活節島在當地語言中稱為「拉帕努伊」（Rapa Nui），島上神祕的巨石像彷彿衛兵一般，站在天頂冷冽明亮的銀河下方。這些稱為「摩艾」的巨大石像或許代表曾經統治此地的古老祖先。在大約 1000 年前，玻里尼西亞人展開了足以比擬現代太空旅程的大膽探險，發現了這個島。
探險攝影師史蒂芬 · 阿爾瓦雷斯在他所謂的「邊疆的原始邊緣」進行攝影工作，「我覺得自己非前往還沒被砍下來的那少數幾個地方不可。」他說。

On Easter Island, also called Rapa Nui, mysterious statues stand sentinel as the Milky Way spins cold and bright above. The giant moai may represent ancestors who ruled here after Polynesians discovered the island some thousand years ago during a wave of exploration that has been compared in its boldness to modern space voyages.
Expedition photographer Stephen Alvarez works on what he calls "the raw edges of the frontier." "I feel a need to go to the few places that haven't been cut down yet," he says. ☐

台灣記憶
Remembering Taiwan

《國家地理》雜誌曾經以專題報導台灣十餘次。1969年1月，台灣登上《國家地理》雜誌的封面，這篇由海倫與法蘭克‧史瑞德完成的四十多頁的報導，不僅涵蓋了台灣全島的風土人情，對當時的國防軍事也做了深入報導。在台灣經濟正振翅起飛的1982年，國家地理描繪了一個富庶安逸，但新的政治變革也悄然醞釀的島嶼。國家地理對台灣的大篇幅報導最後一次是在1993年。著名攝影師朱蒂‧科布為「台灣錢淹腳目」的年代留下了許多經典的註腳，也觸及了台灣當時已方興未艾的民主運動和日漸惡化的環境問題。

這些時間跨度將近百年的照片，清楚地鋪陳出台灣經歷過的各個階段和各種面相。從這些照片當中，我們不僅能回味台灣歷史，也能更加體會國家地理客觀、全面，而且深入的報導風格。

National Geographic magazine has featured Taiwan in a dozen articles since 1920. Taiwan appeared on the cover of the *National Geographic* in January 1969. The coverage, more than 40 pages long and produced by Helen and Frank Schreider, offered a panoramic view of the landscapes and people of Taiwan, in addition to in-depth reporting on Taiwan's national defense. As Taiwan's economy took flight in the 1980s, a story in 1982 described an island where, though prosperous and peaceful, political changes were brewing. *National Geographic*'s last feature story on Taiwan was in 1993. Of that era, when Taiwan was "awash in money", acclaimed photographer Jodi Cobb captured images that would become classic footnotes of that period in Taiwan's history, when democracy movements raged and environmental issues grew.
Spanning almost a century, these images delineate the different stages and faces of Taiwan through time. Through these pictures, we not only relive Taiwan's history, but also gain a better sense of the kind of objective, comprehensive and in-depth journalism that is the hallmark of the *National Geographic* style.

* 「台灣記憶」中，部分年代較早的原始圖說經過較大幅的編輯、增添與改寫，以讓圖片說明更豐富並符合真實。
*In this section, some of the original captions from the earlier stories have been revised and expanded to include additional and more accurate information.

來源 / 美國新聞總署
Source/ USIA

▲ **台灣，台北**
TAIPEI, TAIWAN | **1955 年**

台北街頭，警察在瞭望台內指揮交通。戰後台灣不再採行日治時期靠左行駛的道路通行方向，汽車、腳踏車一律靠道路右側行駛。最常見的交通工具是二輪或三輪車輛，經常可見三輪車在街頭競相載客。不過隨著台灣社會生活形態及都市發展的變遷，政府於 1968 年全面禁止行駛三輪車，並輔導三輪車夫轉業為計程車司機，曾經穿梭於台灣大街小巷的三輪車，走入歷史，僅存於人們的記憶之中。

A policeman in his crow's-nest directs traffic in Taipei. Cars and bicycles move to the right, a postwar change-over from the Japanese left-right rule. Most traffic is two- or three-wheeled, with foot-powered pedicabs vying for fares. With urbanization and the accompanying social and life-style changes, the government banned pedicabs in 1968, and provided assistance for pedicab drivers to become taxi drivers instead. So it was that the pedicab became part of history and people's memories. □

〈巡弋紛擾多事的福爾摩沙海峽〉 | 刊登時間：1955 年 4 月
"PATROLLING TROUBLED FORMOSA STRAIT" | **PUBLISHED IN: APRIL 1955**

攝影／約瑟夫 · 巴蘭廷
Photography/ Joseph W. Ballantine

▲ **台灣，台北**　│　**1945 年**
TAIPEI, TAIWAN

台北街頭，群眾夾道觀賞祭典遊行的人龍與花車，這幕景象，讓作者想起
昔日在美國馬戲團進城時的遊行，同樣也是吸引人潮圍觀的熱鬧盛事。樂
隊在最前面開路，後面跟著遊行隊伍。打鼓的男孩走在吹嗩吶的人之間，
就和美國的鼓號樂隊一樣。雖然是大白天，男子還是扛著上面畫了龍和各
種人物的紙製大燈籠。花車上的陽傘下，坐著穿了戲服的女孩。

In Taipei, ceremonial processions with decorated floats are to the
Chinese crowds what old-time circus parade was to Americans. The
procession is led by the band; between trumpet men march the drummer
boys, just as in a fire-and-drum corps. Though it is daylight, men carry
big paper lanterns covered with dragons and characters. Costumed
girls, under parasols, ride on floats. □

〈**我曾住在福爾摩沙**〉　│　刊登時間：**1945 年 1 月**
"I LIVED IN FORMOSA"　│　PUBLISHED IN: JANUARY 1945

攝影／貝勒 · 羅伯茲
Photography/ J. Baylor Roberts

▲ **台灣，台北**
TAIPEI, TAIWAN | **1950 年**

位於台北的前日本總督府在國民政府遷台後改名為「介壽館」，由國民黨軍隊進駐。每天天亮後不久，就會傳來軍隊操練的口號聲。當時的台北市人口約 44 萬，主要的交通工具是腳踏車、人力車，和腳踏車改裝的三輪車。極少數的富裕中國人（大多是政府官員），從上海和其他大陸港口帶來了凱迪拉克、水星、別克、克萊斯勒等美國車。不過街上的公車很少，也沒有電車。而日治時代靠左邊走的規則，在國民政府遷台後也改成了靠右邊走。不過三輪車滿街橫衝直撞，不怎麼理會交通規則。

Renamed "Long Live Chiang Kai Shek Hall," the former Japanese government building in Taipei now houses Chinese troops. Most of the swollen city's 439,793 people seemed to be riding bicycles, rickshaws, or bicycle buggies called pedicabs. The city has a few buses but no streetcars. Wealthy Chinese, chiefly Government officials had brought Cadillacs, Mercuries, Buicks, Chryslers from Shanghai and other mainland ports. The city has a few buses but no streetcars. Except for pedicabs, which often darted about with little regard for the rules, traffic moved on the right-hand side. □

〈福爾摩沙 ─ 東方熱點〉 | 刊登時間：1950 年 2 月
"FORMOSA - HOT SPOT OF THE EAST " | PUBLISHED IN: FEBRUARY 1950
作者：佛萊德瑞克 · G · 沃斯伯勒　By Frederick G. Vosburgh

▲ **台灣，台南**
TAINAN, TAIWAN | **1950 年**

<div>攝影／貝勒 · 羅伯茲
Photography/ J. Baylor Roberts</div>

瘦削的年輕國軍，行軍穿越舊府城台南的火車站前廣場。台南一度是台灣島的首府，作者造訪時則是全台第三大城。此處也醞釀著民怨，導致1947年2月與3月時遭國民政府鎮壓的「台灣人動亂事件」〔即二二八事件〕。從車站屋頂看出去，位於西部海岸平原，到處長著椰子樹、人口20萬2000的台南，看起來就和德州潘漢德的小鎮一樣平坦。圖中有塔樓的那棟建築物是《中華日報》總社。

Lean young Chinese Nationalist soldiers march through the railroad station plaza in Tainan, once the capital of the island and now its third largest city. Here simmered some of the discontent which resulted in the suppressed revolt of Formosans against the Chinese Nationalists in February and March 1947. From the station's roof this palm-plumed city of 202,000 looks as flat as a Texas Panhandle town; it lies on the west coast plain. The towered building is a newspaper office. ☐

▲ **台灣，台南**
TAINAN, TAIWAN | **1950 年**

<div>攝影／貝勒 · 羅伯茲
Photography/ J. Baylor Roberts</div>

每當台南的供水系統出現問題，軍人就改用赤崁樓邊的井水。打水的軍人穿著操練時的短褲。赤崁樓位於台南的中心地帶，原址本是荷蘭人統治台灣時所興建的歐式建築，名為「普羅民遮城」，鄭成功趕走荷蘭人後，將普羅民遮城改為承天府衙門，作為全島最高的行政機構。清朝時，普羅民遮城逐漸頹圮，台南人也先後在原址興建了文昌閣、五子祠等中式建築。二次大戰後，赤崁樓經過重新修繕，作者造訪的時候，屋頂有盤龍卻會漏水的赤崁樓已經成了博物館。

When Tainan's water system fails, soldiers use this well beside old Fort Providentia. The men are clad for physical training. After defeating the Dutch, Koxinga rebuilt the fort in Chinese style. It gradually fell into disrepair during the Qing Dynasty, but was restored after the Second World War. Now [1950s] its ornate dragon-crowned but leaky roof shelters a museum. ☐

攝影／海倫與法蘭克 · 史瑞德
Photography/ Helen and Frank Schreider

▲ **台灣，中央山脈**
CENTRAL MOUNTAIN RANGE, TAIWAN | **1969 年**

飛龍中隊從中央山脈疾飛而過；此中隊由洛克希德 F-104 星式戰鬥機組成，隸屬於擁有 10 萬員額的中華民國空軍。這張照片得來不易。作者希望拍攝台灣最高峰玉山，但積雪、山崩和厚厚的雲層，讓作者屢屢無法從地面一窺玉山真貌。一位空軍朋友建議作者搭上教練機和飛龍中隊一起飛行，才從空中拍到這張中央山脈的珍貴照片。圖片中間的秀姑巒山（3,825 公尺）是中央山脈最高峰，後方遠處可見玉山北峰（3,858 公尺）。

"FLYING DRAGON" Squadron: Lockheed F-104 Starfighters of the 100,000-man Republic of China Air Force flash past Taiwan's Central Mountain Range.
This was a hard-earned photo. The author had hoped to photograph Taiwan's highest peak, Yu Shan, or Jade Mountain, but snows, landslides and clouds frustrated every attempt to view the mountain from land. A Chinese Air Force friend suggested that the author take a flight with the Flying Dragon Squadron and shoot Yu Shan from the air. So the author jumped in a trainer and flew with the Flying Dragon Squadron, snapping this rare aerial photograph of the Central Mountain Range. In the middle is 3,825-meter Hsiuguluan Mountain, tallest peak of the Central Mountain Range, with the north peak of Yu Shan, at 3,858 meters, visible in the background. □

〈台灣：不眠的龍〉 | 刊登時間：1969 年 1 月
"TAIWAN, THE WATCHFUL DRAGON" | PUBLISHED IN: JANUARY 1969

攝影／海倫與法蘭克 • 史瑞德
Photography/ Helen and Frank Schreider

▲ **台灣，金門**
KINMEN, TAIWAN | **1969 年**

以後弓動作鍛鍊肌肉的蛙人接受嚴格的專業訓練，負責清除水雷，並在兩棲突擊中先行搶灘。
軍隊灌輸的觀念強調要反攻大陸。但蔣介石靠著超過 20 億美元的美援所建立的超過 60 萬大軍，
主要卻是用於防禦。軍隊缺乏攻擊用的船艦與飛機。
不論身分地位、經濟狀況、人脈關係或教育程度，所有男性都要服兵役。軍隊人數約有 60 萬，
是全國人口的 5%，但薪資卻也是全世界最低的前幾名，以大兵來說，一個月大概是 7.5 美元左
右。但作者卻發現軍人鬥志高昂，滿腔熱血。

Muscle-building backbends toughen frogmen trained to clear away underwater mines and hit
the beach first during amphibious assault. Troop indoctrination stresses retaking the mainland.
But Chiang's 600,000-strong army, built with more than two billion dollars' worth of American
aid, is primarily defensive. It lacks the ships and planes needed for invasion.
No one, regardless of position, wealth, connections, or education is exempt from military
service. Some 600,000 men are in uniform, 5 percent of the population, and they are among
the lowest paid in the world, about US$7.50 a month for privates. Yet we found high morale
and enthusiasm. ☐

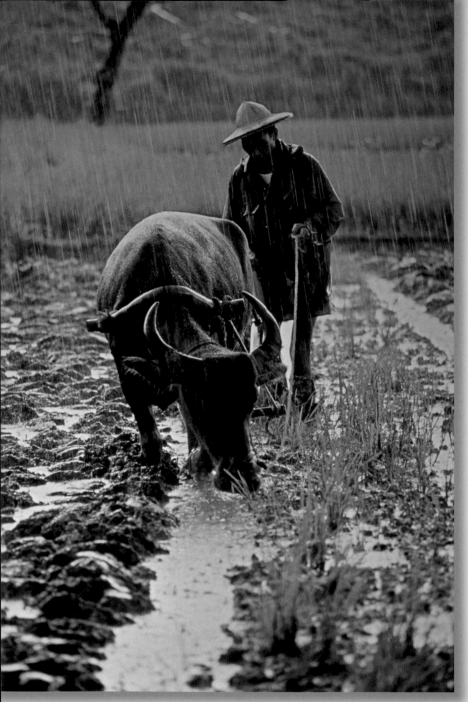

水牛是稻農數百年來最忠實的僕人，圖中這頭水牛正拉著犁穿越被雨季浸潤的田地。儘管台灣有34萬頭水牛，卻仍然供不應求。而農夫的新朋友，就是耕耘機了。一台耕耘機的工作量可以抵五頭水牛。耕耘機都是日本或台灣生產，目前〔1969年〕全台耕耘機的總數約有2萬1500台左右。

水牛對早年台灣農業發展貢獻良多，政府還一度規定13歲以下的水牛不能宰殺販售。只是農業機械化後，台灣水牛飼養頭數逐年減少，1986年畜產試驗所成立「台灣水牛養育中心」，協助水牛的保種與推廣工作。

Centuries-old servant of the rice farmer, a water buffalo draws his master's plow through a field soaked by the monsoon's deluge. Despite 340,000 buffaloes on this island, they remain in short supply. The farmer's new friend is the power tiller, which can do the work of five water buffaloes. Some 21,500 of these small tractors, manufactured in Japan and Taiwan, are now [1969] in use. Water buffalos played such an important role in Taiwan's early agricultural industry that the government once proclaimed that water buffaloes under 13 were not to be slaughtered for meat. With agricultural mechanization beginning in the 1960s, however, the number of water buffalos in Taiwan steadily declined. In 1986 a breeding center was established under the Livestock Research Institute to conserve the animal. □

攝影／海倫與法蘭克・史瑞德
Photography/ Helen and Frank Schreider

▲ **台灣**
TAIWAN | **1969 年**

〈台灣：不眠的龍〉 | 刊登時間：1969 年 1 月
"TAIWAN, THE WATCHFUL DRAGON" | PUBLISHED IN: JANUARY 1969

攝影／朱蒂 · 科布
Photography/ Jodi Cobb

▲ **台灣，台北** | **1992 年**
TAIPEI, TAIWAN

漫天黃彩帶淹沒了 1992 年職棒總冠軍兄弟象隊的球員。棒球是當時台灣唯一的職業運動，發展蓬勃，深受熱情球迷支持。中華職棒聯盟成立才三年，只有四支球隊，分別是兄弟象、味全龍、統一獅，三商虎。1992 年的職棒比賽觀眾也創新高，全年平均下來，每場約有 6878 名觀眾。從 1951 年開始，台灣的經濟成長率每年平均都將近 9%，這一年的國民平均所得將直逼 1 萬美元，讓台灣躋身亞洲其他工業精英國家之列。這樣的財富也讓台灣人有餘裕享受休閒生活。

A blizzard of streamers engulfs Taiwan's 1992 baseball champs, the Brother Elephants. Growing in number, fans enthusiastically support the island's only professional sport. The Chinese Professional Baseball League, established just three years earlier, has four teams: Brother Elephants, Wei-Chuan Dragons, Uni-President Lions and Mercuries Tigers. The average attendance reached a record high in 1992, with 6,878 spectators per game.
Since 1951, the island's annual economic growth has averaged almost 9 percent. This year per capita income will approach US$10,000, bringing Taiwan into line with the other members of Asia's industrial elite. This wealth has also bought the Taiwanese time to enjoy their leisure. ☐

〈另一個中國的變革〉 | 刊登時間：1993 年 11 月
"THE OTHER CHINA CHANGES COURSE: TAIWAN" | PUBLISHED IN: NOVEMBER 1993
撰文：亞瑟 · 里奇 攝影：朱蒂 · 科布 By Arthur Zich Photographs by Jodi Cobb

主辦單位：遠雄文教公益基金會
　　　　　《國家地理》雜誌中文版
策展團隊：大石國際文化
　　　　　李永適　陳其輝　胡宗香　黃正綱　柯虹玉
　　　　　魏靖儀　洪莉珺　彭龍儀　陳郁分　江怡蘋
　　　　　潘彥安　古昌雯　宋憶萍
藝術總監：陳其輝
美術編輯：陳自強
特別感謝

中文圖錄編審：胡宗香　鍾慧元
中文圖錄翻譯：林潔盈　張淑貞　劉怡伶　盧郁心
阿美族／Pangcah阿美族守護聯盟、社團法人臺南市馬
楞楞學會 Kilang Manah 玎硡・瑪那Natawran（娜荳蘭）
部落，Sicimi Simuy 林定 Farangaw（馬蘭）部落，Namoh
Nofu 那莫・諾虎 Tafalong（太巴塱）部落，Sra Manpo
Ciwidian 李孟儒 Angcoh（安通）部落，Tipus Hafay 林易
蓉 Natawran（娜荳蘭）娜荳蘭部落，Fotol Biung 謝博剛
中央研究院民族學研究所研究助理，Ingay Tali 殷艾・達
利 Fata’ an（馬太鞍）部落，排灣族／Laway Napiday 郭
軍毅 Farangaw（馬蘭）部落，Vikung Lalengeang 威弓
Daladalai（達來）部落，魯凱族／Amale Gadhu 阿媽樂・
卡督Kucapungane（古茶柏安，舊稱好茶）部落
廖鎮洲 友原有限公司
提供資料並協助指正
出　版　者：大石國際文化有限公司
地　　　址：台北市內湖區堤頂大道二段181號3樓
電　　　話：(02) 8797-1758
傳　　　真：(02) 8797-1756
印　　　刷：博創印藝文化事業有限公司
2015年（民104）1月初版

定價：新臺幣 299 元
本書正體中文版由 National Geographic Society
授權大石國際文化有限公司出版
版權所有，翻印必究
ISBN：978-986-5918-29-3 (平裝)
＊ 本書如有破損、缺頁、裝訂錯誤，請寄回本公司更換

國家地理學會是世界上最大的非營利科學與教育組織之
一。學會成立於1888年，以「增進與普及地理知識」為宗
旨，致力於啟發人們對地球的關心。國家地理學會透過
雜誌、電視節目、影片、音樂、電台、圖書、DVD、地圖、
展覽、活動、學校出版計畫、互動式媒體與商品來呈現世
界。國家地理學會的會刊《國家地理》雜誌，以英文及其
他39種語言發行，每月有6,000萬讀者閱讀。國家地理頻
道在171個國家以38種語言播放，有4.4億個家庭收看。國
家地理學會資助超過一萬項科學研究、環境保護與探索
計畫，並支持一項掃除「地理文盲」的教育計畫。

國家圖書館出版品預行編目（CIP）資料

探索無限：國家地理125年經典影像大展. -- 初版. --
臺北市：大石國際文化，民102.09

　　面；　　公分

ISBN 978-986-5918-29-3(平裝)

1.攝影作品 2.攝影史

957.9　　　　102018447

Copyright © 2013 National Geographic Society
All rights reserved.

Copyright Complex Chinese edition © 2013 National Geographic Society
All rights reserved.

Reproduction of the whole or any part of the contents without written per-
mission from the publisher is prohibited.